ANTEBELLUM HOMES of GEORGIA

Foreword by Joseph B. Mahan

ANTEBELLUM HOMES

Photographs

and Text by

DAVID KING GLEASON

of GEORGIA

Louisiana State University Press

Baton Rouge and London

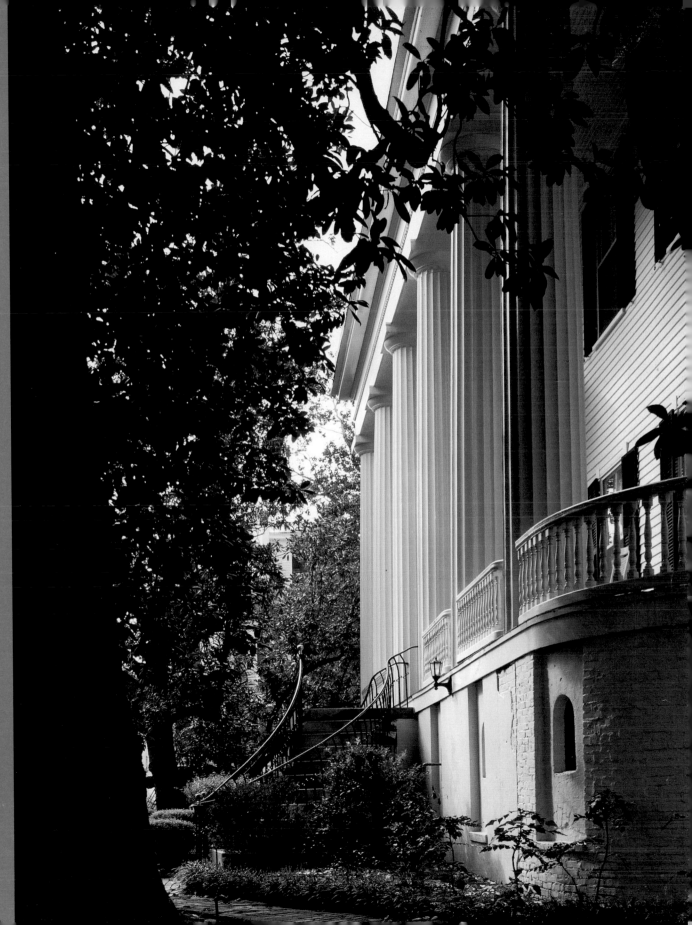

To my two bosses: Josie and Gisela

Designer: Albert Crochet
Typeface: Cheltenham Book
Typesetter: CSA Press, Inc.
Printer and Binder: Dai Nippon, Tokyo, Japan

10 9 8 7 6 5 4 3 2 1

Library of Congress Cataloging-in-Publication Data

Gleason, David K.
 Antebellum homes of Georgia.

 Includes index.
 1. Plantations—Georgia—Pictorial works.
 2. Dwellings—Georgia—Pictorial works. 3. Archi-
tecture, Domestic—Georgia—Pictorial works.
 4. Georgia—Description and travel—1981– —
Views. I. Title.
F287.G5 1987 975.8 87-2986
ISBN 0-8071-1432-4

I extend my special thanks to the talented staff of Gleason Photography: Gisela O'Brien, studio manager, who made all the color prints for this book; Craig Saucier and Sondra Dornier, who did much of the research; Paige Dugas, Cyndy Branton, and Josie Gleason. Special thanks also to my friends in Georgia: Pam and Walter Stapleton of the Guerry House in Americus, great hosts, marvelous chefs and entertainers, and students of southern history and the Civil War, who made their house our home; Butch and Barbara Reeves of Albany, warm hosts and hard workers, especially Butch, who spent a day with me lugging lights, cameras, and tripods in the Albany area; William Banks of Newnan, gracious host and talented writer; the Wilson family: Epp, James, and Robert in Thomson, who introduced me to houses in their area; Chip Hall in Albany; Gloria Belcher in Madison; Julian Adams and the Charlie Gleason family in Augusta; Dr. J. B. Mahan in Columbus, and Janice Biggers and Clason Kyle of the Historic Columbus Foundation; Bruce Sherwood and Kitty and Lee Oliver in Macon; Betty "Beegee" Baugh and Ray Olivier in Milledgeville; Phil Secrist in Marietta; and Erich Montgomery in Savannah.

Thanks also go to the professionals at the Historic Preservation Section of Georgia's Department of Natural Resources: Richard Cloues, Kenneth Thomas, and Charlotte Ramsay, who have a treasury of information about Georgia's antebellum homes and an enthusiasm to match; and to those dedicated librarians across Georgia who received us on short notice and provided volumes of information and much encouragement.

Finally, special thanks go to all those who own or manage these great old homes: we banged on their doors and disrupted their days, but still they welcomed us with unfailingly gracious Georgia hospitality.

Contents

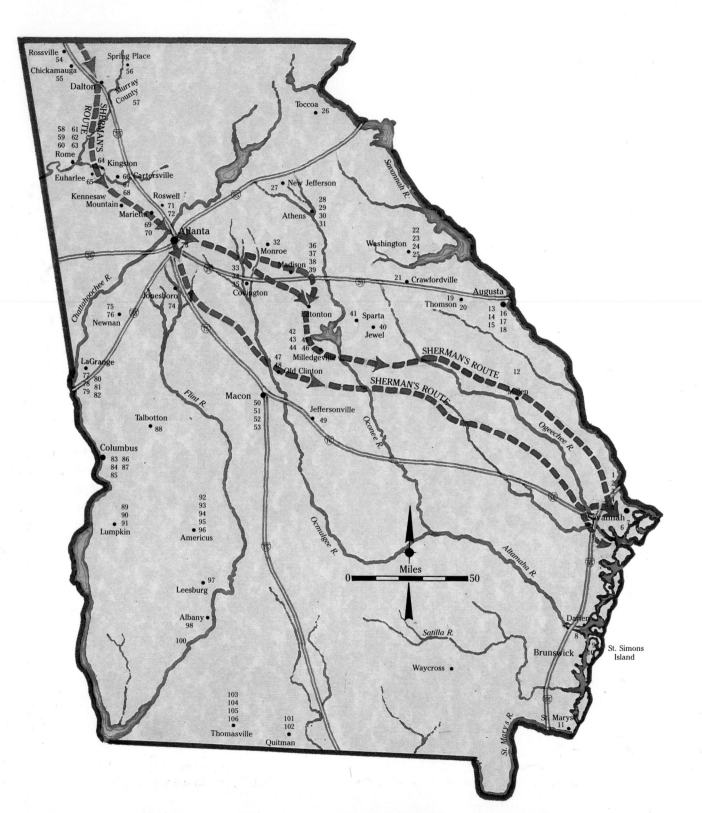

1 Green-Meldrim House
2 Andrew Low House
3 William Scarbrough House
4 Wayne-Gordon House
5 Richardson House
6 Wild Heron
7 Wormsloe
8 Hofyl-Broadfield Plantation
9 Tabby Slave Cabins, Hamilton Plantation
10 Cannon's Point
11 Orange Hall
12 Birdsville Plantation
13 Ezekiel Harris Home
14 Fruitlands
15 Meadow Garden
16 Ware's Folly
17 Montrose
18 High Gate
19 Hickory Hill
20 Snow Hill
21 Alexander H. Stevens House
22 Washington-Wilkes Museum
23 Robert Toombs House
24 Wickersham House
25 Callaway Plantation
26 Traveler's Rest
27 Shields-Ethridge
28 President's House
29 Howell Cobb House
30 Sledge-Cobb House
31 Taylor-Grady House
32 Briscoe-Selman
33 Whitehall
34 Dixie Manor
35 Mt. Pleasant
36 Thurleston
37 Bonar Hall
38 Robin's Nest Farm
39 Atkinson Brick House
40 Rock Mill
41 Glen Mary
42 The Homestead
43 Stetson-Sanford
44 Lockerly
45 Rockwell
46 Gatewood
47 Lockett-Hamilton
48 Rosser-Barron-Hamilton
49 Hollywood
50 Woodruff House

51 Holt-Peeler-Snow
52 Raines-Carmichael-Oliver
53 Hay House
54 John Ross House
55 Gordon-Lee House
56 Chief Vann House
57 Carter's Quarters
58 Chieftains
59 Oak Hill
60 Thornwood
61 Home on the Hill
62 Arcadia
63 Colonial Heights
64 Barnsley Gardens
65 Valley View
66 Ryals-Davis House
67 Clarendon
68 John Clayton House
69 Archibald Howell House
70 Tranquilla
71 Bulloch Hall
72 Great Oaks
73 Tullie Smith Hall
74 Lovejoy
75 Gordon-Banks House
76 Buena Vista
77 The Oaks
78 John Hill House
79 Nutwood
80 Forest Home
81 Boddie House
82 Bellevue
83 The Wynn House
84 Dinglewood
85 Gordonido
86 Rankin House
87 St. Elmo
88 Rebel Ridge
89 Moye Farms
90 McDonald House at Westville
91 Fitzgerald Plantation (near Omaha)
92 The Guerry House
93 Dr. Hinkle House
94 Col. Fish House
95 Bagley House
96 Liberty Hall
97 Grey Moss
98 Cypress Pond
99 Tarva
Pinebloom
101 Hunter Plantation
102 Eudora
103 Greenwood

104 Pebble Hill
105 Seminole
106 Susina

Foreword

by Joseph B. Mahan

This book's title, *Antebellum Homes of Georgia*, will evoke thoughts of Tara and Twelve Oaks in the minds of many readers. These fictional places, the most famous of Georgia plantations, exist as part of *Gone With the Wind* in dual form—as descriptions on the pages of the novel and as briefly seen images in the motion picture version. It is the latter form that most people will recall. In their mind's eye they will see the somewhat squat Tara with oversized square columns and the stately Twelve Oaks with its graceful Ionic colonnade framed by towering trees.

The thoughtful reader of Margaret Mitchell's description of these two plantation homes gains a more accurate picture, especially if the person has traveled in the Georgia Piedmont and observed the relics of the fabled Cotton Kingdom that are dispersed throughout the region. This reader soon identifies Tara with the indigenous Plantation Plain architectural type upon which had been grafted a portico of sturdy square columns. This was the manner that local carpenter-builders devised in the mid-1830s to counter the intrusion of the classical Greek Revival mode. The relocated McDonald House in the living history village of Westville is a fine example of this indigenous classical style.

The more academic Greek Revival architectural style was being introduced belatedly into the state by master builders trained in the urban centers of the Northeast, where it had been in vogue for more than thirty years. A mansion house such as Twelve Oaks would certainly have been the creation of a master working in the Greek Revival style. Mitchell made it clear that the Wilkes family, the owners of Twelve Oaks, possessed a cultural refinement that complemented the elegance and sophistication of their imposing residence. The same was not true at Tara, the home of Gerald O'Hara and his family. Like them, their plantation house was the embodiment of sturdy quality and simple style, but not of elegance. There were once hundreds of examples of the architectural types represented in these two fictional houses. There are still splendid specimens of both, as David Gleason's camera proves.

The contemporary reader of *Gone With the Wind* may assume that its description of Georgia's plantation society is as complete as it is accurate. This is not quite true, however. There was another stratum in this society that Mitchell did not introduce to her readers but that was described by another novelist who wrote about Georgia in the halcyon days before the Civil War.

This novelist was Augusta Evans Wilson, whose most famous book, *St. Elmo*, remained popular for many years after its publication in 1866. This author, who was herself part of the society about which she wrote, depicted a rarefied social group whose refinement and elegance were derived partially from their origins in the old coastal aristocracy of Georgia and South Carolina but also from contacts in Europe and from their travels abroad. These travels were incident to the trading and transporting of cotton to foreign markets or were the result of wealth from the cotton mills that were flourishing across the state, especially in Columbus and Macon.

As might be anticipated, the opulent homes of these wealthy cosmopolites were built according to European patterns, to house furniture they shipped home from abroad, and not in the mundane and outdated Greek Revival mode. The principal setting for *St. Elmo* is a residence of this sort.

In *St. Elmo* there is no mention of the Civil War, for the time portrayed is the prosperous 1850s. There is only one mention of cotton, and that is indirectly. The heroine, an innocent teenage girl left alone in the world by the recent death of her grandfather, travels on a train from Chattanooga, Tennessee, to Columbus. She faces the unhappy prospect of working in the cotton mills of that city, but she is saved from this dismal fate by a disastrous train wreck from which she is rescued by a kindly benefactor.

The hero of the romantic tale is St. Elmo Murray, the worldly and jaded son of an affluent, urbane family. He spends much of his time traveling to strange places seeking exotic pleasures but returns periodically for brief sojourns at a palatial home his mother occupies somewhere in the hill country of northern Georgia.

This villa is described as a place of considerable grandeur. There are formal gardens with statuary and serpentine walks, a glass-enclosed conservatory, a splashing fountain, and a cloisterlike gallery with a floor of variegated tile. Inside the villa, there are rich furnishings, including a marble table whose top is inlaid with signs of the zodiac done in a wide variety of colored stones. This table supports a mysterious locked box that contains St. Elmo's secret.

It is not coincidental that the pretentious domicile of the Murrays, near the Western and Atlantic Railroad and a few hours travel south of Chattanooga, resembled in these particulars an actual estate that existed at the time in the same location. This was Woodlands, the country estate of Godfrey Barnsley (later known as Barnsley Gardens). It was in style a Tuscan villa, the ruins of which are shown most dramatically in this volume.

An English native, Barnsley came to Savannah as a youth and developed one of the largest cotton bro-

kerage firms in the country. In the 1840s and 50s he moved the headquarters of his company to Mobile and finally to New Orleans. In Mobile, Barnsley had become acquainted with the novelist Augusta Evans Wilson. She was a house guest at Woodlands for several days in the fall of 1865 while she was writing *St. Elmo*. Barnsley was the son-in-law of William Scarbrough, a cotton exporter whose splendiferous English Regency house in Savannah is also pictured herein.

Not all of the splendid residences of the wealthier owners were situated on plantations devoted to the growing of cotton. For example, the river port city of Columbus was bordered on the east and north by low, round hills. These hills were occupied before 1860 by villas that were the centers of small plantations of about one hundred acres. These estates belonged to physicians, lawyers, bankers, millowners, steamboat owners, and merchants. Their acreage contained landscaped grounds, gardens, orchards, and vineyards, but no cotton fields.

In Macon, during the 1850s, William Butler Johnston constructed perhaps the grandest of all the residences of this type. A twenty-four-room Italian Renaissance villa, this great house cost a quarter of a million dollars to build. It was replete with fine exotic woodwork, stained glass windows, silver-plated hardware, and steps and floors of Carrara marble. As was true at Barnsley's estate, a copper-lined reservoir in the roof structure provided water for a plumbing system and a gas plant to light the house.

A Georgia native who trained first to be a jeweler, Johnston made his initial wealth from a cotton mill he organized in Macon. He increased his assets with income from an insurance company that he also founded there, as well as other enterprises. By 1850, he had amassed sufficient resources to allow him to spend three years with his wife touring Europe and studying its art and architecture. They became infatuated with Italian Renaissance architecture and returned to build their magnificent home in that style.

Although the builders of the homes included in this collection were of varied economic, social, and national origins, they had one very important thing in common: they were residents of Georgia at a most advantageous time. The greatest advantage was that cotton growing had been made profitable by the invention of the cotton gin and the coincidental development of the steam engine, which facilitated the transportation of crops to an expanding world market. Not even the ownership of slaves and their labor was more significant. Equally fortuitous was the availability of an abundance of fertile land at low cost. The state used a very liberal system to distribute to citizens and recent immigrants alike the vast quantities of land that were obtained through the dispossession of resident Indian tribes.

This land became available in thirteen large areas between 1802 and 1832. In the former year state leaders reached an agreement with the federal government under which Georgia relinquished to the United States government its disputed claim to lands that would become parts of Alabama and Mississippi. This concession was given in return for the assumption of claims against Georgia pertaining to these lands and the promise to remove all the Indians from the remainder of the state's territory as soon as was practicable.

During the ensuing thirty years the frequent land cessions, obtained under varying degrees of duress from the Creeks, Seminoles, and Cherokees, permitted the state to gain possession of all the territory it claimed. The land thus obtained was used to achieve the desired effect of enticing settlers into a previously nonproductive, unprotected section of the state.

This clearly perceived purpose on the part of the state leaders became apparent in 1803 when the legislature passed a new law establishing a system of land grants that provided for the complete surveying of land in any Indian cession and for laying it out into lots to be granted to individual owners. These lots were 202.5 acres until 1832, when land from the Cherokee Nation was divided into 160-acre lots, except for the more valuable areas where gold was found. There the lots were only 40 acres.

When the survey of a ceded area was complete, the land was distributed by a lottery. Every free white male citizen of the United States who had lived in Georgia for the previous year was allowed one chance in the lottery, as was every family of orphans under twenty-one years of age. Every man with a wife and minor child and every widow with minor children were given two chances, as were veterans of the nation's wars. All land obtained through these lotteries carried fees of four dollars per hundred acres.

Many of the lucky winners in these lotteries established residence on the land they had obtained. Most of them, however, offered it for sale at whatever price it would bring. The availability of land that resulted coincided with the expanding cotton industry and nurtured the period of easy abundance of which this book bears evidence.

That period covered only a brief few decades. The Civil War brought this prosperity to a more precipitous end than was already impending. The soil was becoming exhausted because of prolonged cultivation of cotton, and competition in producing this crop was increasing in an ever-widening geographic area. First, the main area of competition was the other Gulf states, into which settlers carrying the cotton culture of Georgia moved; later, it was Arkansas and Texas, which took the lead toward the end of the period.

The diversity and rich quality of Georgia homes in this storied era are dramatically clear in Gleason's unique photographs. A few of these homes were built in exotic styles with the use of imported materials and skills. Most, however, were indigenous outgrowths of a sophisticated earlier period represented by the Ezekiel Harris House in Augusta and the handsome brick residence of the Cherokee chieftain James Vann at Spring Place, built in 1804 far beyond what was then the state's frontier. All the examples shown in these beautiful photographic studies share a common element. They are part of the architectural complexity that characterized Georgia in the antebellum period.

SAVANNAH
AND THE
GOLDEN
COAST

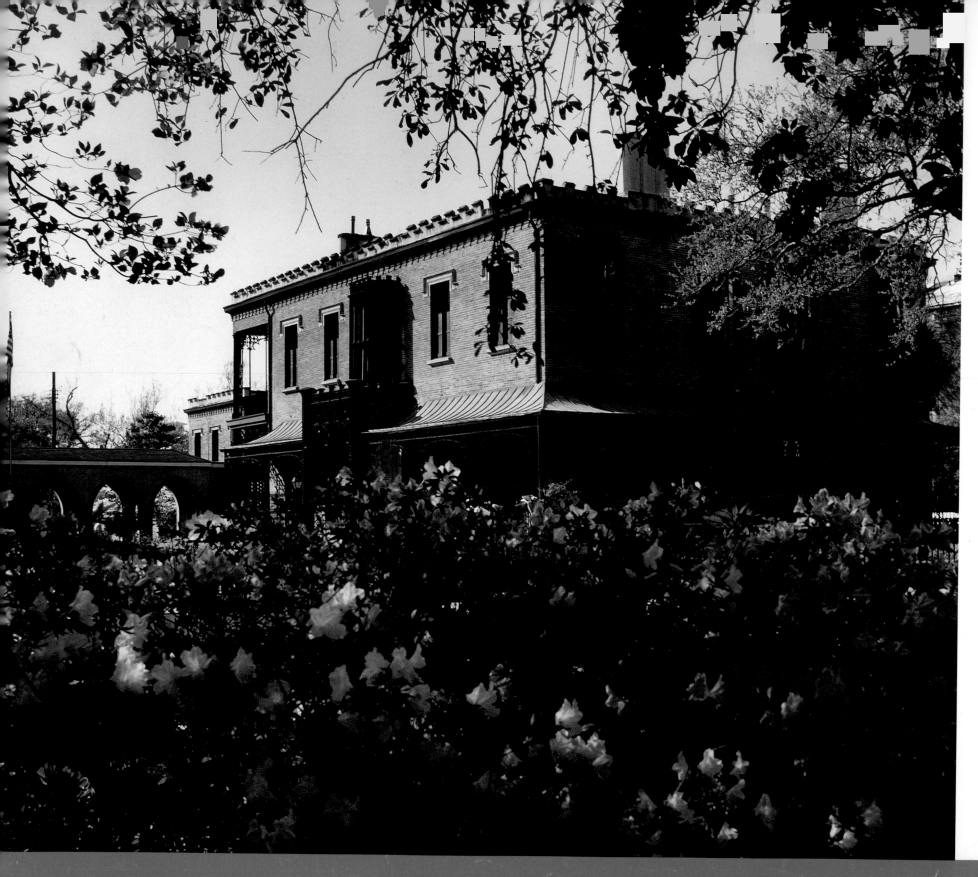

Green-Meldrim House, *ca.* 1853

When his March to the Sea ended in Savannah in December, 1864, General William Tecumseh Sherman made his headquarters in an imposing Gothic Revival house designed by a New York architect for a British subject who had become one of the most powerful men in Savannah.

Charles Green was a cotton factor (exporter) who went to Savannah when he was seventeen and amassed a fortune. In the early 1850s, he retained New York architect John S. Norris, who had designed a mansion for Andrew Low in Savannah in 1848. The resulting Gothic Revival mansion was completed at a cost of $93,000, making it the most expensive house built in Savannah before the Civil War.

Although he was a British subject, Green identified with the South. His son was in the Confederate army. But when Sherman's army of over sixty thousand men approached Savannah after virtually destroying Atlanta, cutting a sixty-mile-wide path of devastation through Georgia from Atlanta to the sea and overcoming the port city's outlying fortifications, diplomacy was the order of the day.

At the suggestion of Savannah businessmen, a delegation met Sherman, and Green invited him to make his new house his headquarters. Sherman's troops exercised restraint in Savannah, saving it from the fate they dealt Atlanta and Columbia, South Carolina.

The house remained the residence of Charles Green until his death in 1881. It was later bought by Judge Peter Meldrim, a distinguished jurist, who welcomed President William McKinley to his home. It is now the parish house for St. John's Episcopal Church.

Andrew Low House, *ca.* 1848

Known as one of the richest men in the English-speaking world, Andrew Low, Charles Green's partner, was a cotton merchant of Liverpool, England, and Savannah, Georgia. He selected John S. Norris of New York as the architect for the early Victorian Renaissance villa, built on a double-sized lot facing Lafayette Square.

William Makepeace Thackeray, noted British author, was a house guest on lecture tours in 1853 and 1856, and when Sherman stayed at the Green house, General Robert E. Lee was a guest of Andrew Low, who held a reception in his honor at his mansion.

In 1886, William Mackay Low, Andrew's son, married Juliette Gordon. In 1912, she organized the first Girl Scout troop in the United States, using the carriage house as a meeting place.

The National Society of the Colonial Dames of America in the State of Georgia bought the house for their state headquarters in 1928. They have restored it to its 1840s period. Juliette Gordon Low's mother, Mrs. William Washington Gordon, was the founder of the Georgia chapter of the National Society of Colonial Dames.

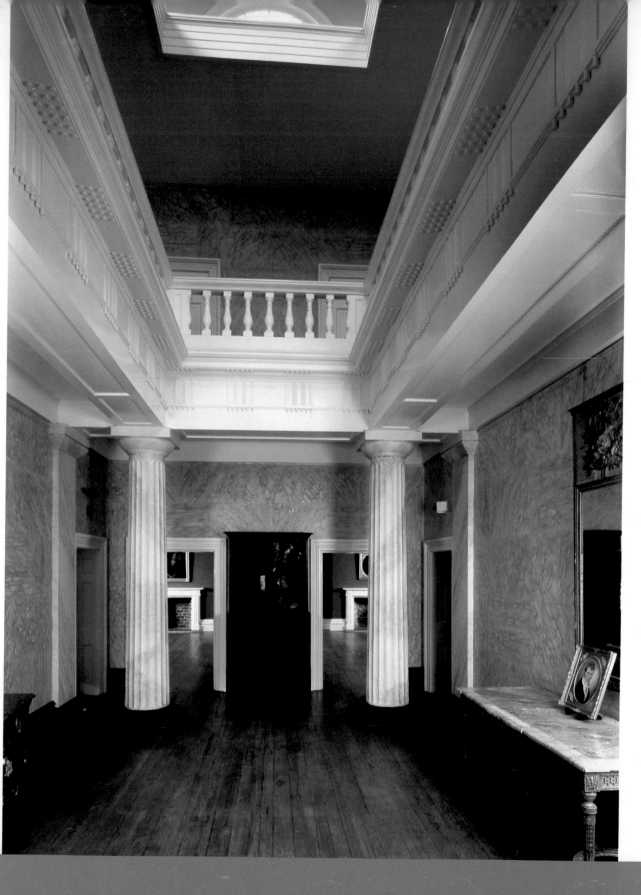

William Scarbrough House, 1819

William Scarbrough was a planter, merchant, and entrepreneur in Savannah following the end of the War of 1812. He owned cotton land in South Carolina and was a principal investor in the *Savannah*, which in 1819 was the first steamship to cross the Atlantic. He sold his cotton acreage to generate cash for his steamship enterprises, which were to prove unprofitable in the financial squeeze of 1818 through the early 1820s. Dependent upon high freight rates, which dropped by two-thirds between 1815 and 1819, Scarbrough was forced to auction his assets and finally was jailed for debt.

Godfrey Barnsley, who had married his daughter Julia, bought the house at auction. Scarbrough and the Barnsleys continued to occupy the mansion until the 1850s.

During Reconstruction, the house became a school for black students. It was known as the West Broad Street School for the next 90 years. The Historic Savannah Foundation acquired the classic house, then nearly a ruin, in 1972 and after protracted effort has returned the mansion remarkably close to its pristine condition of 1819, when President Monroe was entertained there.

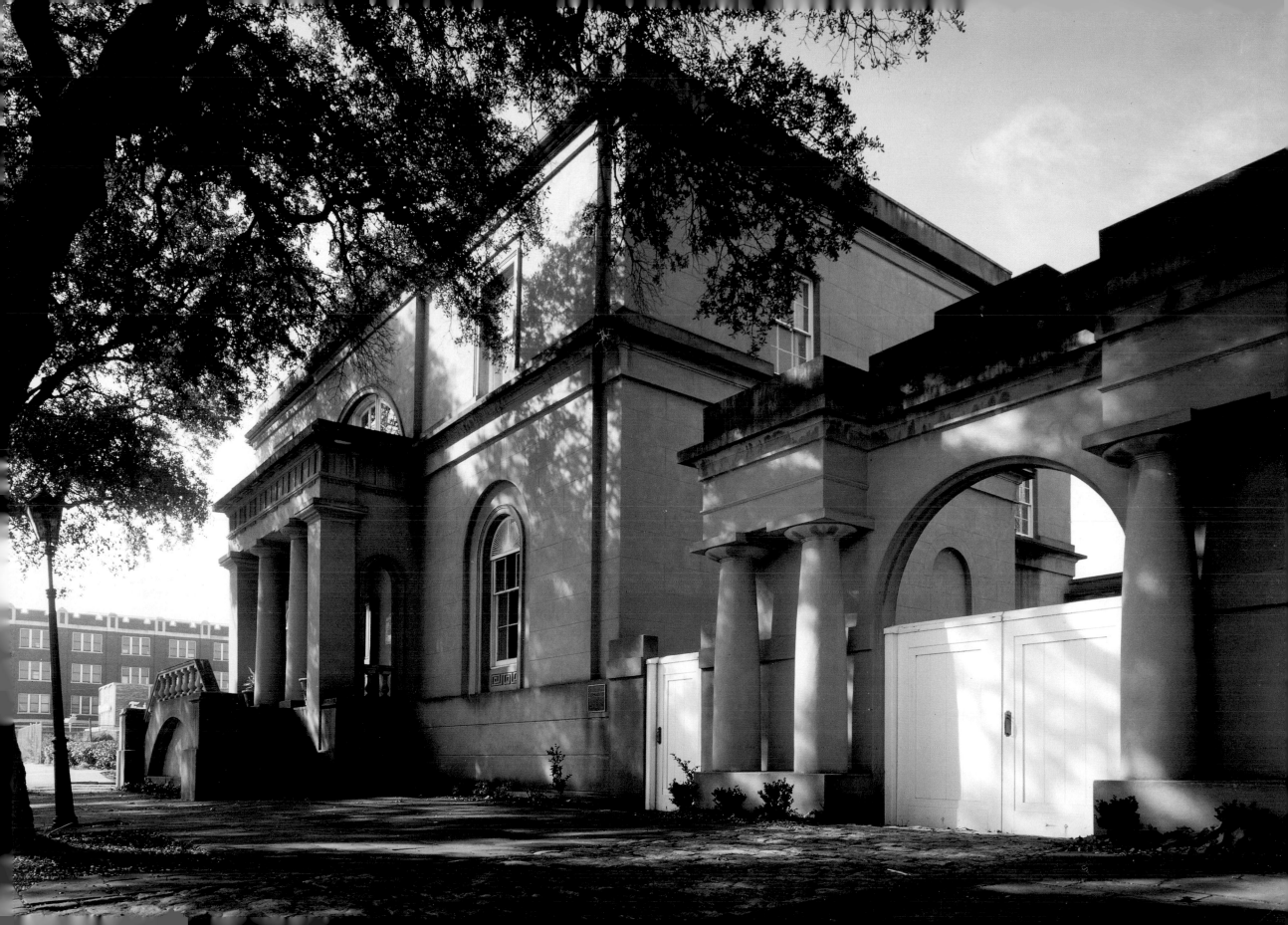

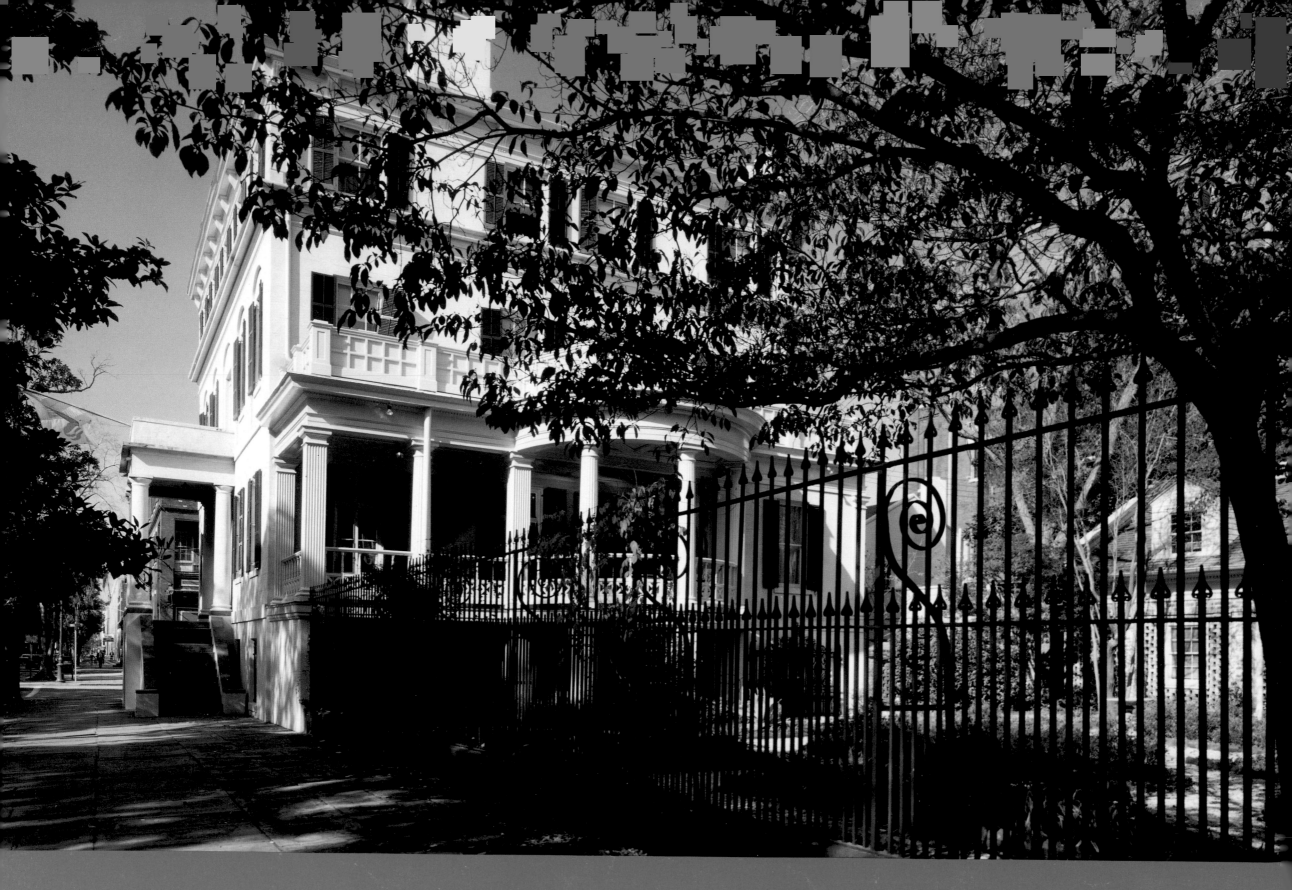

Wayne-Gordon House, 1818 (left)

In 1818, James M. Wayne, mayor of Savannah, began construction on his Regency style house at the corner of Bull and Oglethorpe streets in Savannah. Originally two stories over a raised basement, the design is attributed to a young English architect, William Jay, who came to Savannah in December, 1817. A third floor and curved piazza were added in 1886.

Wayne sold his house to his niece and her husband, William Washington Gordon I, in 1831. Juliette Gordon Low, founder of the Girl Scouts of America, was born in this house on October 31, 1860. It remained in her family until 1953, when the house was purchased by the Girl Scouts of the U.S.A., who soon began restoration.

The Juliette Gordon Low Center is a national program center for Girl Scouts and a house museum showing life in the late 1800s. It is on the National Register of Historic Places.

Richardson House, 1819

A West Indian merchant who married the daughter of Robert Bolton, Georgia's first postmaster, Richard Richardson became a plantation owner, financier, and president of the Savannah branch of the Bank of the United States. He retained his brother-in-law, William Jay, a talented young architect trained in London, to sketch a Savannah mansion for him while Jay was still in England. The foundations for the house were probably already laid before Jay reached Savannah. They were made of tabby, a durable building material made of equal parts of oyster shells, lime made from the shells, sand, and water.

Considered one of the finest Regency houses in the country, the Richardson House (now known as the Richardson-Owens-Thomas House) introduced bold new forms of architecture to Savannah, influencing architectural design in that region for many years.

The Marquis de Lafayette spoke from the unique cast-iron balcony on the south side of the house in 1825. Cast acanthus leaves, painted to resemble stone, support the unusual veranda.

George W. Owens bought the house and all furnishings in 1830, and it stayed in the family until his granddaughter Margaret Gray Thomas died in 1951. She willed the mansion to the Telfair Academy of Arts and Sciences as a house museum.

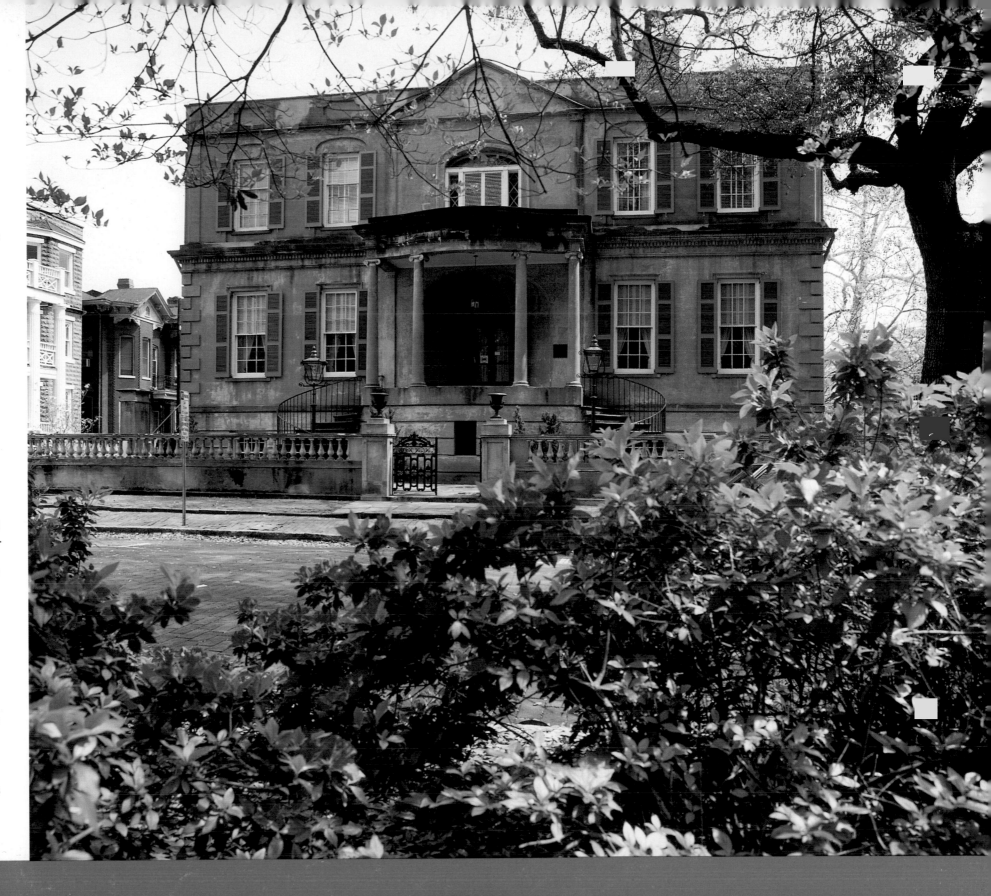

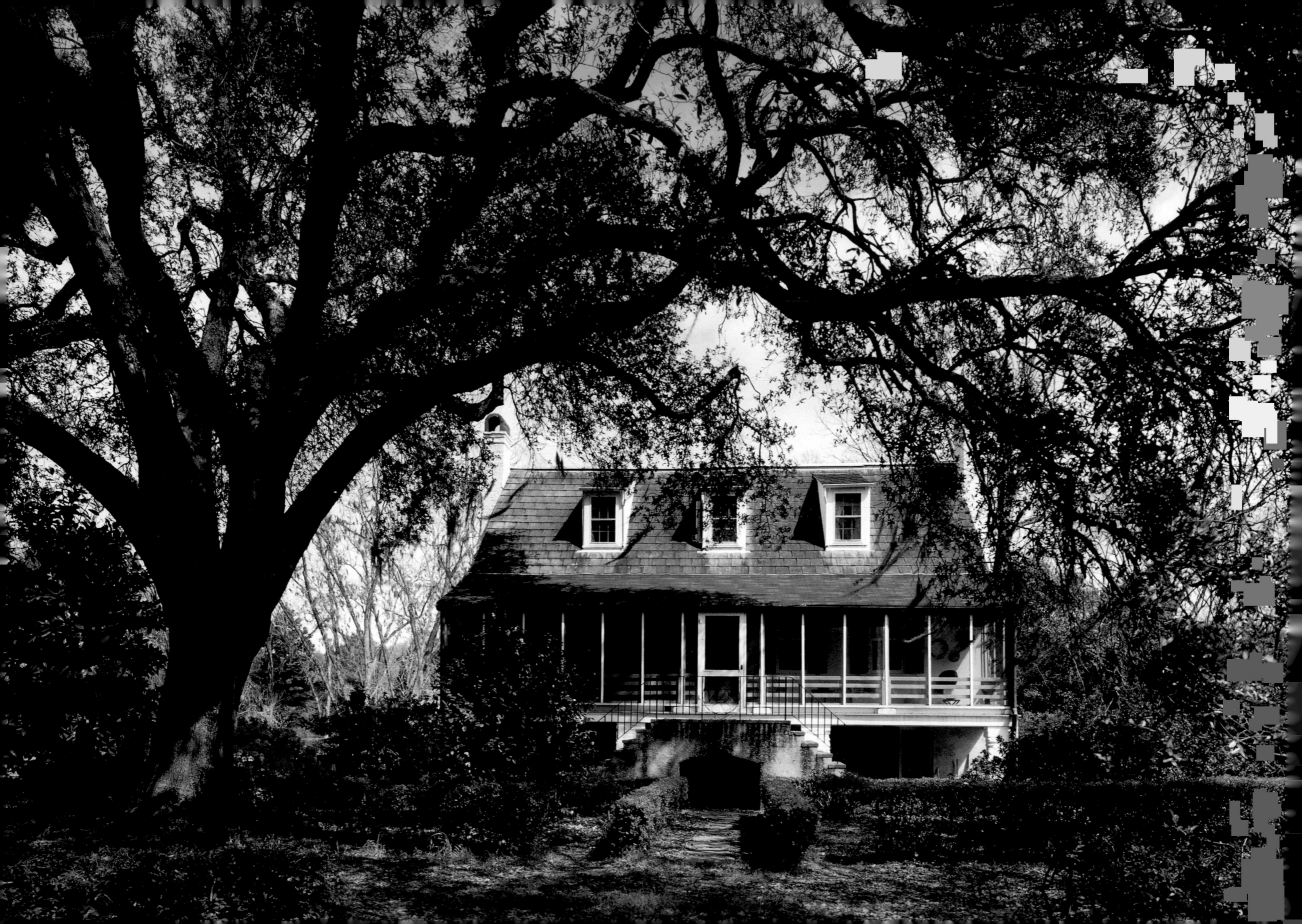

Wild Heron, 1756 (left)

The oldest plantation house and probably the oldest wooden house still standing in Georgia, Wild Heron is located near the Little Ogeechee River about twelve miles below Savannah. The plantation of about a thousand acres remained in the original family from 1755, when it was ceded to Colonel Francis Harris via a grant from George II, until 1935. The original land grant document was "liberated" by one of Sherman's troops in 1864, but it was returned anonymously by way of the Savannah postmaster in 1909.

Essentially a raised West India cottage, the one-and-a-half-story farmhouse rests on a raised brick basement. It was little changed by the Shelby Myricks of Savannah after their purchase of Wild Heron as a summer home in 1935.

Its original territory diminished to only a few acres, Wild Heron was purchased by Dr. and Mrs. Erich Schweistris in 1977 and restored once more. Structurally, little was required, but the owners have stabilized the soft brick of the columns and foundation (a continual process) and painted and rewired the downstairs, adding new cabinets and kitchen equipment. Upstairs, on the main floor, the rooms are being painted, wallpapered, and furnished to return Wild Heron to the period of the early 1800s.

Wormsloe, 1739

Noble Jones, one of the first settlers in Georgia, arrived on the *Ann* with James Edward Oglethorpe, trustee of the fledgling colony. A soldier, constable, member of the royal council, and surveyor, Jones laid out the towns of New Ebenezer and Augusta and built his own fortified house on his plantation on the Isle of Hope, guarding the seaward approach to Savannah from the south.

Tabby ruins mark the walls of the fort Jones built in 1739. The front tabby wall was incorporated into the eight-foot-high walls of the fort, which measured about sixty by seventy feet, with projecting bastions at all four corners. The house had five rooms on the ground floor and was probably one and a half stories, with the portion above the tabby walls made of wood.

Noble Jones later was named the chief justice of the new colony, and his son, Dr. Noble Jones, became the Georgia Medical Society's first president. Wormsloe's holdings expanded through the antebellum years, and the plantation is still owned by descendants of Noble Jones.

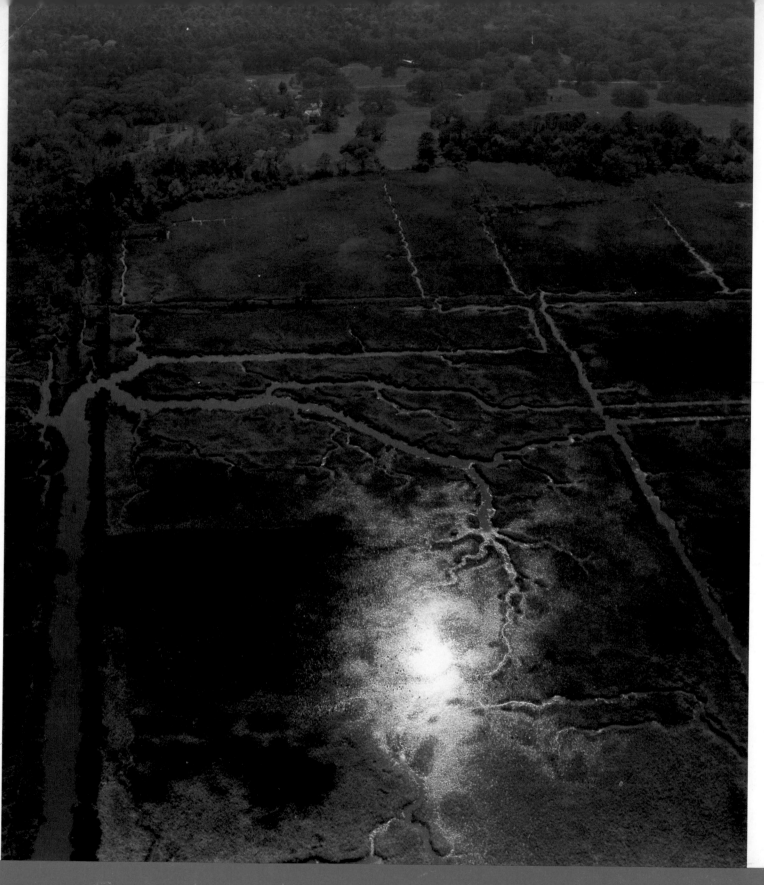

Hofyl-Broadfield Plantation

A rice plantation from 1807 until 1915, Hofyl-Broadfield remained in the same family until 1973, when Ophelia Dent, fifth generation descendant, willed the property to the state of Georgia, which maintains it as a state historic site where visitors may walk the grounds of a coastal rice plantation.

In about 1807, William Brailsford of Charleston used slave labor to clear cypress swamps on the Altamaha River, build earthen dikes and irrigation ditches, and begin the cultivation of rice. He named the plantation Broadfield. His son-in-law, James M. Troup, expanded the family's holdings to 7,300 acres, several homes, and 357 slaves by 1847.

Troup's daughter Ophelia wed George C. Dent in 1847, and they moved to a plantation adjacent to Broadfield. They named it Hofyl after a Swiss school Dent had attended. The present house on Hofyl was built in the 1850s, possibly after the Broadfield house burned in 1858. Much of its furniture is original.

After the Civil War, the plantation's fortunes declined, although the Dent family continued to produce rice until 1915. Later, the Dents opened a dairy that operated until 1942, supervised by Miriam Dent and Ophelia Dent.

(left) Rectangular blocks in the marshland reveal the outlines of Hofyl's former rice fields, abandoned for over seventy years.

Slave Cabins at Hamilton Plantation

Two tabby slave cabins, one a museum and the other a guest house of Epworth-by-the-Sea, a Methodist conference center and retreat, are among the few reminders of Hamilton Plantation on Gascoigne Bluff on St. Simons Island.

In 1736, Captain James Gascoigne brought Oglethorpe's first settlers to the island strongpoint at Fort Frederica, the southernmost bastion of the young colony of Georgia. He was the first owner of the plantation that was later purchased by James Hamilton, a Scotsman. Accompanying Oglethorpe on his trip to St. Simons were John Wesley and Charles Wesley, Anglican missionaries who later founded the Methodist Church.

The sturdy live oak timbers for the USS *Constitution*, "Old Ironsides," built in Boston in 1797, are said to have come from Gascoigne Bluff.

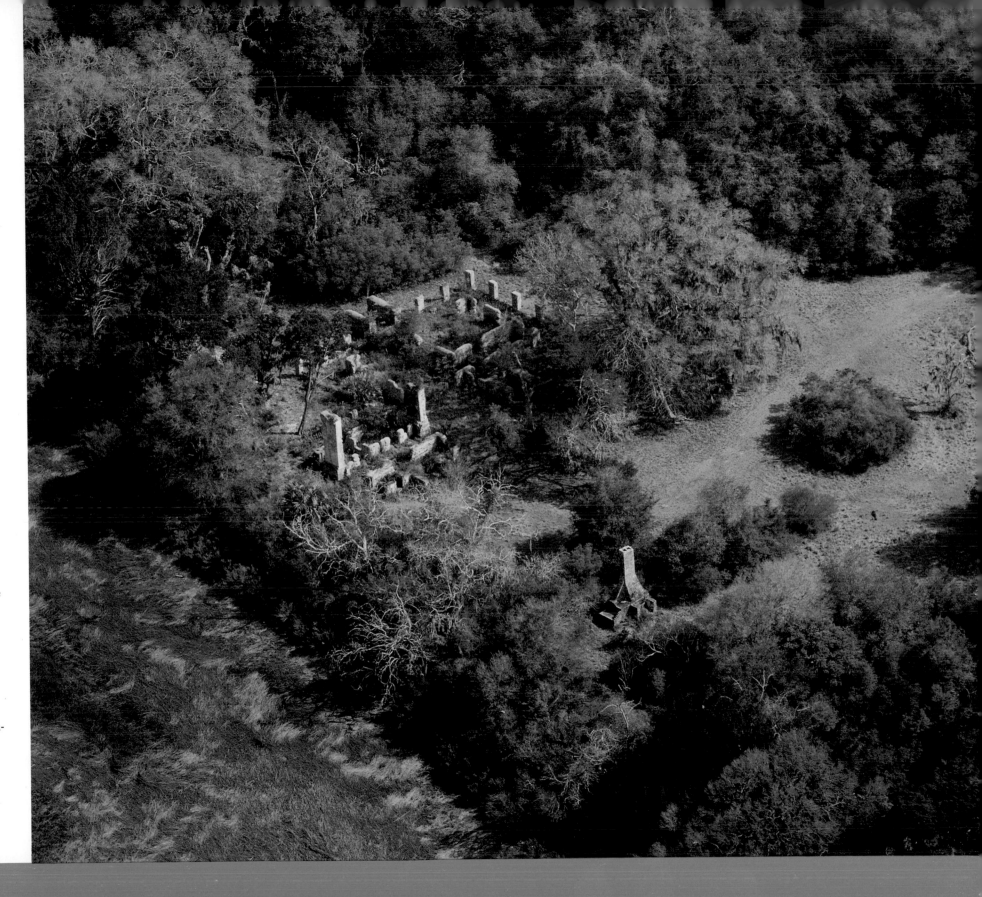

Cannon's Point, *ca.* 1804

John Couper came to the north end of St. Simons Island in 1796 and founded one of the great plantations along the Georgia coast. He first made his home in a small one-and-a-half-story house built by Daniel Cannon in 1738 and in 1804 built a handsome two-and-a-half-story mansion. Only the tabby walls of the lower floor of the house remain, along with the walls, chimneys, and fireplaces of an elaborate kitchen.

The Coupers entertained lavishly, and their house was visited by guests from around the United States and Europe, including Aaron Burr, after his duel that resulted in the death of Alexander Hamilton, and Fanny Kemble, English actress, wife of Pierce Butler (who owned nearby Hampton Point), and author of *Journal of a Residence on a Georgian Plantation in 1838-1839*, an antislavery tract she published in England after divorcing her husband. Fanny was more complimentary about the Couper plantation than her own, finding the gardens charming and the slaves treated kindly.

John Couper's son, James Hamilton Couper, studied the Dutch system of dikes and drainage to improve the rice fields on plantations jointly owned by his father and James Hamilton, John Couper's lifelong friend.

Ultimately, James Hamilton Couper owned and managed several plantations, tended by approximately 1,500 slaves, that produced rice, sugar, and Sea Island cotton. After the Civil War, the plantation was owned by the Shadman family. In 1890, the great house was hit by lightning, burned, and was never rebuilt.

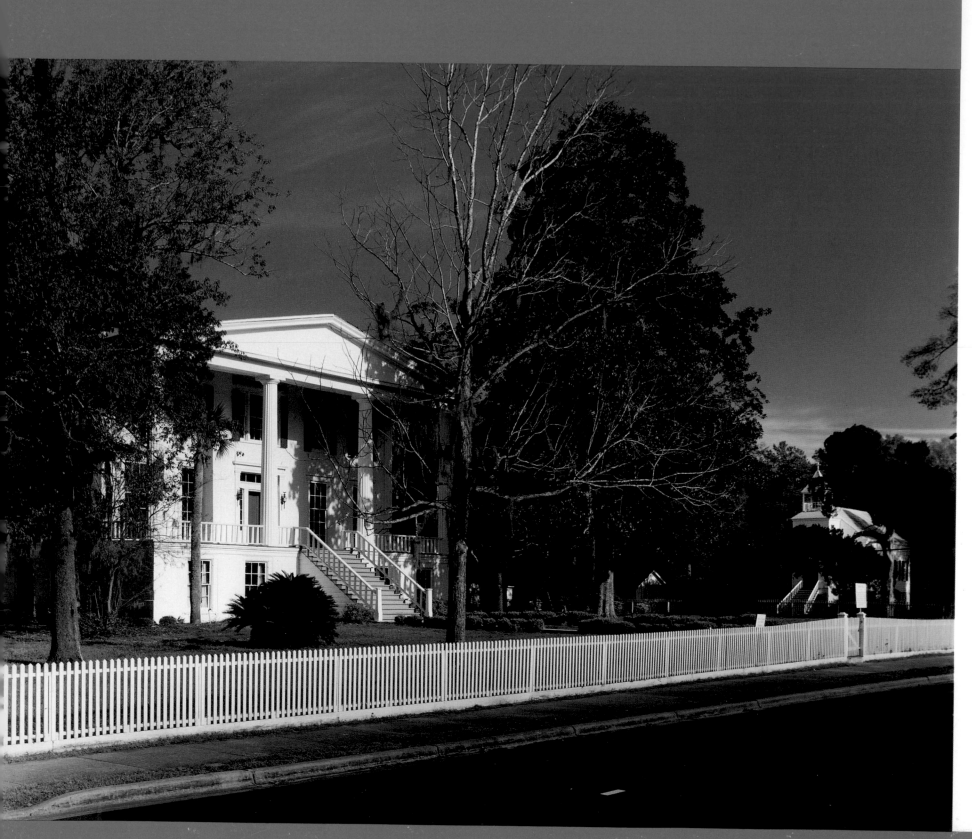

Orange Hall, *ca.* 1826

A Classical Revival mansion, Orange Hall was built by Horace Pratt, a Presbyterian minister, who in 1822 had established the congregation whose church building was across the street. Pratt built the house around 1826 with the help of his father-in-law, John Wood, a Loyalist who had fled Savannah at the onset of the Revolution and had moved to the St. Marys area. He owned eighty-three slaves by 1820.

Pratt's wife, Jane Wood, died in 1829, and in 1832 Pratt married her first cousin, Isabel Ann Drysdale, whose father owned a nearby plantation. In 1839, they moved to Tuscaloosa, Alabama, where Pratt became a professor of English literature. He died of a fever the following year at his brother's house in Roswell, Georgia, Great Oaks.

James Mongin Smith, a rice planter, bought Orange Hall in 1846 and expanded it, possibly giving it its present appearance. He also built a smaller replica in Roswell, where his family spent their summers.

During the Civil War, Orange Hall housed Union troops. By 1870, it was acquired by Silas Fordham of New York as his winter home. The J. H. Beckers of New York purchased it in 1919 and refurbished the house, installing crystal chandeliers, central heat, and a dumbwaiter.

Later, Orange Hall's spacious rooms were converted into apartments, and in 1951 St. Marys Kraft Corporation bought the house. The company deeded Orange Hall to the city in 1960.

Orange Hall is listed in the Historic American Buildings Survey and is on the National Register of Historic Places.

(right) Slave market at Louisville

SAVANNAH
TO
TOCCOA

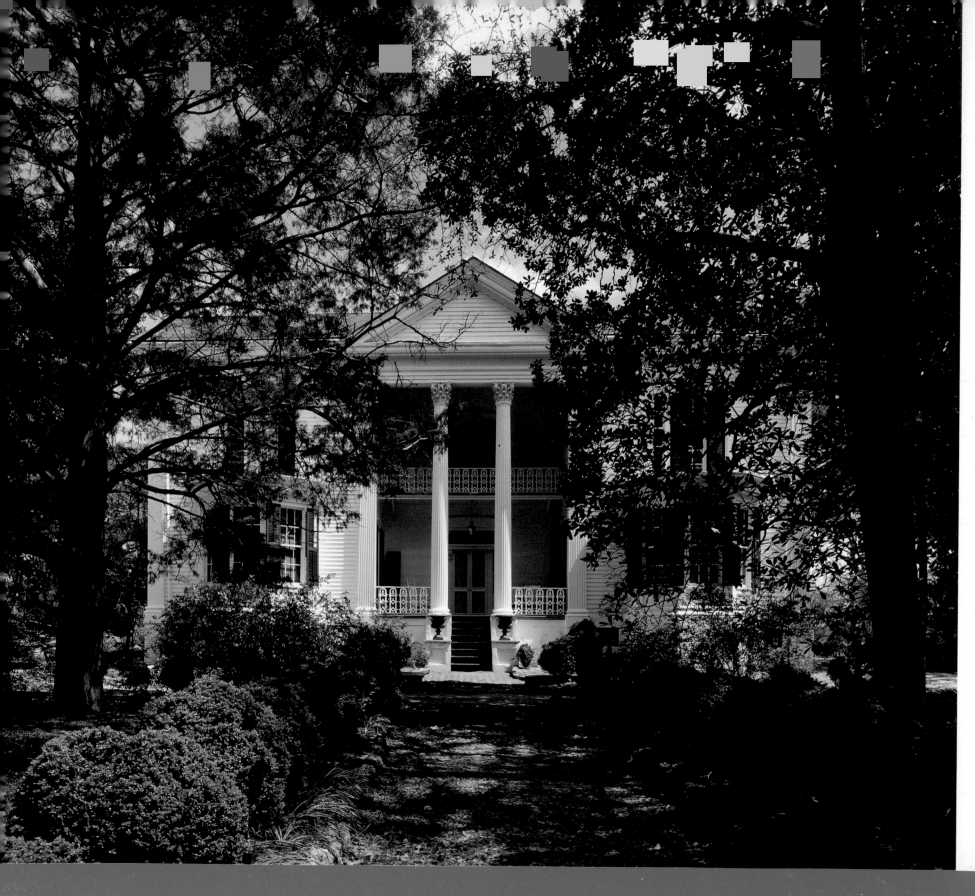

Birdsville Plantation, 1780s

A Welshman, Francis Jones, bought the John Lott place in 1773, which had been a royal grant, in what is now Jenkins and Burke counties about halfway between Savannah and Augusta. His son, Philip Jones, received a bounty grant in 1784 for 287 acres in the Burke County area for service in the Revolutionary War, and it is on that land that he built the oldest part of the present manor house between 1784 and 1789.

Philip died when his son was only one year old, but that young man, Henry Philip, expanded Birdsville's property to a total of 75,000 acres by the time of his death in 1853. He added the Greek Revival front of the house in 1847.

During Sherman's March to the Sea, the house was torched by his bummers (foragers) searching for treasure. They dug in the fresh dirt of the family cemetery (to them a likely place for hiding valuables from the Union army) and uncovered the bodies of twin babies, whose mother, Mrs. William B. Jones, had refused to leave her bed. The bummers extinguished the fire, left the graves uncovered, and departed for Savannah.

There were four stately Jones plantation homes in the area, but the one at Birdsville is the only one still standing. Birdsville is the oldest plantation house in Georgia that has been occupied continuously by members of the same family.

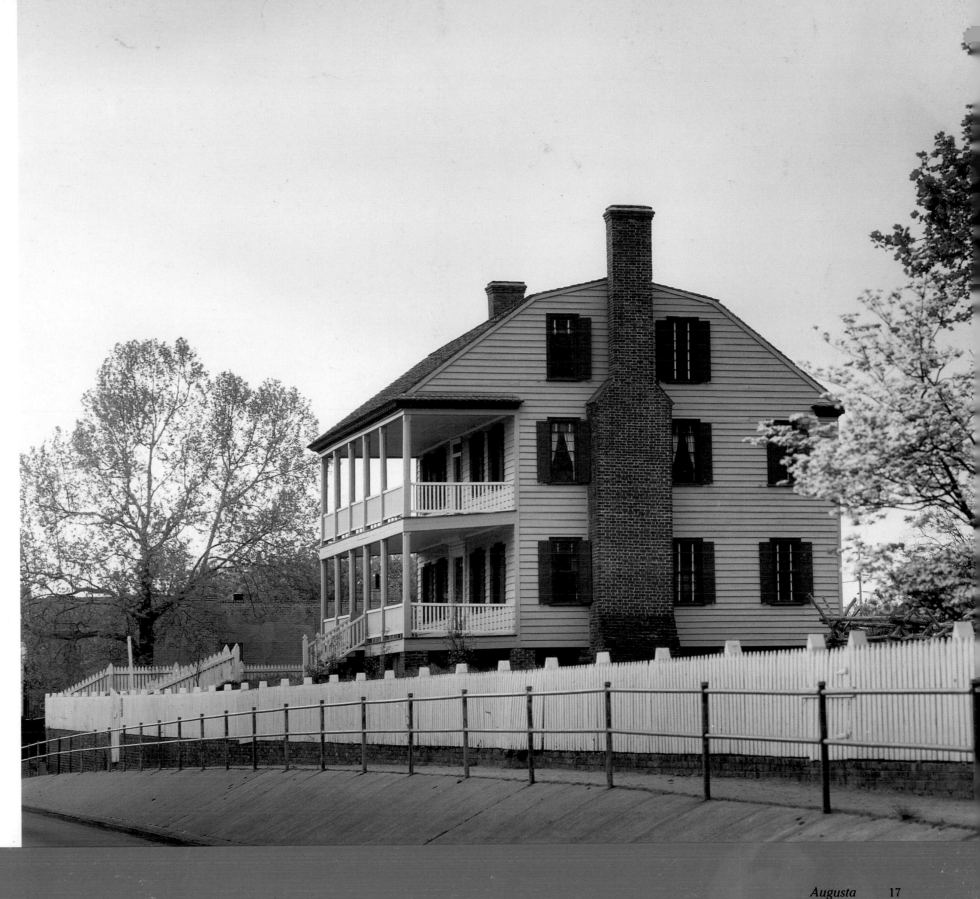

Ezekiel Harris House, *ca.* 1797

On a hill overlooking Augusta, Ezekiel Harris built a large tobacco warehouse and a good frame house with a brick chimney in which he offered accommodations to area tobacco planters, who, having depleted their land in Virginia and North Carolina, had moved into the newly opened territory north and west of Augusta. The house, painted in the original color schemes as revealed by careful paint scrapings, has a New England feeling with its gambrel roof. It also features a vaulted hallway, unique in the Augusta area. The only access to the second and third floors is from an exterior staircase located on the rear piazza of the house, flanked on either side by small cabinet rooms on each floor.

The house museum is administered by the Augusta Heritage Trust.

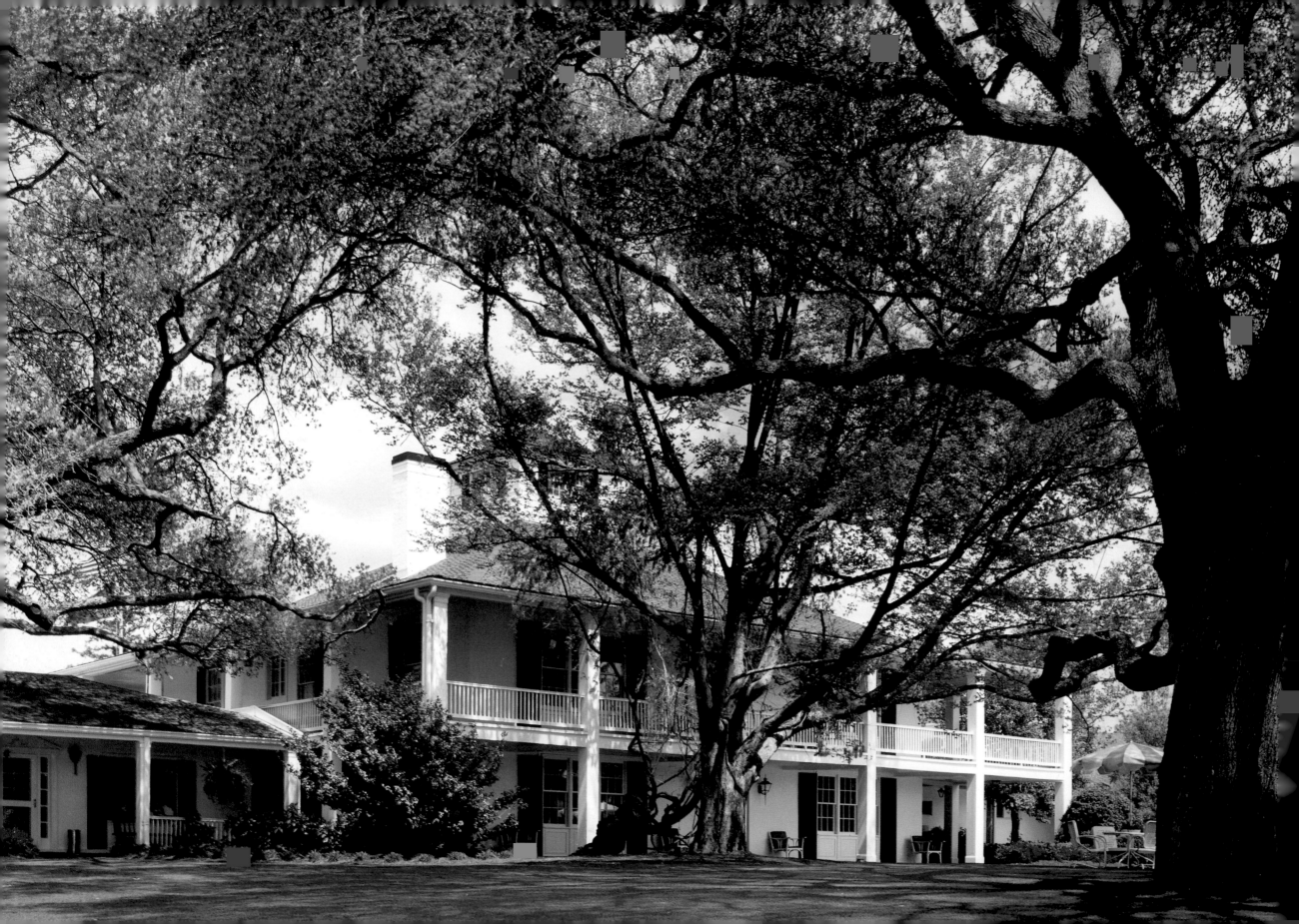

Fruitlands, 1854 (left)

Now the clubhouse of the Augusta National Golf Club, Fruitlands derived its name from the second owner of the square-columned plantation house in present-day Augusta that was planned to overlook a cotton plantation.

A Belgian horticulturist, P. J. A. Berckmans, bought the plantation in 1857 and converted it into Fruitlands Nursery. His plantings of dogwoods, camellias, and azaleas, among many others, are reflected in the plan for the famous golf course laid out nearly a century later by golfing great Bobby Jones and Alistair McKenzie. The former plantation has become the home of the Masters Tournament, held every spring when many of Berckmans' plantings are in bloom.

Meadow Garden, late 1700s

The "farm home" of George Walton, a lawyer, signer of the Declaration of Independence, and twice governor of Georgia, Meadow Garden was originally part of a farm of 121 acres.

The older part of the house was built in the late 1700s, and after the turn of the century, an addition was made that in itself was larger than the original house. The addition had a floor level two feet higher than the old main floor, thus creating Georgia's first split-level house.

Walton died at Meadow Garden in 1804. Now a house museum, the historic house is owned and maintained by the Georgia State Society, National Society Daughters of the American Revolution.

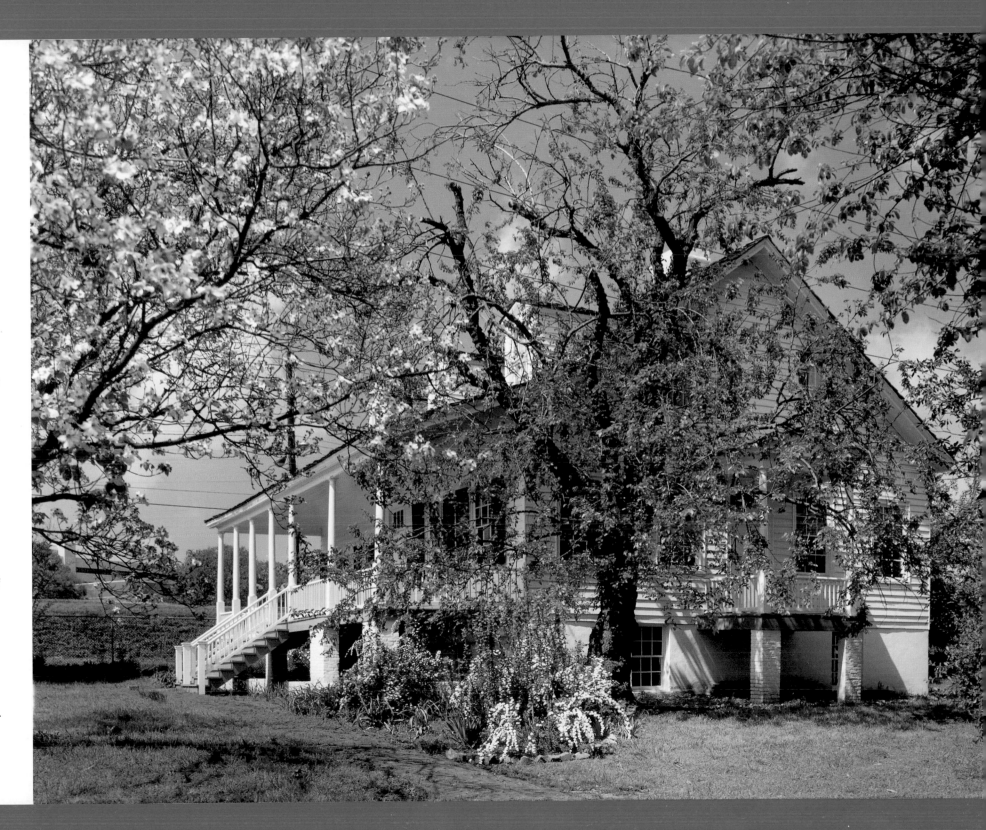

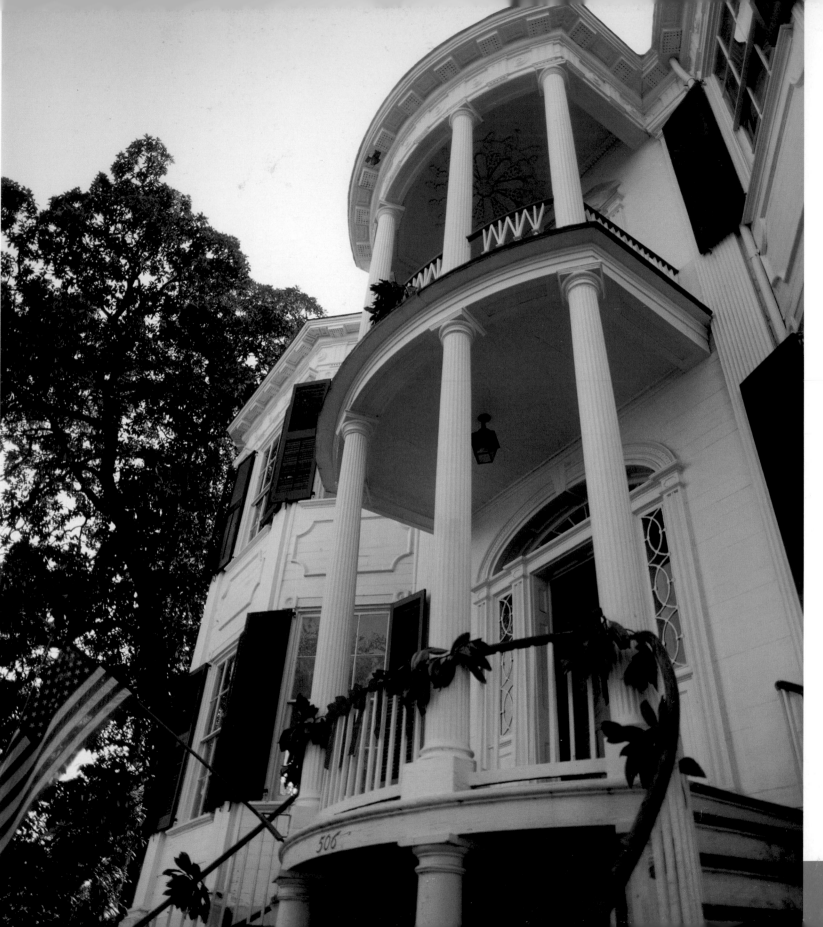

Ware's Folly, 1818

In Georgia in 1818, $40,000 was considered far too much to spend on a house, even if it was a mansion. Hence the name Ware's Folly was given by Augusta's conservative citizenry to the largest and most elaborate mansion yet built in Augusta.

Nicholas Ware, a United States senator from 1821 to 1824, built the town house on Telfair Street in Augusta, possibly using the services of architect Daniel Pratt. The design has also been attributed to Gabriel Manigault of Charleston because it has much in common with a house Manigault built for his brother. However, the South Carolina architect died some time before construction on Ware's house began.

The house stands two-and-a-half stories over a raised basement. An elliptical flying stairway on one side of the center hall climbs from the ground-floor basement to the attic, and a double parlor separated by sliding doors is crowned by a wide, elaborate fanlight.

Ware's Folly, the Ware-Sibley-Clark House, is now the home of the Gertrude Herbert Institute of Art. It is listed in the Historic American Buildings Survey and is on the National Register of Historic Places.

Montrose, 1849 (right)

One of the loveliest Greek Revival homes in the Summerville area of Augusta is Montrose, built in 1849. It is now the Alan Fuqua Center for young people.

With the main floor and a half-story above built over a raised basement, Montrose has double parlors with matching marble mantels. Its full-length front windows allowed its occupants to enjoy the summer breezes of the Sand Hills area of Summerville, originally an area of antebellum summer homes overlooking Augusta.

Behind the house is a separate octagonal brick kitchen and a "classical" privy. Montrose received perhaps its greatest renown for being the postbellum home of Charles Colcock Jones, Jr., historian, author, and lawyer who had one of the finest libraries in the South.

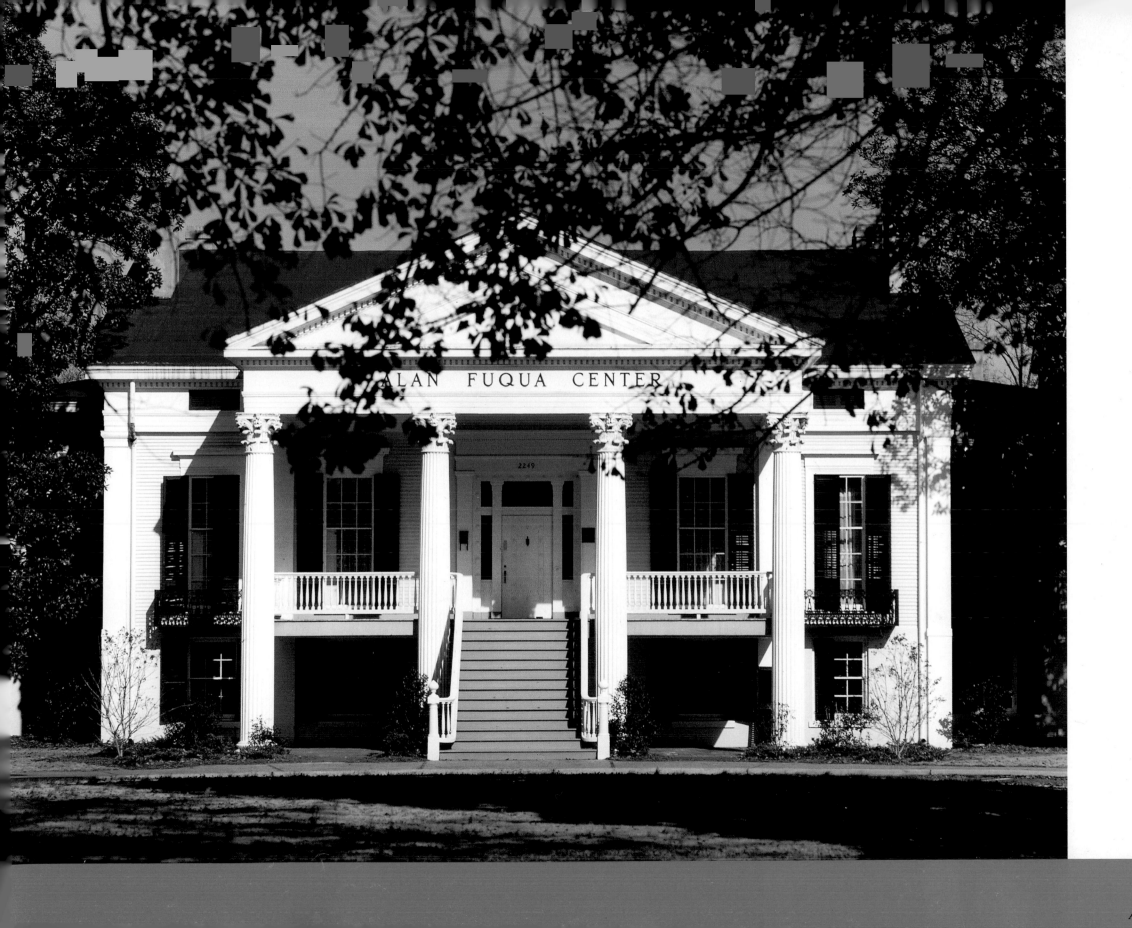

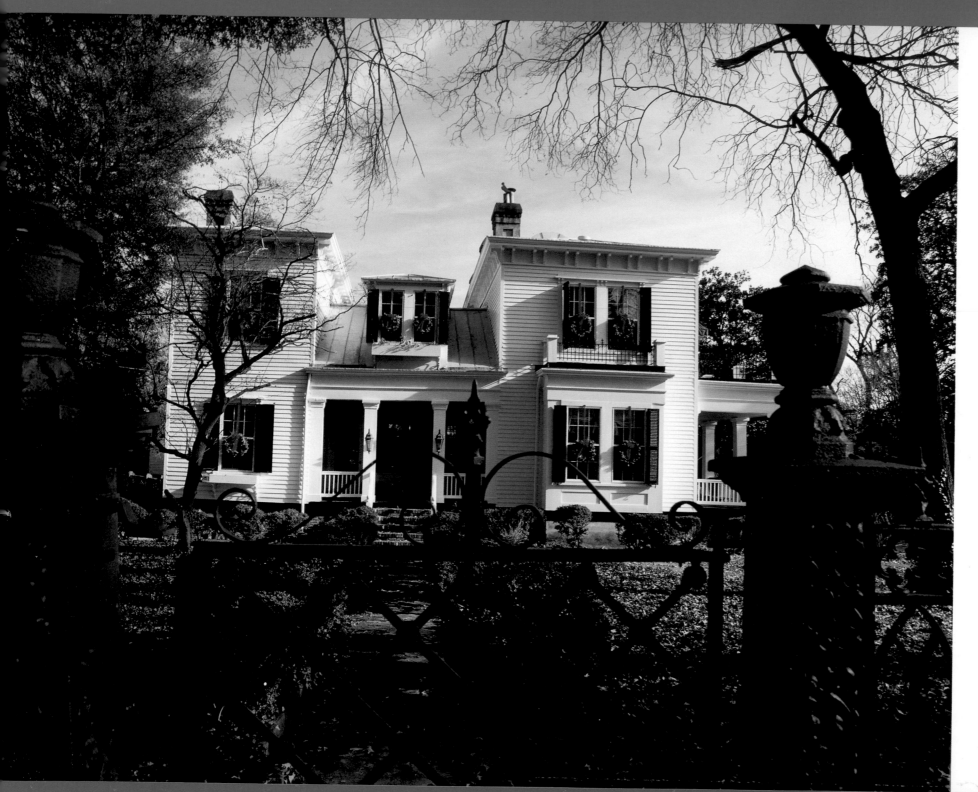

High Gate, 1808

High Gate, on Milledge Avenue in Augusta, takes its name from the iron fence and gates that encircle the property overlooking Augusta from the high ground of the Summerville area.

An early owner was Hugh Nesbitt, who left the Federal style one-story cottage flanked by two 2-story blocks on either side to his daughter Mary Anne, wife of Judge Starnes of the United States Supreme Court. High Gate remained in the Starnes family until 1910.

Hickory Hill, *ca.* 1864 (right)

Hickory Hill was built by Captain John Wilson in Thomson, Georgia, during the Civil War. In 1900 Thomas E. Watson bought Hickory Hill and its accompanying one-thousand-acre estate, and remodeled and expanded the imposing three-story house. He installed the first electric lights and gas works in Thomson, indoor plumbing, and his own water works.

Watson, one of the founders of the Populist party in the 1890s, moved to Hickory Hill in 1905 and operated his own publishing business on his estate.

Hickory Hill, also known as the Thomas Watson House, is owned and has been restored by Mr. Walter Brown of South Carolina.

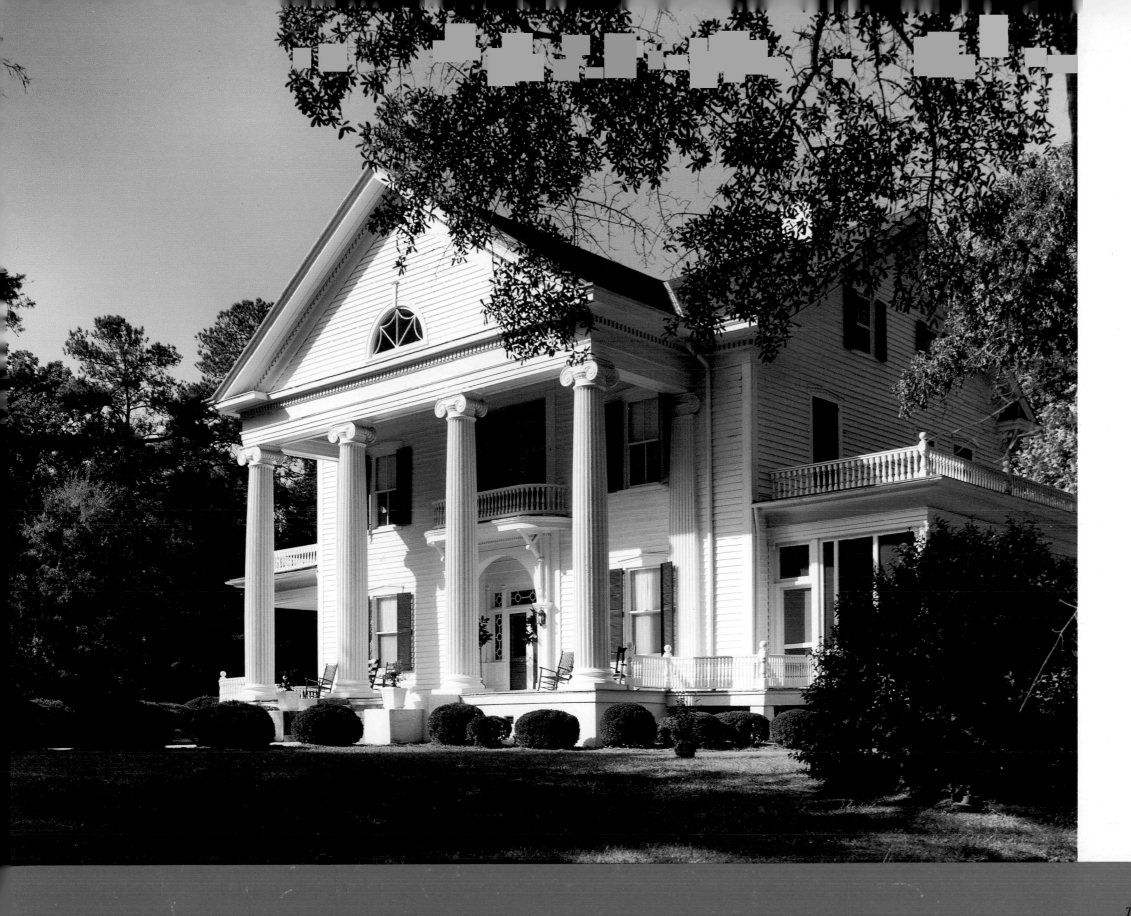

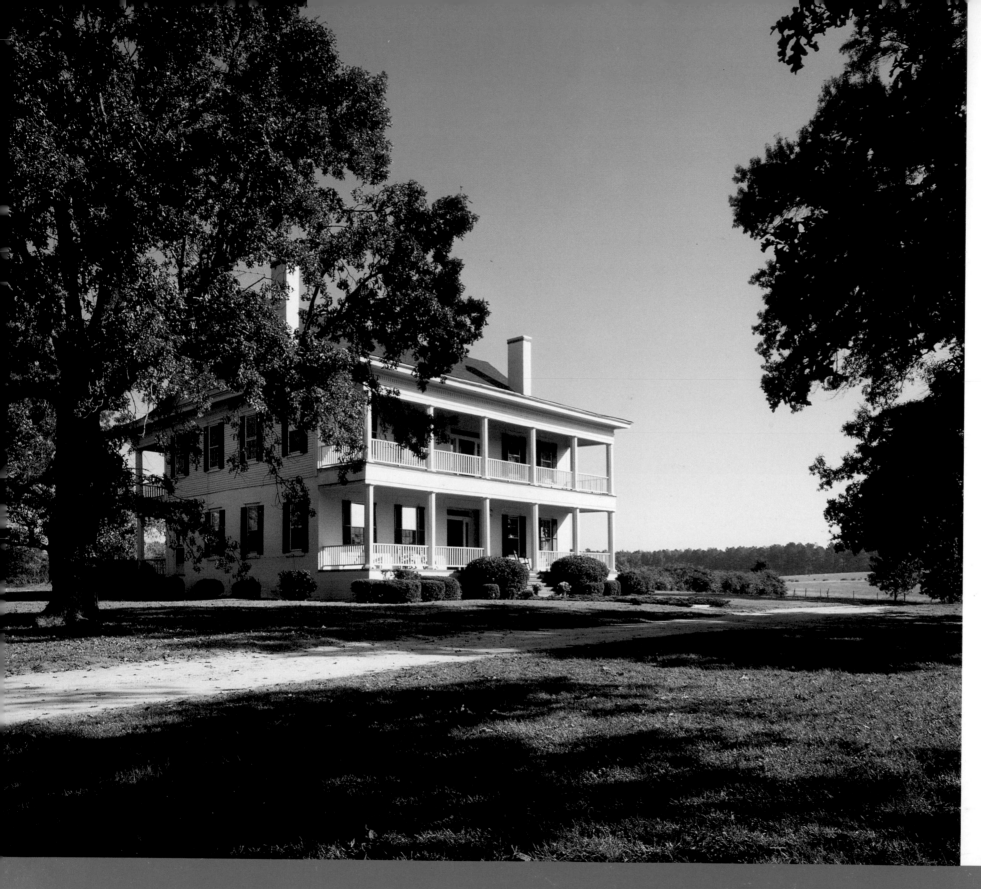

Snow Hill, 1850s

Built near Thomson in 1852 or 1859, Snow Hill was built overlooking the old Wrightsboro Road (Stagecoach Road) by James Hamilton, who had established his cotton plantation in McDuffie County in 1840. In 1859, he sold the house and plantation, which amounted to 1,595 acres in 1852, to Montroville Fulton for $17,550.

Snow Hill has brick walls, inside and outside, on the lower floor and wood on the upper floor. The plaster-over-brick interior walls downstairs are twelve to fourteen inches thick, and the ceilings are twelve feet high.

Mr. and Mrs. J. E. Harrison acquired the house and 160 acres in 1967 and began the careful process of restoring Snow Hill. They grow peaches on the hills that were once white with cotton.

Snow Hill is on the National Register of Historic Places.

Alexander H. Stephens House,
pre-1845, 1875

The home of and memorial to the vice-president of the Confederacy, Alexander H. Stephens, Liberty Hall is located in Crawfordville, two miles from his birthplace.

Born in 1812, and an orphan at fourteen, Stephens graduated from Franklin College (now the University of Georgia) when he was twenty. After teaching for two years, he studied law, was accepted to the bar in three months, and began his law practice at the county courthouse in Crawfordville. Stephens roomed with the Williamson Birds and in 1845 bought Liberty Hall from their estate. He also owned a plantation two miles from town, and thirty-two slaves.

A United States congressman from the mid-1840s until the onset of the Civil War, Stephens was a moderate. At Georgia's convention in 1861, he voted against secession but cast his lot with the South. That same year he was elected vice-president of the Confederacy.

At the end of the war, he returned to Liberty Hall, where he was seized by Union troops on May 11, 1865 (no mean feat, since he weighed barely one hundred pounds and was in ill health), and imprisoned for eighteen months at Fort Warren at Boston harbor in Massachusetts.

Stephens returned to Congress in 1872 and was elected governor of Georgia in 1882. He died four months after his inauguration.

The pre-1845 part of Liberty Hall stood where the big house stands today. After he bought the property in 1845, Stephens added the structure to the rear, and in 1875, razed the original house to the front and built the existing two-story building.

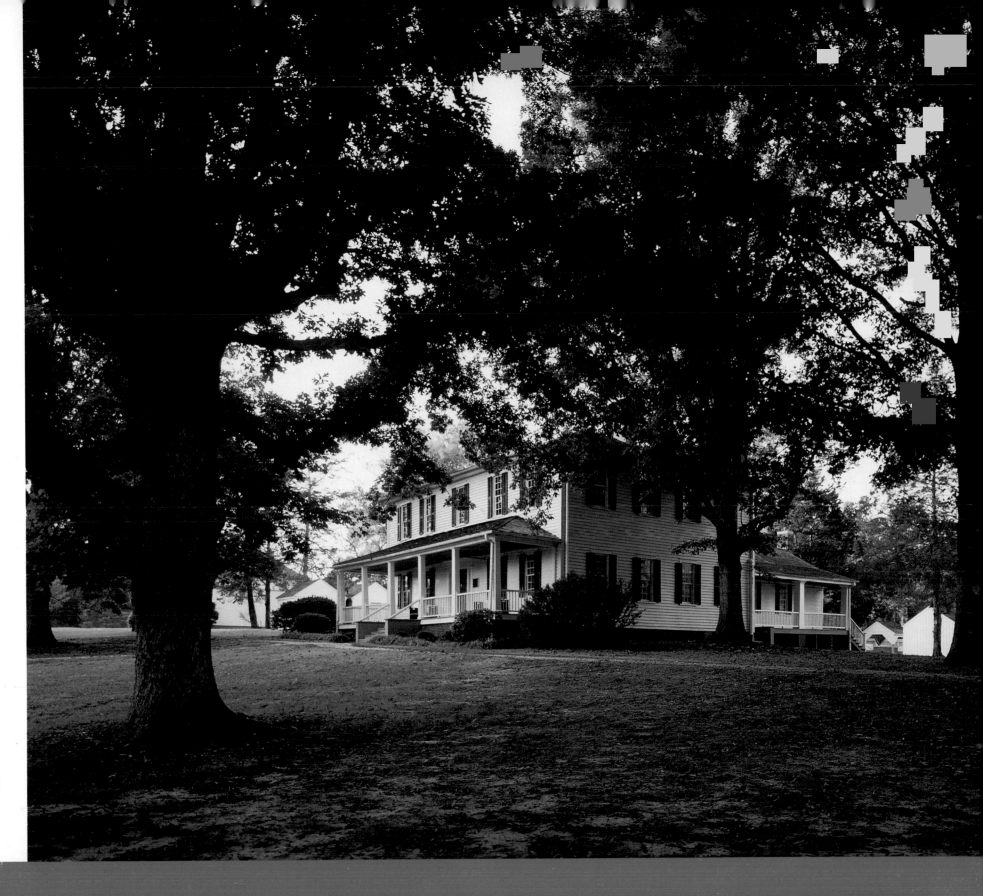

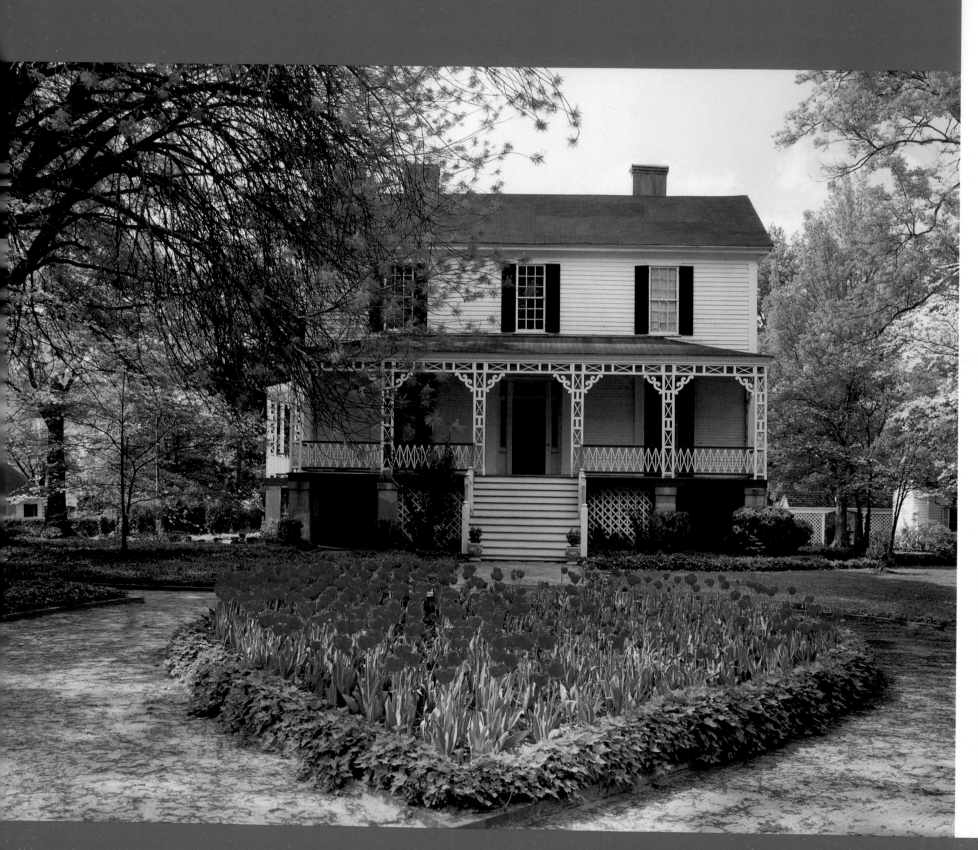

Washington-Wilkes Historic Museum, 1836, 1850s

Also known as the Barnett-Slaton House, the home of the Washington-Wilkes Historic Museum was built on land owned by a South Carolinian, Micajah Williams, one of the founders of Washington, Georgia, the first municipality in the United States to be named after George Washington.

In 1835, Albert Gallatin Semmes bought the one-hundred-acre tract, built a house on it, and almost immediately sold it to Mrs. Mary Sneed for $4,500.

Mrs. Sneed lived in the house for about twenty years and then sold the property to Samuel Barnett, Georgia's first railroad commissioner, who added the front rooms, hallway, and present staircase.

Barnett's daughter married Dr. Edward McKenree Bounds, and Bounds descendants occupied the house until 1913. At that time, the acreage was subdivided, and the house and grounds were acquired by William Armstrong Slaton.

The city of Washington acquired the property in the late 1950s and deeded it to the state of Georgia as a museum. The Washington-Wilkes Historic Museum has been restored and furnished to represent the life-style of a well-to-do family of the 1850s. It has been operated by the city of Washington since the mid-1960s and is on the National Register of Historic Places.

Robert Toombs House, 1794

A lawyer, legislator, and planter who owned land and slaves in Georgia, Alabama, and Texas, Robert Toombs was a United States senator when the Civil War began. He was soon appointed secretary of state for the Confederacy. He preferred military service, however, and was named a general, performing creditably from Manassas to Malvern Hill. After these battles he returned to his home in Washington, in Georgia's Wilkes County. During the rest of the war he was highly critical of the Jefferson Davis government of the Confederacy.

General Toombs's name was high on the list of "traitors" for whom Union troops were searching at the end of hostilities. Toombs escaped from the back door of his mansion while Federal soldiers demanded entrance at the front.

The general spent seven months eluding Federal search parties in the South and then sailed to Europe. He returned two years later and met with President Johnson at the White House. The president was a fellow senator in the years before the war and allowed Toombs to go home to Georgia. Toombs never petitioned for amnesty. He died an "unreconstructed rebel" in 1885.

The Toombs House was built in 1794 by Dr. Joel Abbott. The fluted columns and other additions were made in 1837 when Toombs bought the house and enlarged and remodeled it.

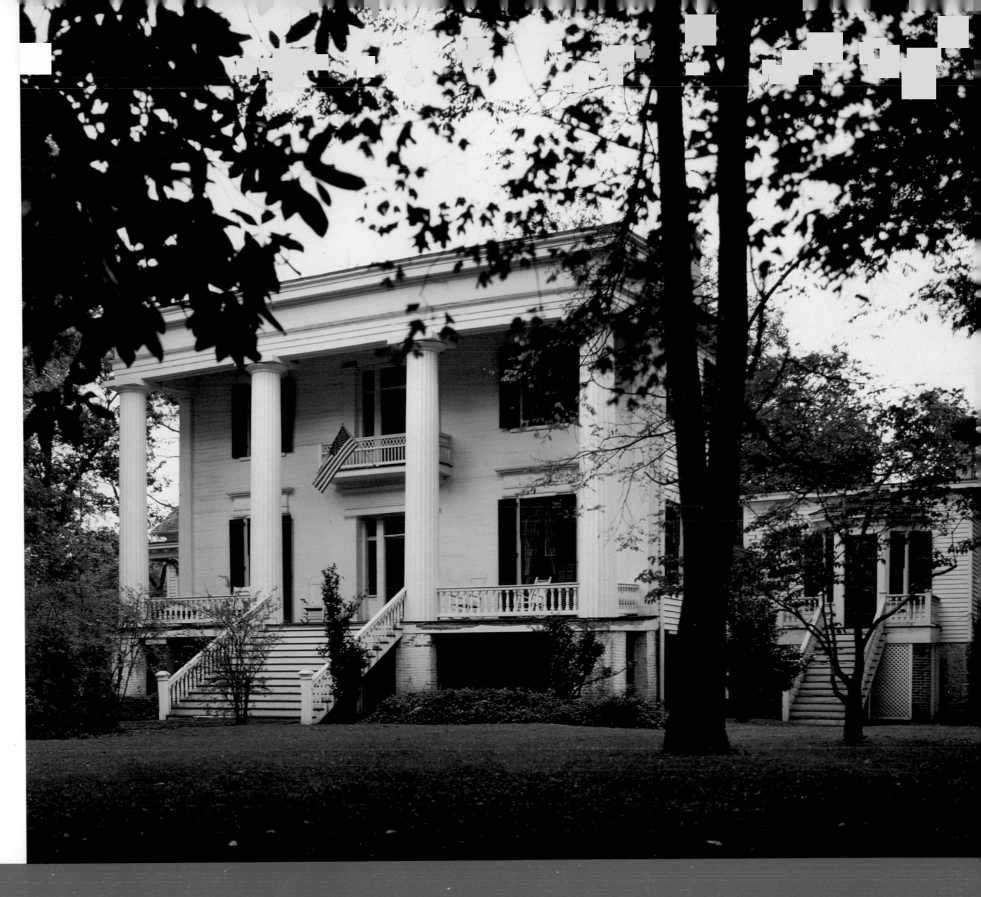

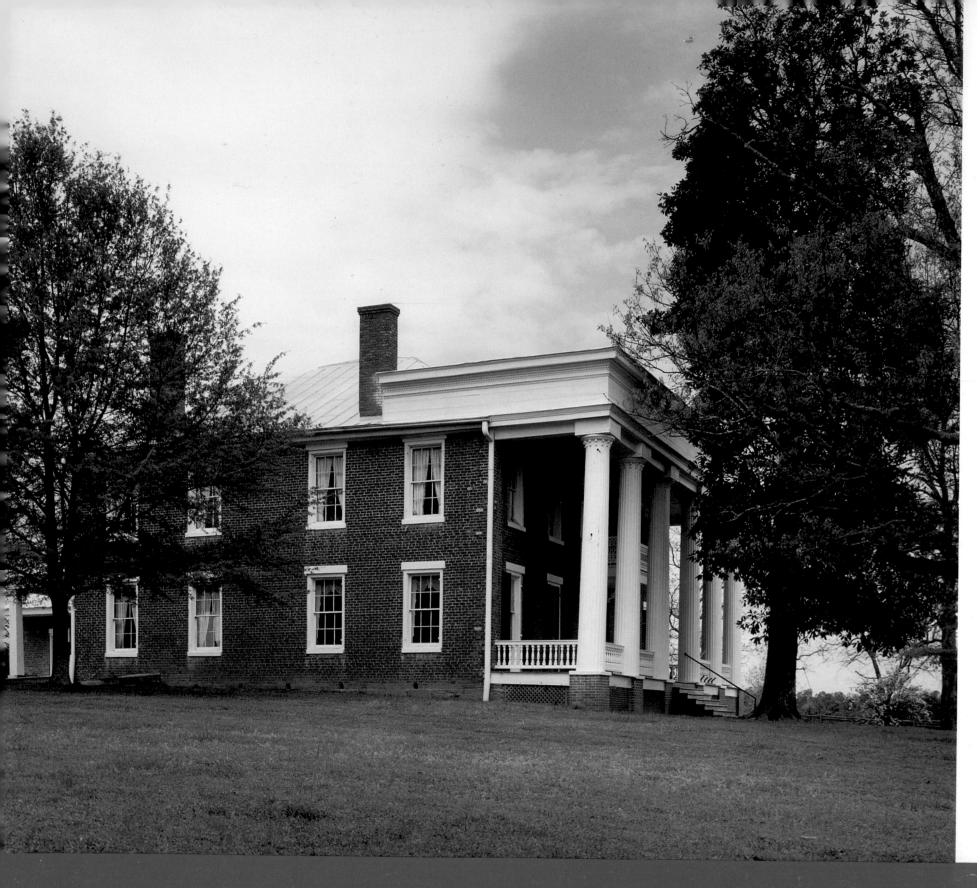

Callaway Plantation, 1869

Built just four years after the end of the Civil War, the manor house of this three-thousand-acre cotton plantation was an exceptionally fine one to have been built so soon after the war. Tradition has it that the family's cotton money was in England, held up by the Civil War, and was not available until some time after Appomattox.

The grounds of Callaway Plantation, located about five miles west of Washington, now house a collection of early Georgia buildings, including a settler's log cabin from around 1785. Near the cabin is a two-story Federal Plain style wooden house from the 1790s furnished in that period. The manor house is furnished in the time of the mid-1800s.

Other features of the plantation include the smokehouse, pigeon house (young pigeons, squab, had a regular place on the antebellum dinner table), barn, the family cemetery.

The surrounding land is still owned by descendants of Job and Joshua Callaway, who founded the plantation in 1783. The property was never out of the family until 1966, when the house and eleven acres were given to the city of Washington by Katie Mae Arnold Hardin, the daughter of Nat and Susan A. Callaway Arnold, and her children. Three years later, the Hardin family granted forty-five additional acres to the complex.

Callaway Plantation is a historic restoration project of the city of Washington and is administered by its Historic Properties Commission.

Charles Wickersham House, 1819

In Washington, Georgia, the antebellum Heard Building housed a branch of the Georgia Bank. In a room within that structure, the cabinet of the Confederate States of America held its last meeting on May 5, 1865, presided over by Jefferson Davis.

That building was demolished in 1904, but the mantelpiece of that historic room now rests in the Charles Wickersham House, located diagonally across the street from the Robert Toombs House. The Wickersham House was once a dormitory for Washington's Female Seminary.

The earliest part of the house was built by Elizabeth Tarver, who bought lumber to build her cottage from Colonel Nicholas Long, who had moved to Wilkes County from North Carolina. Long owned a sawmill, and he specified that Mrs. Tarver should receive the services of two of his carpenters for three months, as well as the lot of lumber for which she had contracted. The cottage was expanded regularly as prosperity grew in Wilkes County.

The Reverend Alexander Webster, from Connecticut, once lived in this house. He came to Washington to teach in the local academy, was ordained a minister, and became the first pastor of Washington's Presbyterian Church.

The Charles Wickershams bought the Greek Revival home forty-five years ago from Mrs. L. M. Ellis, an antique collector who owned other Heard family artifacts.

Traveler's Rest, 1815

The first settler on the land on which Traveler's Rest stands was Major Jesse Walton, who was killed by Creek Indians shortly after he acquired the property in 1785. His children sold the acreage in 1813 to Walton's son-in-law, Joseph Martin, who then began construction of the present house. Martin sold the site in 1818 to James R. Wyly, a builder of the Unicoi Turnpike, which ended in the vicinity of Traveler's Rest. Wyly enlarged the house and added travelers' facilities, making the house into a combination residence and stagecoach inn.

For six thousand dollars, Wyly's neighbor Devereaux Jarrett bought the house and other land in the area in 1833. He further expanded his house and inn, operating a variety of enterprises including a toll bridge, tavern, smithy, tanyard, country store, post office, sawmill, grist mill, and large plantation. He became known as the richest man in the Tougaloo Valley.

There is no center hall at Traveler's Rest. The front rooms open directly onto the long front porch, and an independent stairway leads from the porch to two rooms upstairs.

Traveler's Rest remained in the Jarrett family for five generations, until Mary Jarrett White sold the land and three acres to the state of Georgia and the Jarrett Manor Foundation in 1955.

The Parks, Recreation, and Historic Sites Division of the Georgia Department of Natural Resources administers Traveler's Rest as a mid-nineteenth-century stagecoach inn and home of a prosperous northeast Georgia businessman and planter.

DOWN
THE
PLANTATION
TRAIL

Shields-Ethridge House, 1866

The Shields Plantation was established in 1803 by Joseph, Patrick, and Samuel Shields, brothers who came to the Jackson County area, northwest of Athens, from Oglethorpe County in 1803.

Originally, their plantation covered between 300 and 400 acres. It grew to 850 acres, worked by 25 slaves, before the Civil War.

The house was built just a year after the end of the war, by Joseph Robert Shields, Joseph Shields's grandson. Many of the original antebellum outbuildings are still on the property, as well as a 1920s cotton gin with its original equipment in remarkably good condition.

The plantation has always remained in the family. Joyce Ethridge, a fifth-generation direct descendant, recently deeded the house and grounds to her daughter, Susan Ethridge Chaisson.

President's House, *ca.* 1857 (right)

The home of the presidents of the University of Georgia since 1949, this white-columned Greek Revival mansion is one of the finest in the South.

A twenty-by-forty-foot double drawing room with the original chandeliers, elaborate plaster cornices, and carved marble mantelpieces complements the templelike exterior, which has fourteen fluted Corinthian columns on three sides of the house.

The stately home, possibly the last monumental Greek Revival mansion to be built in Georgia before the Civil War, was built in 1857 and 1858 for John T. Grant, a Virginian, for $25,355.25.

In 1869, Benjamin H. Hill moved to Athens from LaGrange and bought the house, having worn out his welcome in LaGrange, since he supported reconciliation with the North after the war was lost. From Athens, Hill was elected United States congressman and later a senator. He is said to have persuaded President Hayes to end Federal military rule in Georgia. Reconstruction ended for the Empire State of the South in 1877.

Captain James White bought the house in 1888, and the University of Georgia acquired it from his daughter's estate in the 1940s.

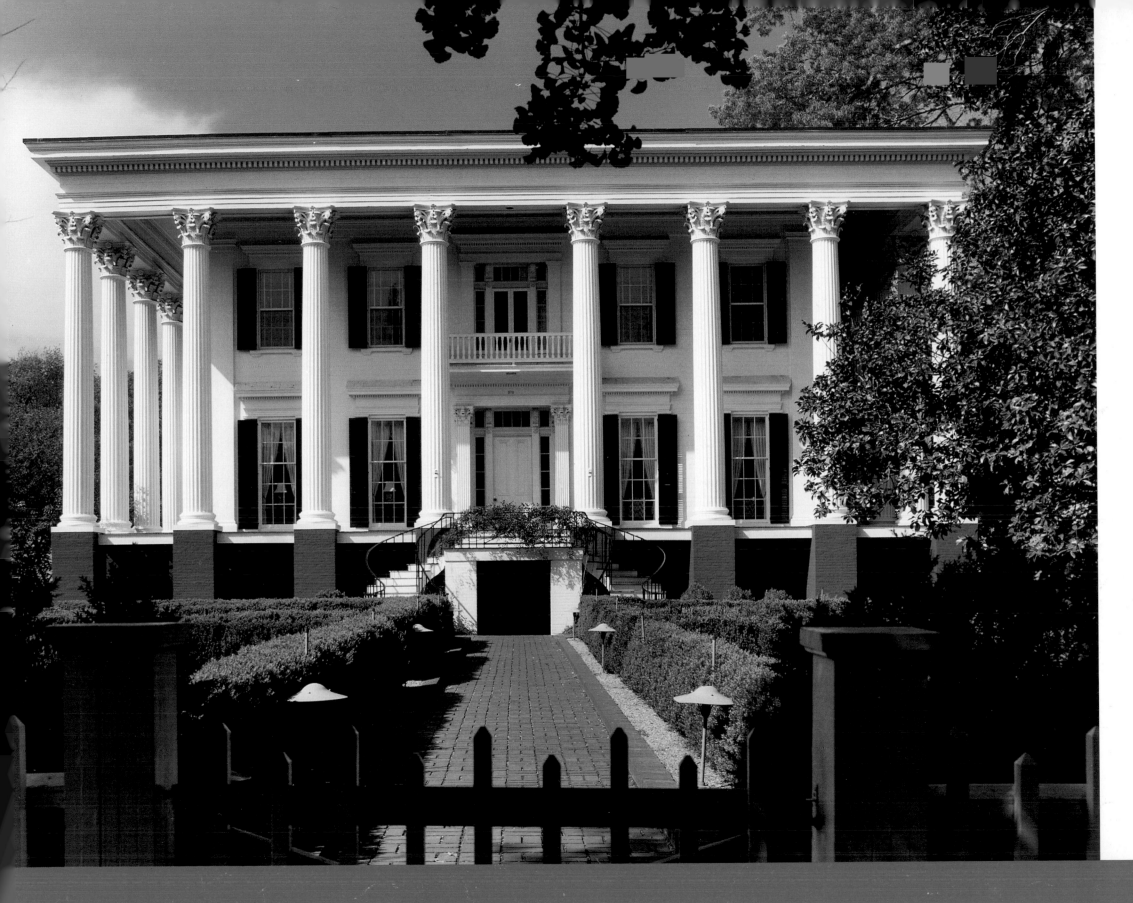

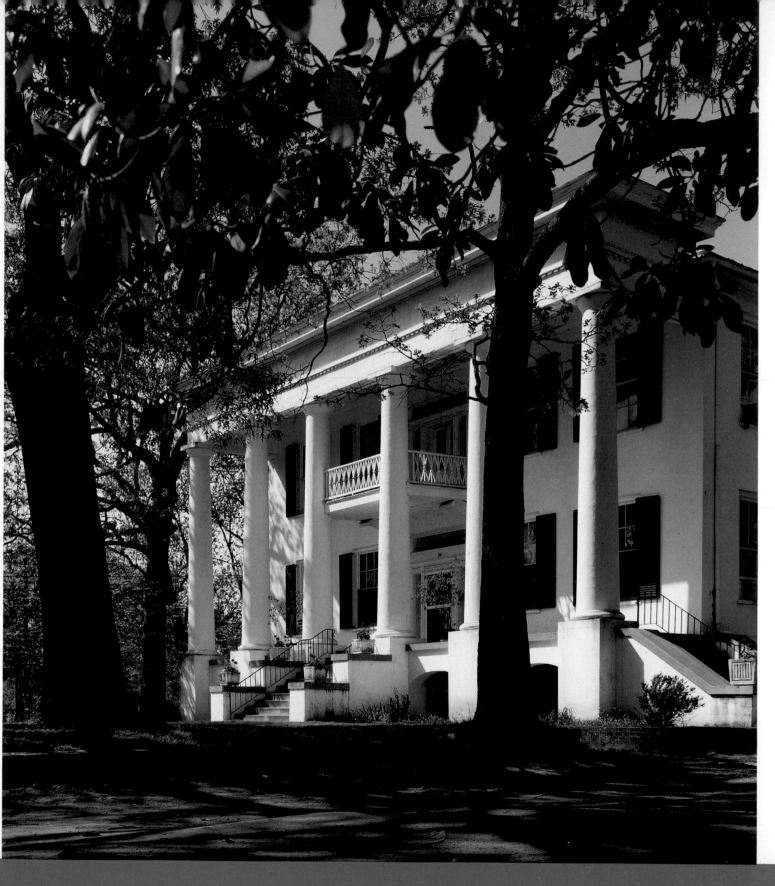

Howell Cobb House, 1835

Howell Cobb brought his bride, Mary Ann Lamar, to the first of two homes he owned in Athens. A block away from white-columned Prince Street, the house stands at the end of Pope Street, originally a drive from Prince Street to the house.

Howell Cobb, of an illustrious Georgia family, became governor of Georgia, United States secretary of the treasury, president of the Confederate Convention of 1861, and a general in the Confederate army.

Sledge-Cobb House, 1860 (right)

This delightful triple-gabled Gothic Revival house was built for James A. Sledge, editor of the *Southern Banner*, an Athens newspaper. The house has cast-iron mantels inside and a cast-iron veranda. Exterior and interior walls are brick, and the woodwork inside is walnut.

A later owner was Mrs. Lamar Cobb, first president of the Ladies Garden Club of Athens, the world's first garden club, organized in 1891.

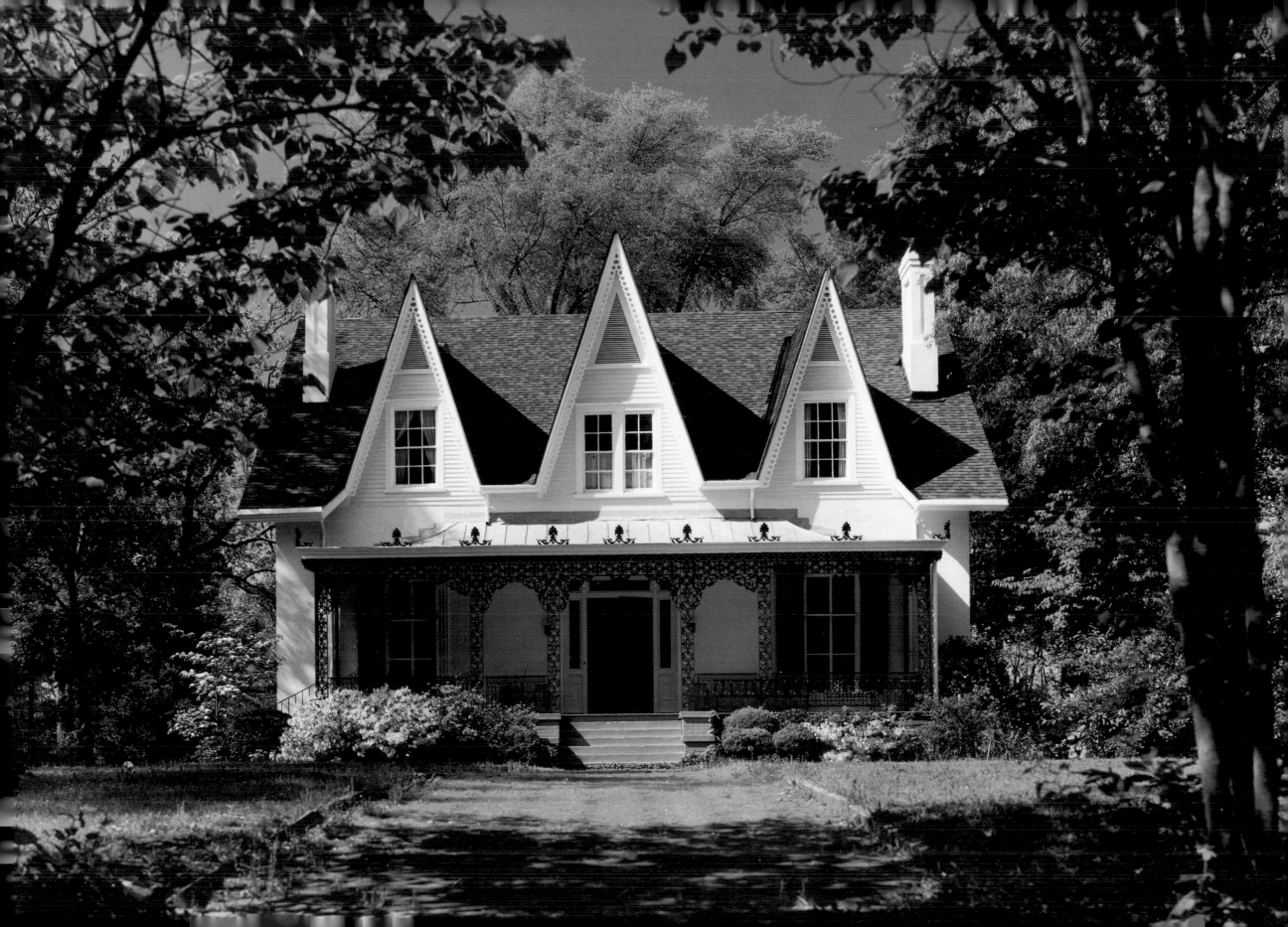

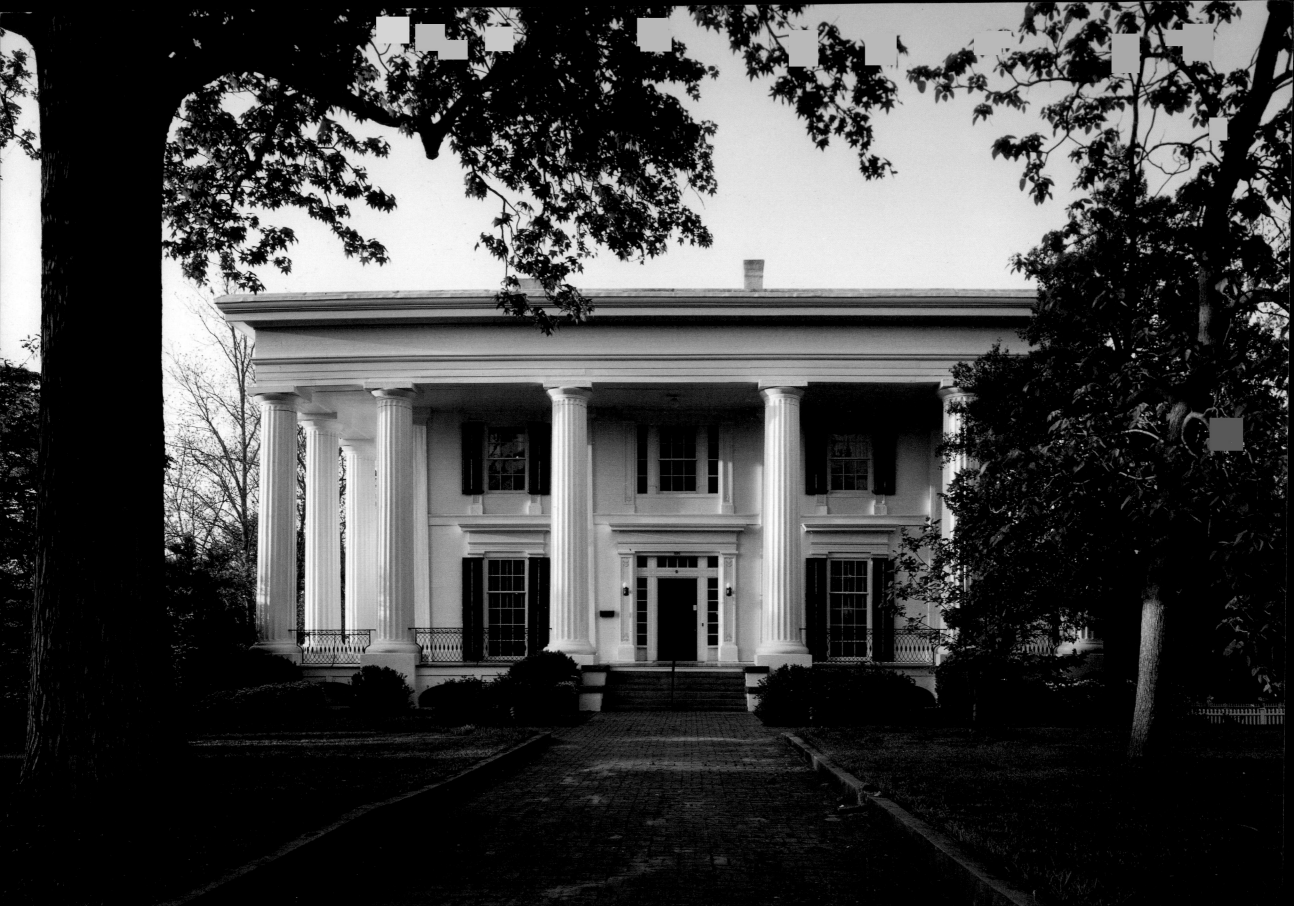

Taylor-Grady House, mid-1840s (left)

General Robert Taylor, a Savannah planter, cotton merchant, and a general in the Georgia militia, built this stately mansion as a summer house but moved to Athens from Savannah so that his sons could study at the University of Georgia. He and his family became permanent residents of Athens, residing in the Doric-columned house whose pillars are said to represent the thirteen original colonies.

In 1863, during the Civil War, Major William S. Grady bought the home, and his son, Henry Woodfin Grady, lived there until graduation from the university in 1868.

Henry Grady became the managing editor of the Atlanta *Constitution*. A great speaker, he urged reconciliation between North and South.

The restored landmark house is now owned by the city of Athens and leased by the Junior League of Athens, Inc.

Briscoe-Selman House, *ca.* 1832

Owned by the same family since its construction, the Briscoe-Selman House was built on "The Hill" in Monroe, Georgia, in about 1832 by Waters Briscoe. His wife, Martha Wellborne Briscoe, was the granddaughter of the Reverend Daniel Marshall, who founded the first Baptist church in Georgia at Kiokee Creek, twenty miles from Augusta, in 1772.

Waters Briscoe was one of the first honor graduates of the University of Georgia. The Briscoes' daughter, Virginia, married George Selman, who acquired up to six thousand acres.

The Briscoe-Selman House, over successive generations, grew from five to fifteen rooms and gained an impressive, columned veranda on three sides that is nearly twenty feet deep.

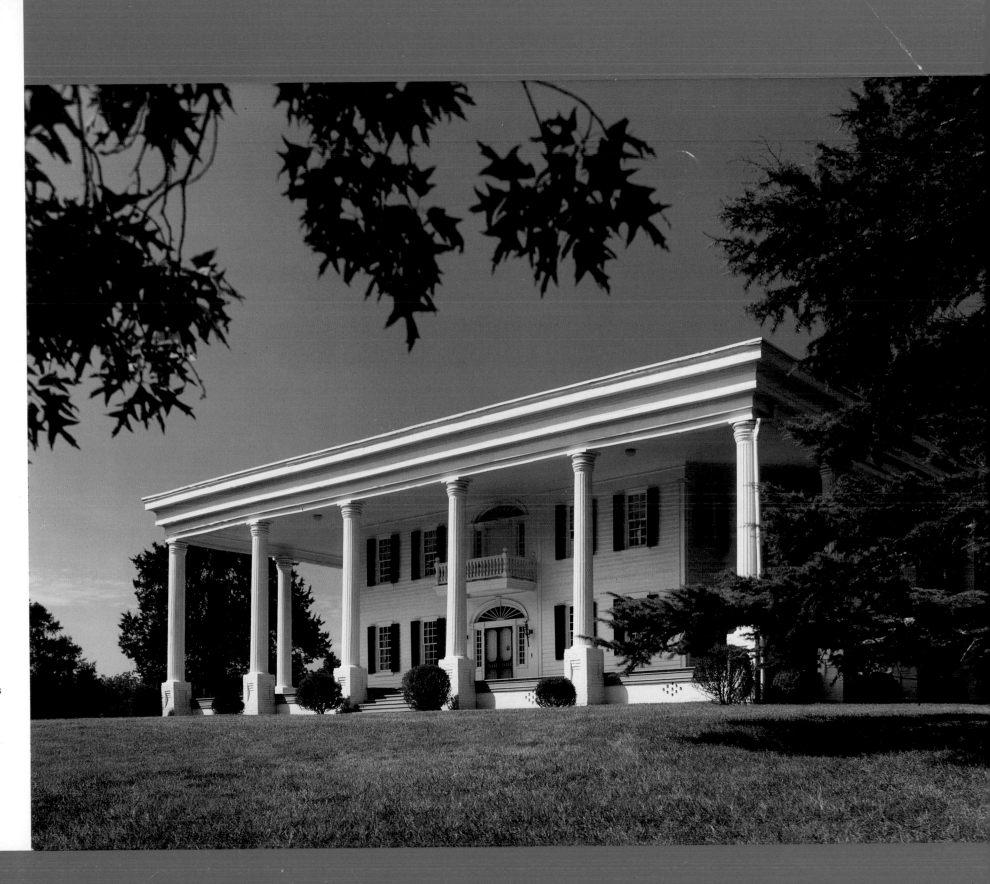

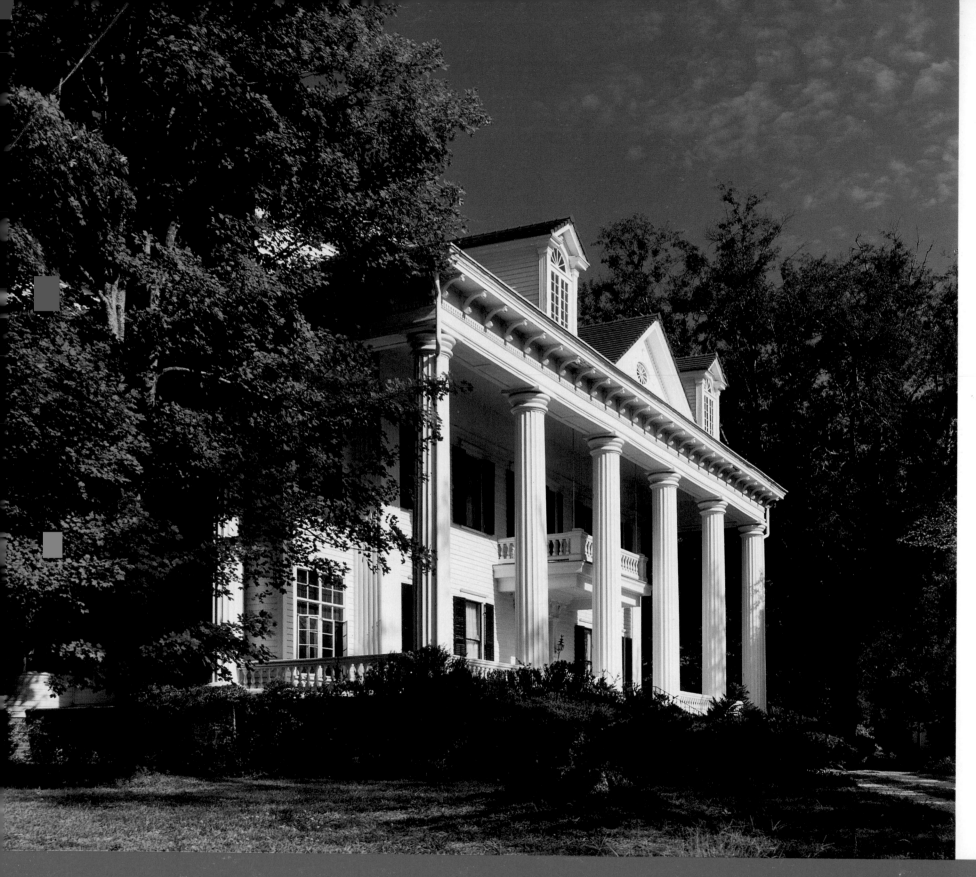

Whitehall, 1830s

Judge John Harris built Whitehall in the 1830s as his town house in Covington, Georgia, east of Atlanta. His large plantation near Covington was occupied by Federal troops on November 18, 1864, when they were beginning Sherman's March to the Sea. The troops "foraged" heavily on the provisions of Harris' plantation.

After the Civil War, property values dropped precipitously and remained depressed for many years. By 1885, William Metcalf, who had owned the town house for six years, sold it and the surrounding thirteen acres for one thousand dollars to Robert Franklin Wright, who had a plantation in Newton County.

Wright and his wife, Salina Frances Robinson, named the house The Cedars, added a boxwood garden to the rear of the mansion, and refurbished the interior. Nathaniel S. Turner bought The Cedars for $6,500 in 1903. The price reflected the work the Wrights had done on the house and gardens, as well as an improving economy.

Turner, born during the Civil War, became a cotton broker and ultimately the president of Covington Mills. Under his hand the house acquired a new name, Whitehall, and its present appearance, with an added third floor with dormer windows, an expanded colonnade, and a second-floor balcony at the entrance.

Margaret Mitchell saw a photograph of the house in the Atlanta *Journal* in February, 1939. She sent the clipping to Wilbur Kurtz, an Atlanta historian and Civil War authority who was in Hollywood consulting with the set designers of *Gone With the Wind*, saying, "I like this for Ashley's home," referring to Twelve Oaks.

Dixie Manor, 1830s

Judge Thomas Jones, an early settler of Covington and Newton counties, built his two-story Regency house with Italian overtones of brick, said by some to have come from England and by others to have been made in Newton County. It is the only two-story brick house in Covington that was built before the Civil War.

Dixie Manor, including fifty-five acres, was sold for five thousand dollars to Osborn T. Rogers in August, 1861. Rogers owned other Georgia property, as well as a plantation in Barbour County, Alabama.

During the Atlanta campaign, the cavalry of Confederate General Joe Wheeler defeated the bluecoats of Union General Stoneman. Wheeler and his staff were rewarded with supper at Dixie Manor.

A little later, Union forces of Garrard's cavalry swept into town, and the Rogers family escaped to their plantation in Alabama. It was two years before they returned to Covington, finding the house itself in relatively good condition. However, the Yankees had cut the carpets up for saddle blankets and smashed crockery and furniture.

Twice during the Atlanta campaign Dixie Manor sheltered a young Confederate soldier, home on sick leave. The first time, the Rogers family hid him in a dry well and moved a chicken coop over it. The second time, when Garrard's cavalry came to town, they concealed him in a space between the double roofs on the house, feeding him only at night.

In 1902, Corrie C. Wright bought the house and one and a quarter acres for two thousand dollars. She gave it the name Dixie Manor and made it her home for over forty years. The house is now owned by Mr. and Mrs. Billy Smith of Covington.

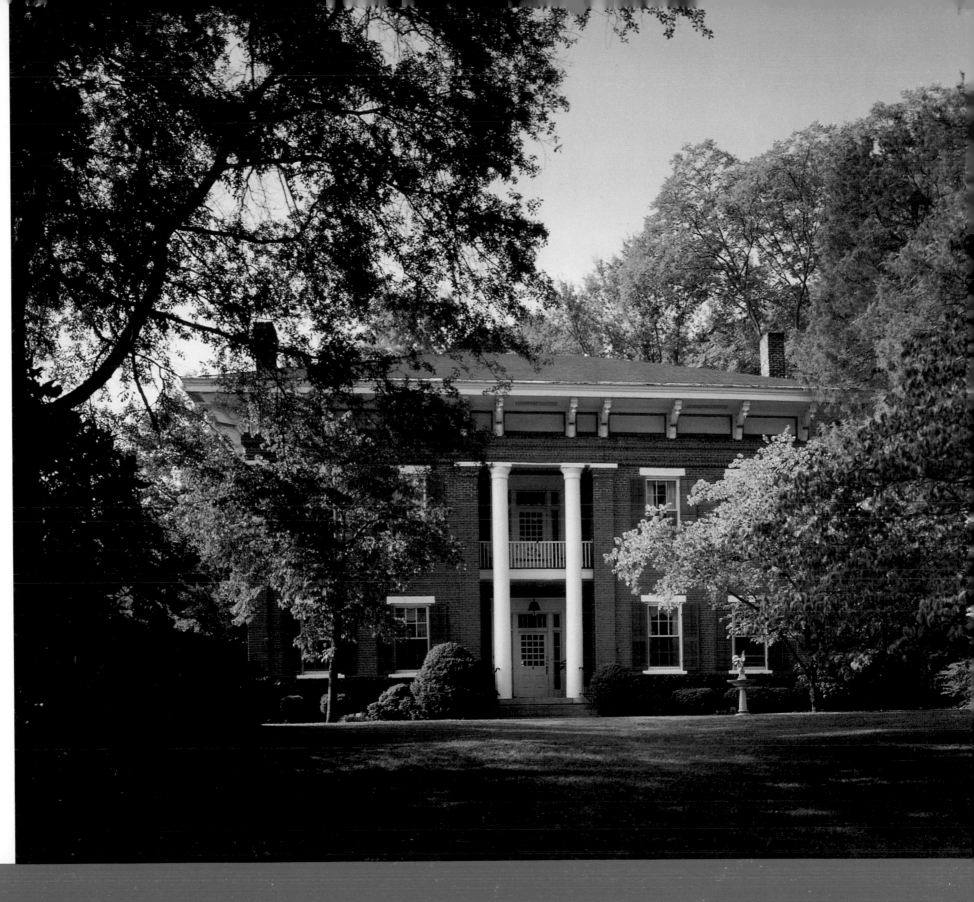

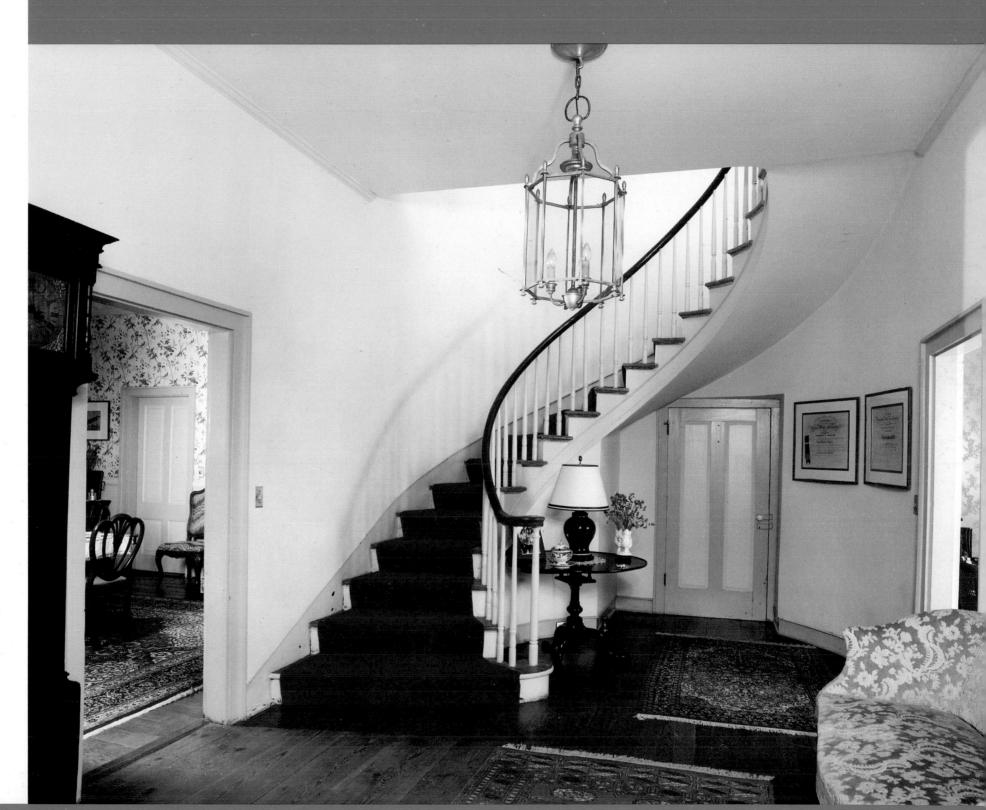

Mt. Pleasant, 1830s

The original part of this house was built by Solomon Graves in 1818, and the present structure was added during the 1830s. The first part was demolished by a later owner in the 1960s.

Solomon Graves came to the Covington area, Newton County, before 1818. He and his children built a plantation said to have included over 7,000 acres and between 200 and 300 slaves.

Two of the slave cabins and the well house are now at the park at Stone Mountain, Georgia.

Mt. Pleasant remained in the Graves family until 1958, when the house and 426 acres were bought by Walter C. Emmel from Montana. In 1972, Mr. and Mrs. Oby Brewer purchased the home, restored it, and have maintained it in excellent condition.

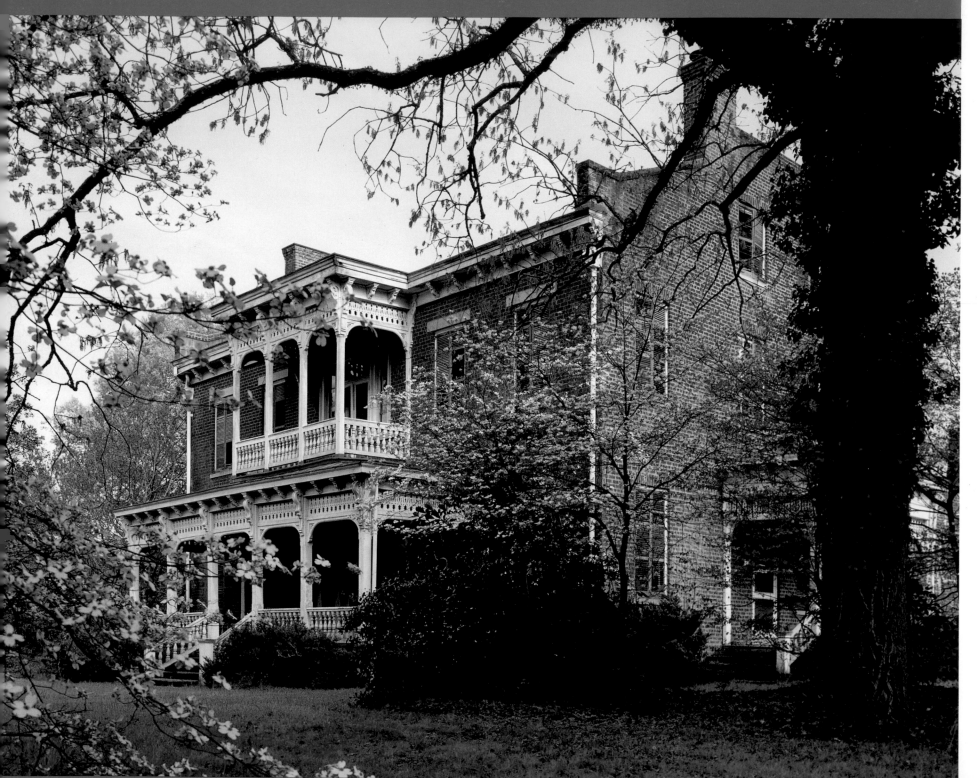

Bonar Hall, 1832

In 1832, Bonar Hall was completed as a Georgian style manor house for John Byne Walker and his heiress bride Eliza Fannin. The Walkers had a cotton plantation outside of Madison, Georgia.

John and Eliza not only had a plantation in Morgan County but extensive acreage in Texas that John visited annually. One year when he visited those holdings, his wife planted a garden on cotton land just outside the brick wall that enclosed the house and lawn. When planting time came around, Walker leveled the garden and seeded it in cotton.

For three years, when he went to Texas, his wife planted her garden. And he annually plowed it under and seeded it in cotton.

Mrs. Walker won the battle of the garden, for her husband spent $30,000, it is said, to import an English landscape architect to design and plant a formal boxwood garden and orchard with rare flowers, trees, and shrubs, many of which still survive.

The house, with slave-made brick walls eighteen inches thick, has its original brick outbuildings, including an orangery (a hothouse for orange trees), tea house and brick kitchen, all placed symmetrically in relation to the house, which is furnished with family heirlooms.

In the 1880s, a new owner, John A. Broughton, replaced the original Doric portico with a lacy Victorian veranda. Bonar Hall was returned to the family of the builder in 1920, when it was purchased by Mr. and Mrs. William T. Bacon. The present mistress, Mrs. Bacon's daughter, Therese Newton, is the present owner and is twice related to the original builder.

Thurleston, *ca.* 1818

A blend of architectural styles, the original part of Thurleston was built "out in the county" in about 1818, by John Walker, who had come to Morgan County from Greene County.

Walker's daughter Eliza married a Baptist clergyman, John Dawson. Several years later, Eliza died, perhaps in childbirth, leaving the Reverend Dawson with four children. Eliza's brothers gave the piece of property on which Thurleston presently stands to Dawson in 1841, and the house was disassembled and moved to that location.

Elijah E. Jones, a wealthy landowner, bought the house and 35 acres for $2,000 in 1845. He spent $7,000 building the massive addition that makes up the front of the house in 1848, using the services of Benjamin Peoples, an architect said to have come from England.

Jones sold Thurleston in 1863 to the Reverend David Edward Butler, who owned a 1,050-acre plantation outside of town. Butler was also a lawyer, and he helped Jesse Mercer found Mercer University in Macon. He was also a president of the Georgia Baptist Convention. Reverend Butler named the imposing house Thurleston, after the ancestral home of the Butlers across the Atlantic Ocean.

Two Butler daughters, widely known as Miss Bessie and Miss Daisy, owned Thurleston until their deaths in the early 1940s, and Butler heirs owned the mansion for years afterward. Clarence and Kathy Whiteside chose Madison as an ideal town in which to raise their children. They bought Thurleston in January, 1982, restored it, and moved in in June, 1983.

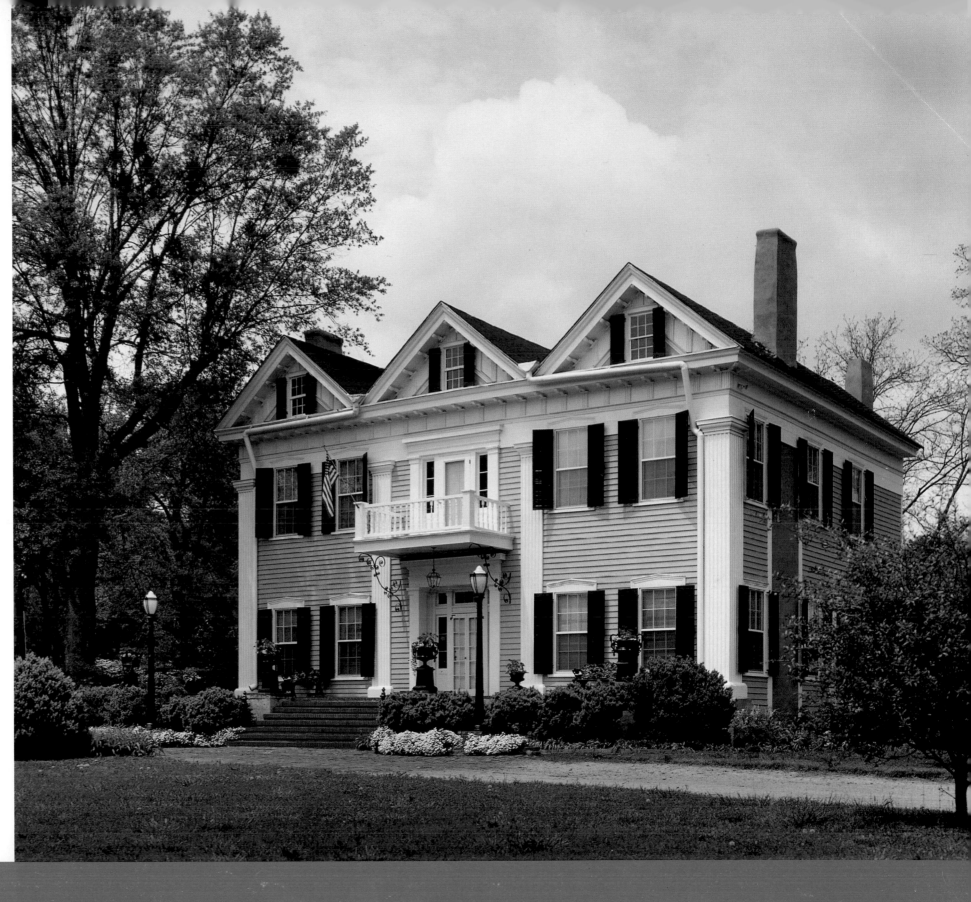

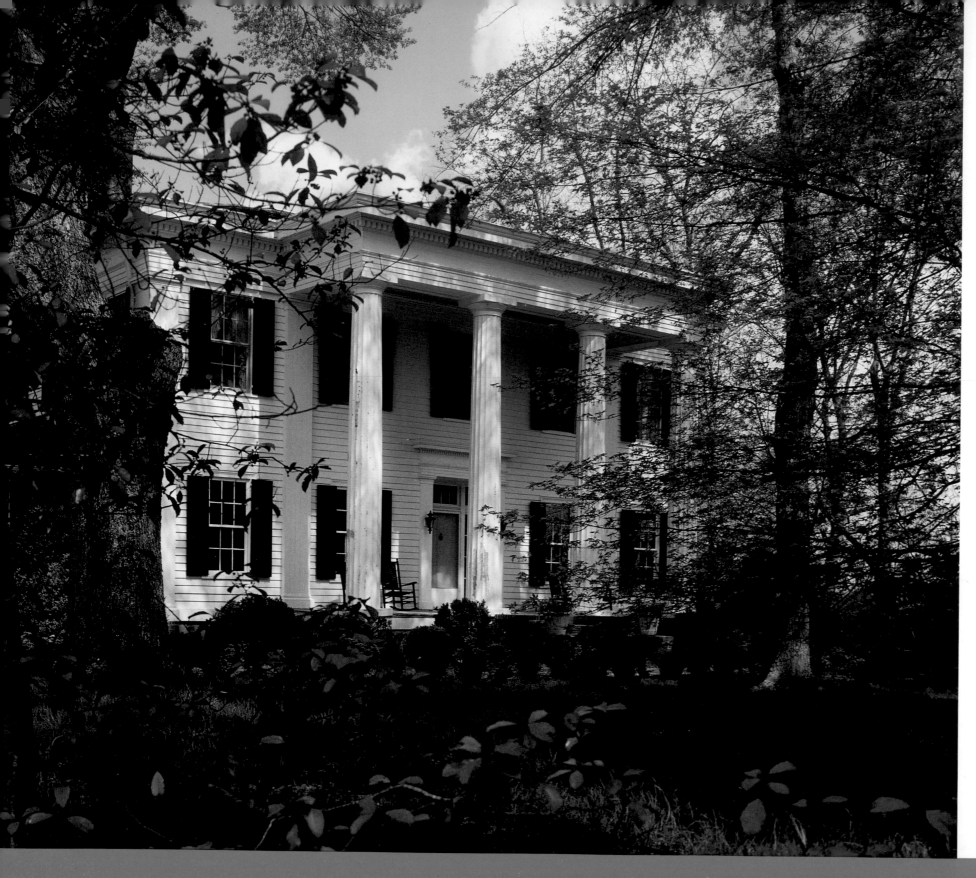

Robin's Nest Farm, 1832

Although Sherman is said to have considered Madison "the town too beautiful to burn," his troops still destroyed cotton gins, the railroad depot, and anything else that could have contributed to the war effort. But they left the houses and the classic storefronts of the courthouse square.

The bluecoats also spared the manor house of a 12,500-acre plantation east of Madison, but they burned the outbuildings. The house, now known as Robin's Nest Farm with much diminished acreage, gradually deteriorated until 1930, when Mr. and Mrs. Clarence McIntyre restored The Oaks, as it was then known. They made it their home for the next fifty years.

In 1982, Dr. H. R. "Bob" Bennett bought The Oaks from Mrs. McIntyre, and renamed it Robin's Nest Farm. Dr. Bennett traded part of a nearby farm of which he was a sixth-generation owner for The Oaks and began a second restoration. He and his bride Lydia have made Robin's Nest Farm a family home once more.

Atkinson Brick House, *ca.* 1800

Atharates Atkinson came to the Madison, Georgia, area in 1841 and bought an existing house believed to have been built in the early part of the nineteenth century. He had been a marble merchant in New Hampshire and went to Georgia to produce pink marble. In addition to mining marble, he became an entrepreneur and cotton planter, owning several farms in the Morgan County area.

Located near a marble quarry, the Atkinson Brick House was the first home of the Atkinsons in Morgan County. By the 1880s members of the family owned the Madison Variety Works, which manufactured the Victorian millwork added to the house during that period.

The Atkinson Brick House is now owned by Atharates Atkinson's great-granddaughter and her husband, Josephine and Howard Brandon. Inside, the house remains much the same as it was before the Civil War. The walls and ceilings are of wide planks of varying width that still bear the marks of the hand plane. The floors are of heart pine.

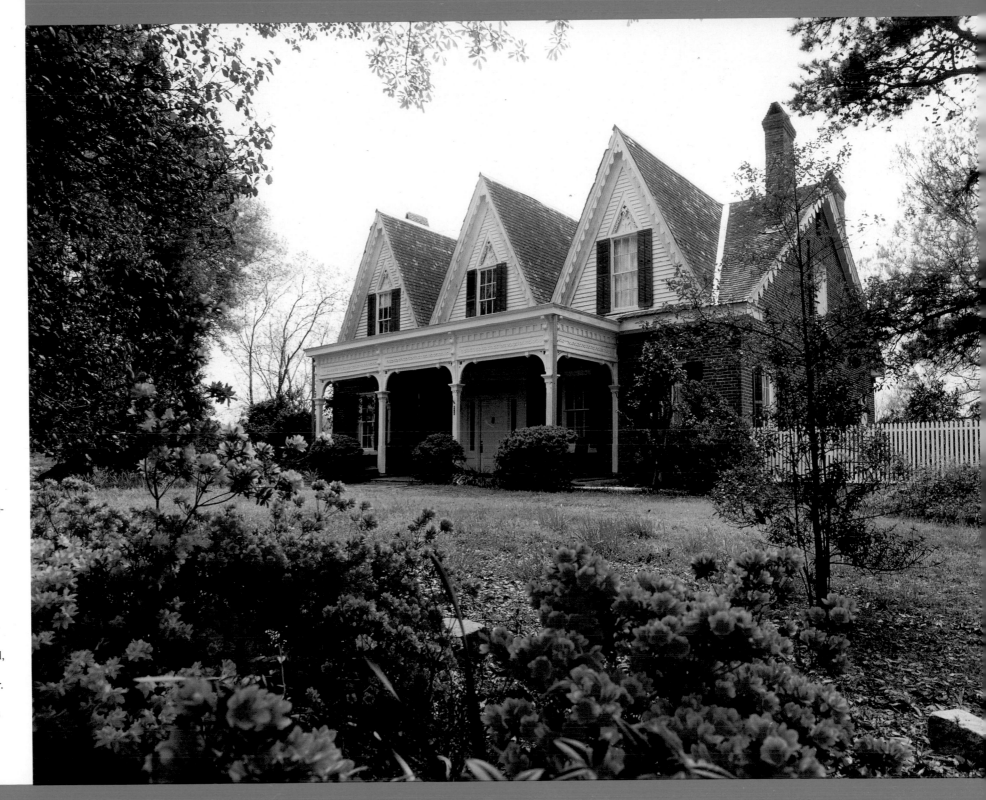

Rock Mill, *ca.* 1810

In the early 1800s, William Shivers built a water-powered grist mill on the banks of the Ogeechee River in Hancock County west of Sparta.

Nearby, at some time between 1810 and 1825, he built a three-story house over a raised basement and named it, appropriately, Rock Mill. The imposing house has seventeen rooms, forty-seven windows, and twelve fireplaces whose flues merge into two massive chimneys. Later, he built a stone textile mill, named Rock Factory, that made wool yarns and cotton goods.

Shivers died in 1852 at the age of sixty-nine, and the house and 1,600 acres were bought by William Simpson of Wilkes County for $23,250. A later owner included A. T. Cason, whose daughter Ida was the grandmother of Howard "Bo" Callaway, 1966 Republican candidate for governor.

During the 1966 gubernatorial campaign, Dr. Olin Shivers of Atlanta read a newspaper article about Bo Callaway and his grandmother's home and realized that Rock Mill could be the home of his ancestor. Further research proved it, and Dr. Shivers returned the house to the family of its original builder. He restored the long-neglected house to its condition of the 1820s, removing a Victorian porch and replacing it with a portico closely resembling the original.

The James Wilson family from Thomson bought the house and four hundred acres in 1978, and it is now owned and well maintained by James and Epp Wilson. Instead of cotton, the plantation now raises horses: thoroughbreds and hunters.

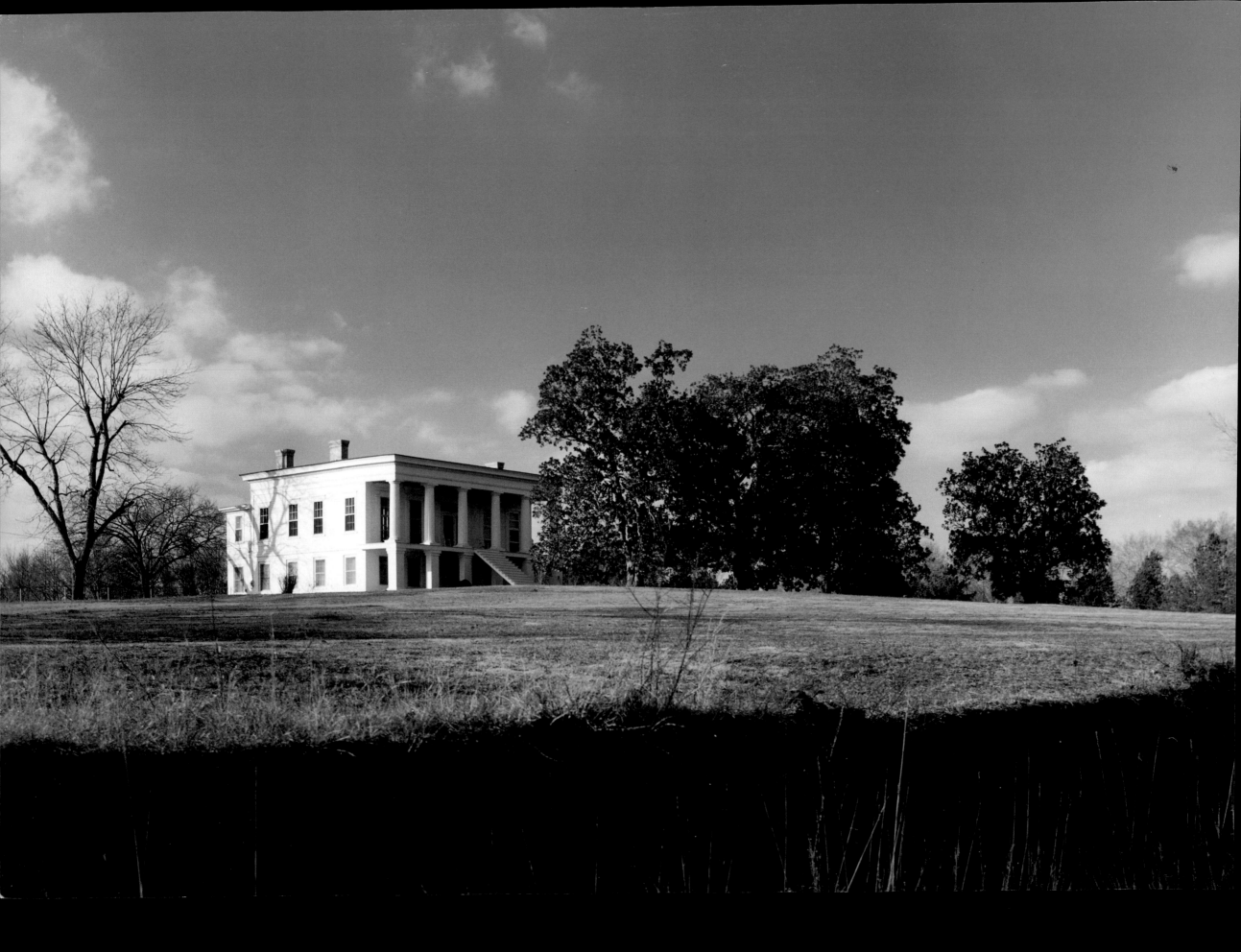

Glen Mary, 1853 (left)

In 1853, Theophilus Jackson Smith built a templelike Greek Revival home that dominates the rolling countryside south of Sparta, in Hancock County.

Essentially a raised cottage, the walls of the downstairs basement are brick, two feet thick. The spacious rooms upstairs, on the main floor, are highlighted by elaborate plaster cornices and medallions.

General and Mrs. Ethan Allen Hitchcock bought Glen Mary in 1869, and later it was owned by the Nicholls family. Mr. and Mrs. Wayne Hill bought the stately house in 1987.

The Homestead, 1818

Peter J. Williams built one of the earlier houses in Milledgeville in 1818, where he brought his bride, Lucinda Parke, of Greensboro, Georgia. The Williams-Ferguson-Lewis House, as it is also known, remains in the same family, with its furnishings added to by members of succeeding generations who have never altered the original proportions of the house.

The Homestead is an archetype of the style of Georgia architecture known as Milledgeville Federal. It is similar to the design of other houses in the area built at about the same time, but it was the first to have a two-story porch.

The boxwood and wisteria in the garden were planted under Lucinda Williams' direction not long after the house was built.

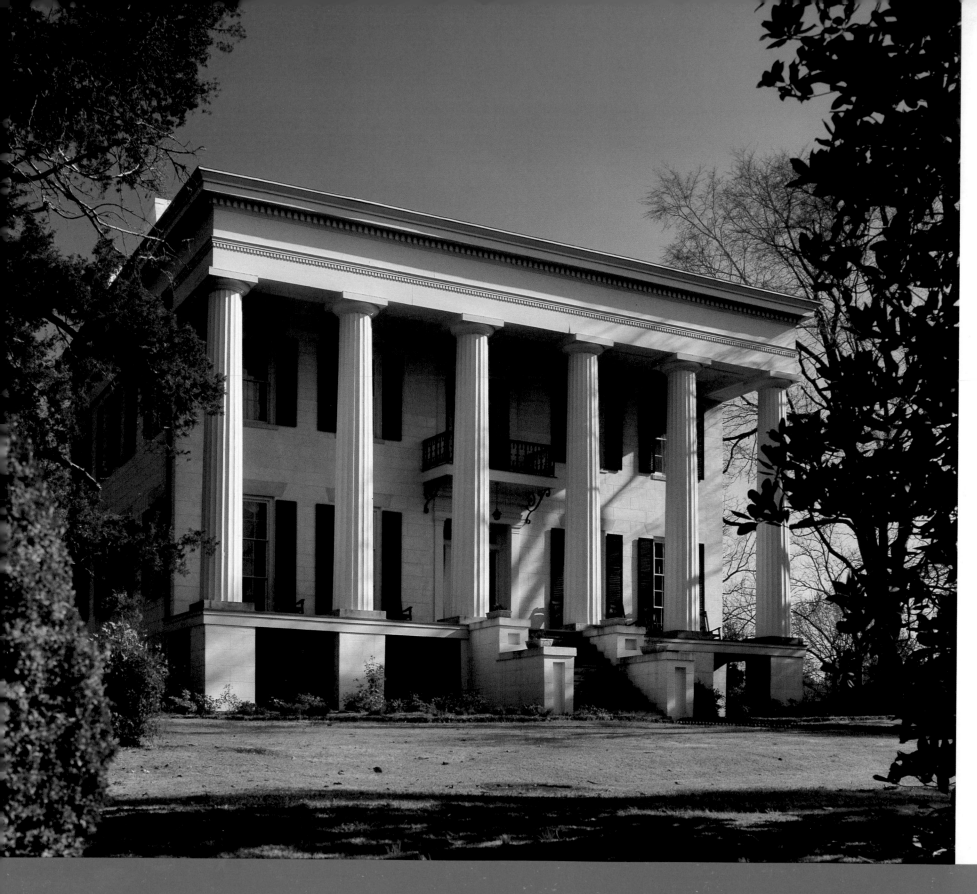

Lockerly Hall, *ca.* 1839

A classic Greek Revival temple house, Lockerly Hall, also known as the Tucker-Hatcher House, was built either by R. J. Nicholls in 1839 or by Judge Daniel R. Tucker in about 1851.

Nicholls, who owned 32 slaves and 2,100 acres in the Milledgeville area in 1841, built a house in the Midway community near Milledgeville called Rose Hill (named for the Cherokee Rose) in about 1839. He died intestate in 1849, and Tucker bought the house and land in 1851. Tucker was considered one of the largest land and slave-holders in the county.

In 1927, the R. W. Hatcher family acquired the house, restored it, and renamed it Lockerly Hall, after an English castle on Mrs. Hatcher's side of the family. A Hatcher daughter married a descendant of Farish Carter, whose home plantation was near Milledgeville.

In 1963, Edward J. Grassman, president of the Georgia Kaolin Company, bought Lockerly Hall and gave it an additional restoration, preserving its original false-grained wainscoting and marbleized skirting. The house remains the property of the company.

Judge Tucker may or may not have built Lockerly Hall after he bought the property, or he may have made alterations to an existing house. Regardless of the builder, Lockerly remains one of the most outstanding examples of the classic Greek Revival plantation home.

Stetson-Sanford House, *ca.* 1825 (right)

John Marler was the architect-builder of this Traditional Federal style house in Milledgeville, which was in the same family for over one hundred years.

The center halls on each floor are off-center to the Palladian porches, as are the doors themselves, although this is apparent only after careful examination.

For fifteen years, from 1951 to 1966, Fannie White and Mary Jo Thompson operated the Stetson-Sanford House as a tea room, attaining national recognition. The two-story house was given to the Old Capital Historical Society, which moved it to its present location in 1966, restored it, and made the house its headquarters.

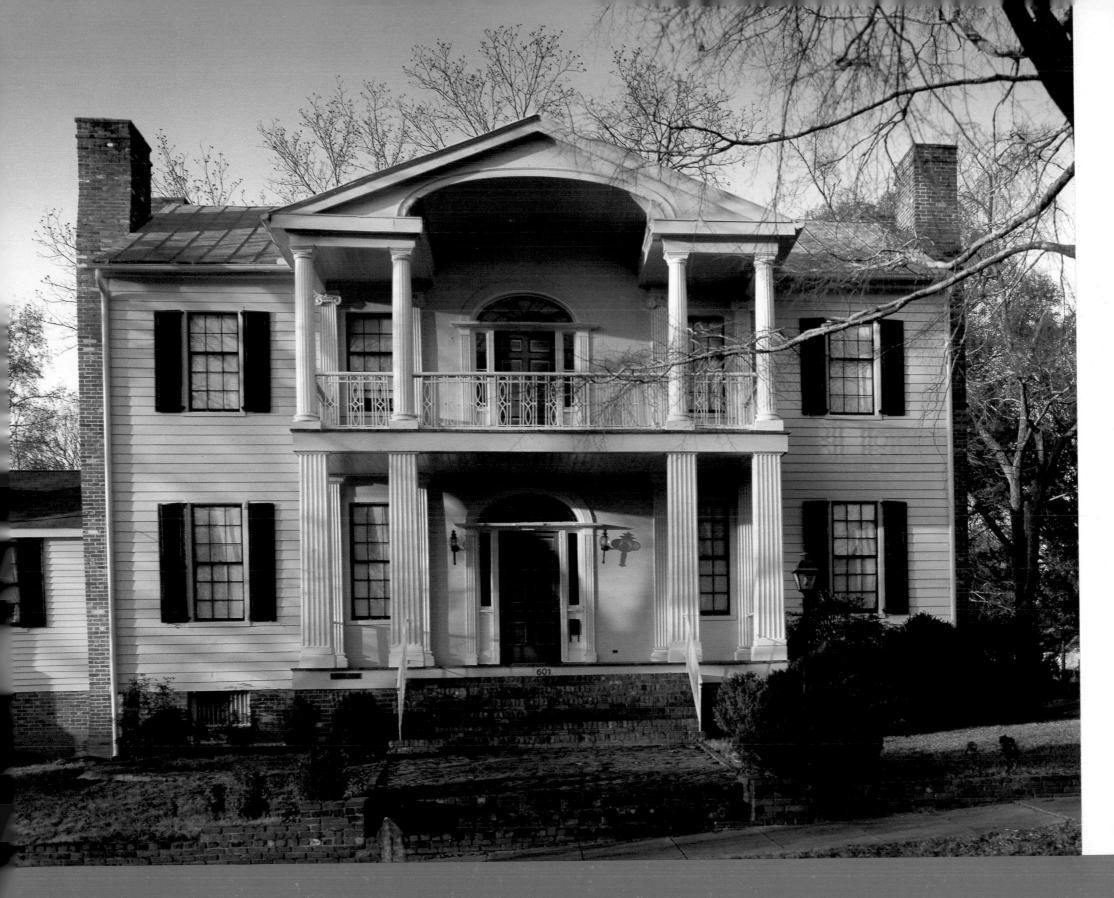

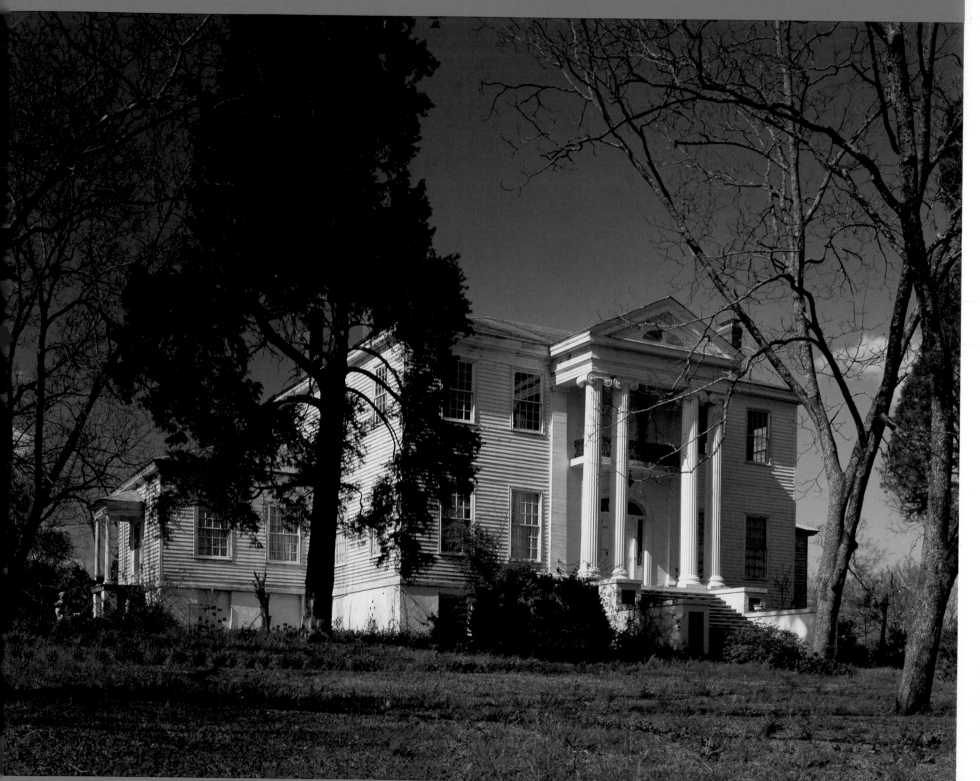

Rockwell, 1838

Colonel Samuel Rockwell, of the seventh generation of Rockwells in America, had become a major landowner and slaveholder in Baldwin County by 1828. Ten years later, he built the imposing house overlooking Allen Memorial Drive in Milledgeville, then Georgia's state capital. He was an attorney and adjutant-general of the Georgia Militia.

The architect-builder was Joseph Lane, Sr., who only a year earlier had come to the Milledgeville area from Portland, Maine. Lane's design of Rockwell, also called Beauvoir and the Governor Johnson House, after Georgia Governor and Confederate Senator Herschel V. Johnson, who later owned the house, is considered an important transition between Milledgeville Federal and Greek Revival architecture. Its doorway with elliptical fanlight is characteristic of the finest in Milledgeville Federal houses, but the balcony and pedimented portico are Greek Revival.

The sliding doors, wainscoting, and woodwork from the dining room at Rockwell are now part of the Georgia Room at the Winterthur Museum near Wilmington, Delaware.

Gatewood, *ca.* 1805

Taking advantage of an early middle Georgia land lottery, John Keating acquired 202.5 acres near Eatonton in the early 1800s and built the first house in Putnam County. The Federal-style front portion was completed in about 1805, and the back wing in 1811 or 1812. Keating came from Virginia, and his house resembles those of Williamsburg in his home state.

Since the 1812 addition, Gatewood has remained relatively unchanged. All woodwork is original, as is the wainscoting and false graining on the doors. In the 1830s Mrs. Frances Gatewood, a widow, bought the house, and it remained in the Gatewood family for one hundred years. The Gatewoods owned extensive property in Putnam County and were among its founding families.

William H. Seward, Abraham Lincoln's secretary of state, taught school in Putnam County in 1819 and fell in love with Mary Gatewood. Her family discouraged the match, and Seward returned to his family in New York state, ultimately to become an ardent abolitionist, senator from New York, and United States secretary of state.

Mrs. Betty "Beegee" Baugh, wife of Milledgeville mayor James Baugh, learned of the possible demolition of the historic house in the 1970s and became determined to acquire the house and move it about thirty-three miles to a location near Milledgeville.

After the house was on its new grounds, the Baughs took about eight years in a gradual process of restoration, adding the amenities of a modern home. They named it Gatewood and have since hosted two reunions of the Gatewood family at their ancestral home.

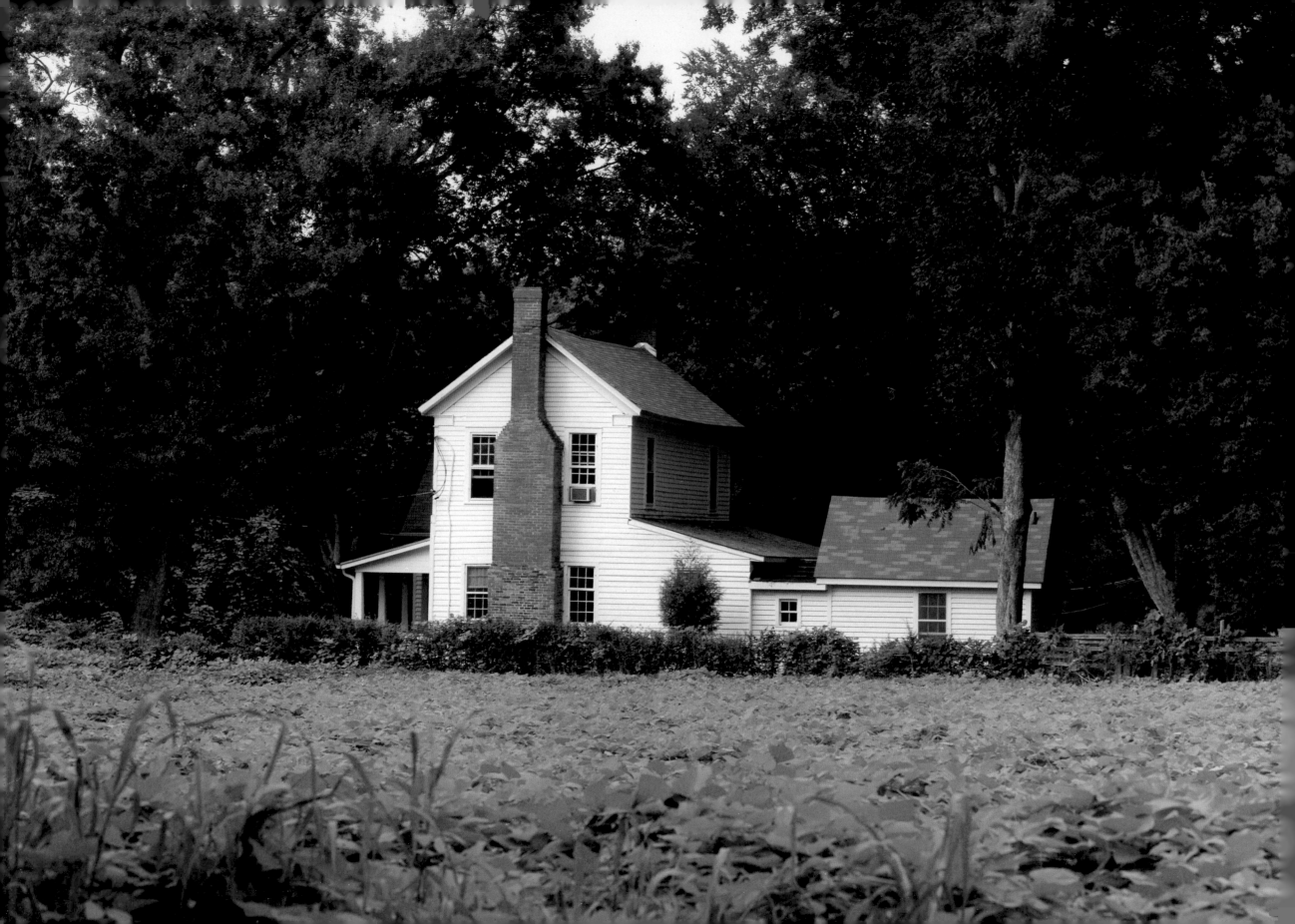

Rosser-Barron-Mauldin House, 1812 (left)

Twelve miles northeast of Macon in Jones County is
the village of Clinton. Settled in 1808, Clinton was the
seat of Georgia's second most populous county in 1820
but lost out in growth to nearby Macon, which was
only a settlement by Fort Hawkins when Clinton was
founded.

The little town continued its serene existence until
1864, when it was visited three times by Union cav-
alry, twice by Stoneman's troops during their abortive
effort to free their comrades at Andersonville, and
once by five thousand of Kilpatrick's cavalry during
Sherman's March to the Sea. When they left Clinton,
one-third of it was in flames.

One of the houses left untouched by the bluecoats
was the Plantation Plain style house built by Daniel
Rosser in 1812. It was owned by the Barron family
from 1899 until 1979, when retired Boy Scout execu-
tive James Mauldin and his wife rescued the house
from the kudzu vines that had completely overgrown
it. Their project took five years, resulting in a comfort-
able house and a charming restoration.

Lockett-Hamilton House, pre-1830

Fifteen thousand Union troops, part of Sherman's
army, marched through Clinton on the Marion Road,
which the Lockett-Hamilton House overlooks.

Although existing records date the two-story house
to 1830, this date seems to refer to the later section.
The older part appears to have been built much ear-
lier, by James Lockett, whose wife lived in the house
until 1860.

After the Civil War, for a few years the house was
the home of James H. Blount, a lawyer and United
States congressman from 1872 to 1892. His daughter,
Eugenia Blount Lamar, born in the house in 1866,
became a president-general of the United Daughters
of the Confederacy. The house was later owned by
Roland T. Ross, a clerk of the Superior Court for over
twenty years.

Mr. and Mrs. Earl Hamilton became the owners of
the house in 1950 and have made a continuing effort
to preserve both their home and the history of Old
Clinton.

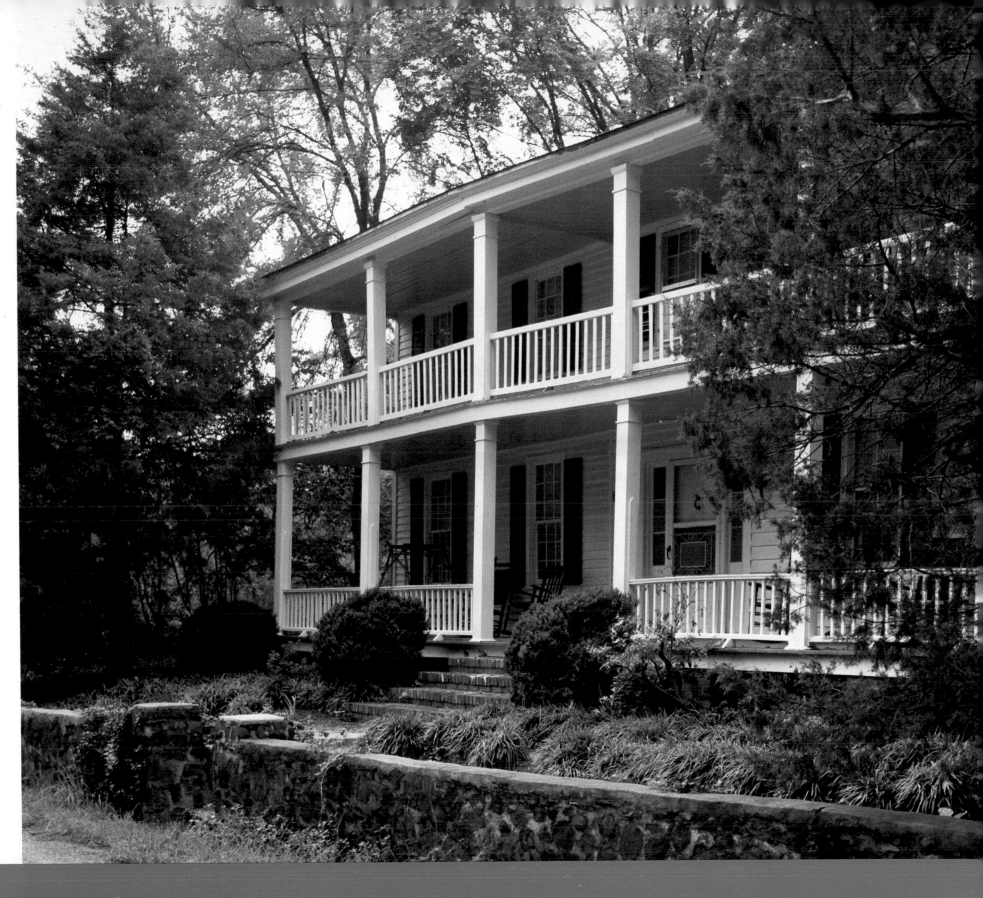

Hollywood, 1850

In the middle of a peanut field southwest of Macon, in Twiggs County near Jeffersonville, John Chapman built Hollywood, named for twenty acres of holly trees near the house. Prior to the Civil War, he owned over seven thousand acres.

Chapman used the services of an architect-builder, a "Yankee carpenter," who remained in the Jeffersonville area for five years, building a number of fine old houses in the vicinity.

Hollywood has six square columns that are twenty-four feet tall, a center hall, and four downstairs rooms with heart-pine floors that measure eighteen by eighteen feet. The twelve-foot ceilings of the downstairs rooms carry plaster cornices and medallions, and the ceilings of the four rooms upstairs are ten feet high.

For the landscaping for the yard, Chapman's slaves dug forty varieties of trees from the banks of the Ocmulgee River. A tornado in the 1940s spared the house but took twenty-five of the original plants. Some of the original forty are still standing.

Mrs. Pearl L. O'Daniel, one of the later owners of the Chapman place, gave a warranty deed in 1918 to W. E. Gettys of Twiggs County, Georgia, for "that tract of land . . . called 'Hollywood.'" The house is still in the family of his daughter, Mrs. Lois Gettys Duncan.

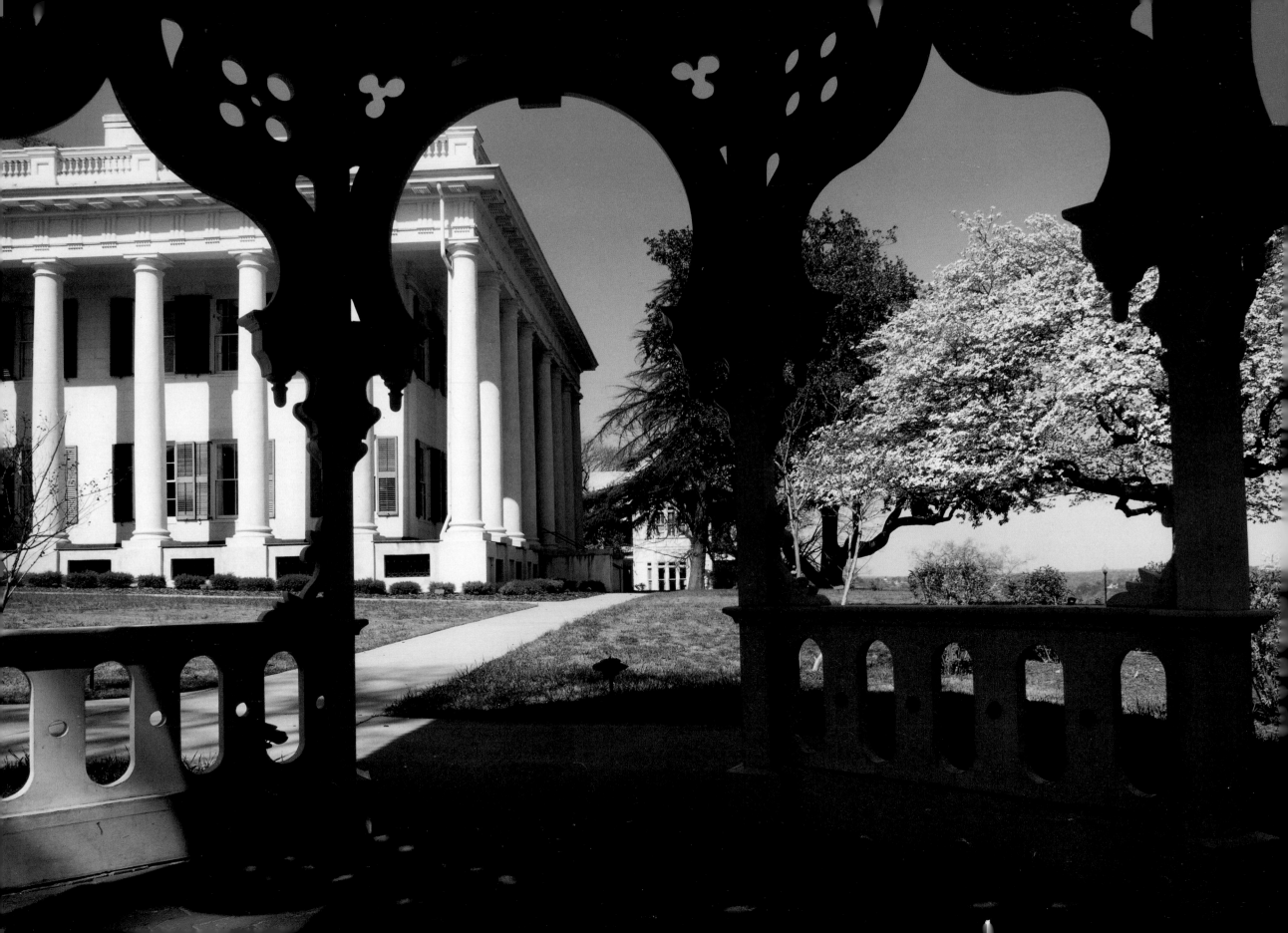

Woodruff House, *ca.* 1836

Jerry Cowles, a banker and railroad financier, retained Elam Alexander, master builder, to build one of the most imposing houses in the Macon area. Cowles encountered financial difficulties in the 1840s and left Macon for New York.

Colonel Joseph Bond, one of the largest cotton planters in the state, bought the stately house shortly thereafter. Bond owned six plantations in the Lee County area south of Macon, and his estate was valued at $1,055,000 when he died in 1859. His cotton land of nearly 20,000 acres was worth $426,067, and his 369 slaves totaled $476,445 in pre–Civil War dollars. Bond was shot by an overseer whom the colonel had knocked off his horse for whipping a slave, an old and faithful servant.

Occupied by both northern and southern forces during the Civil War, Bond's mansion was purchased in 1879 by Samuel T. and Aurelia Coleman, who entertained the former president of the Confederacy, Jefferson Davis, and his family at a reunion in 1887.

Subsequent owners included J. W. Cabiness and B. P. O'Neil. In 1960 the mansion became the home of Stratford Academy. In 1978 George W. Woodruff donated the house to Mercer University. The city of Macon restored the exterior, and the university, aided by Woodruff and the Emily and Ernest Woodruff Foundation, completed the interior.

The massive hand-carved front door is oak and was added during Bond's occupancy. He also added the balcony.

During the Stratford Academy period, the marble mantels were removed and broke into more than one thousand pieces. They were carefully reassembled during the restoration, and missing pieces were fabricated from similar materials.

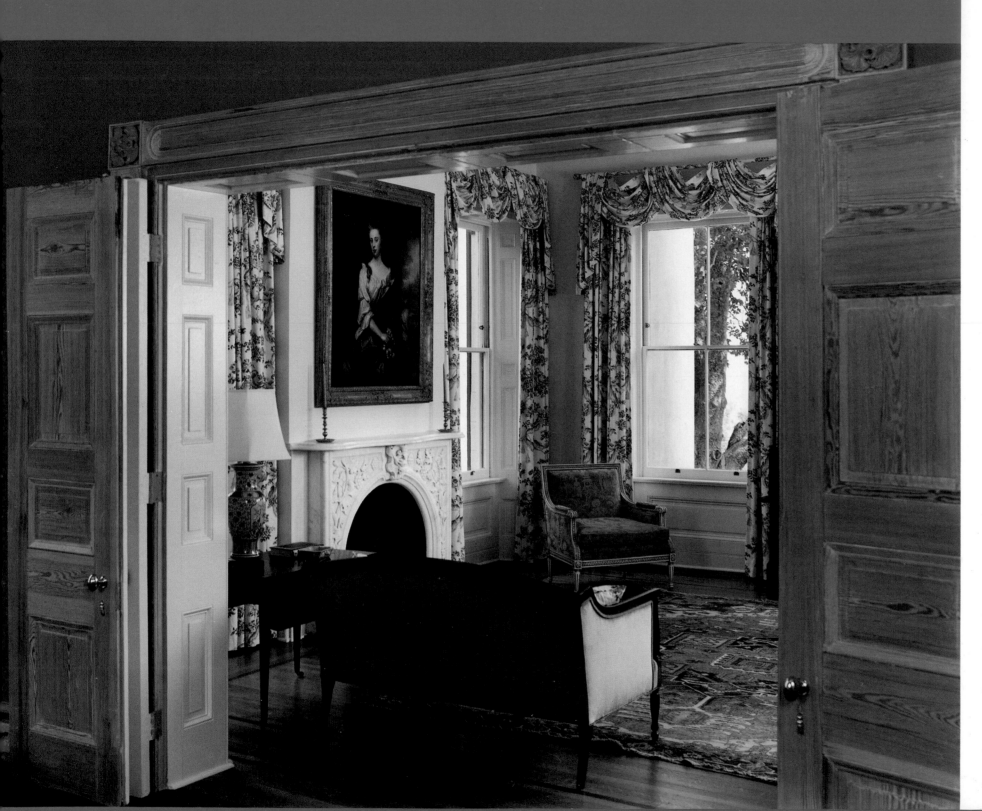

(left) Only a sealant was used in the restoration to show the beauty of the pine woodwork in the Woodruff library.

Holt-Peeler-Snow House, 1840 (right)

In 1840, Elam Alexander designed a handsome Greek Revival house in Macon for Judge Thaddeus Goode Holt. In 1825, as an aide to the governor of Georgia, Holt accompanied the Marquis de Lafayette when he visited Macon that year.

One of the world's richest women, Doris Duke, was Judge Holt's granddaughter. Her mother, Nanaline Holt, was born in this house.

Joseph Dannenberg bought the house in 1884, and curved the columned portico down the east side of the house. The columns on the side are made of sheet metal, and the original six in front are wooden.

Mr. and Mrs. William Snow own the property today and have raised their family in the majestic old house.

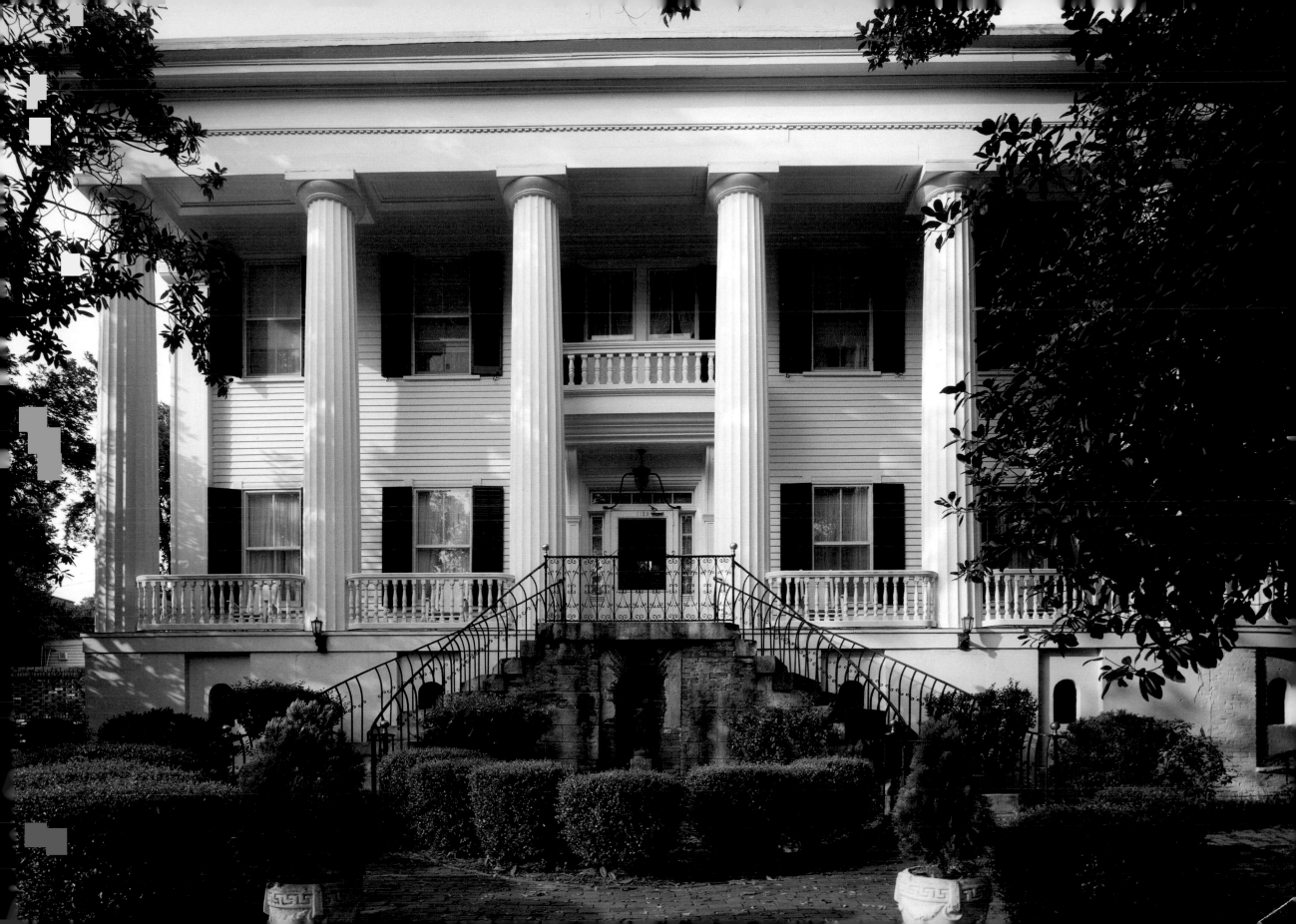

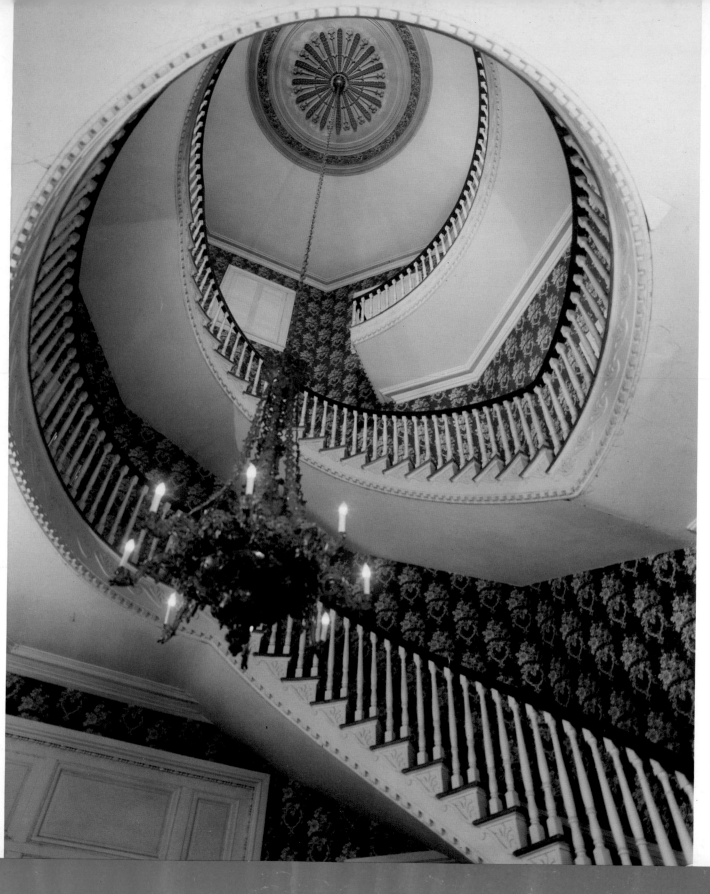

Raines-Carmichael-Oliver House, *ca.* 1840

Architect Elam Alexander built a unique house in Macon for Cadwalader Raines. Instead of the fairly standard floor plan of two rooms on each side of a center hall, Alexander designed this three-story house in the modified form of a Greek cross with arms of equal length.

At the center of the house is a three-story octagonal rotunda, lighted from above, which houses a spiral staircase curving to the cupola on top. The four main rooms on each of two floors extend like massive spokes from the hub of the rotunda, allowing each room to have windows on three sides for maximum ventilation.

The unique house is listed in the National Historic Buildings Survey and is on the National Register of Historic Places.

(right) To the right of the Greek-Cross-shaped Raines-Carmichael-Oliver House is the Holt-Peeler-Snow House.

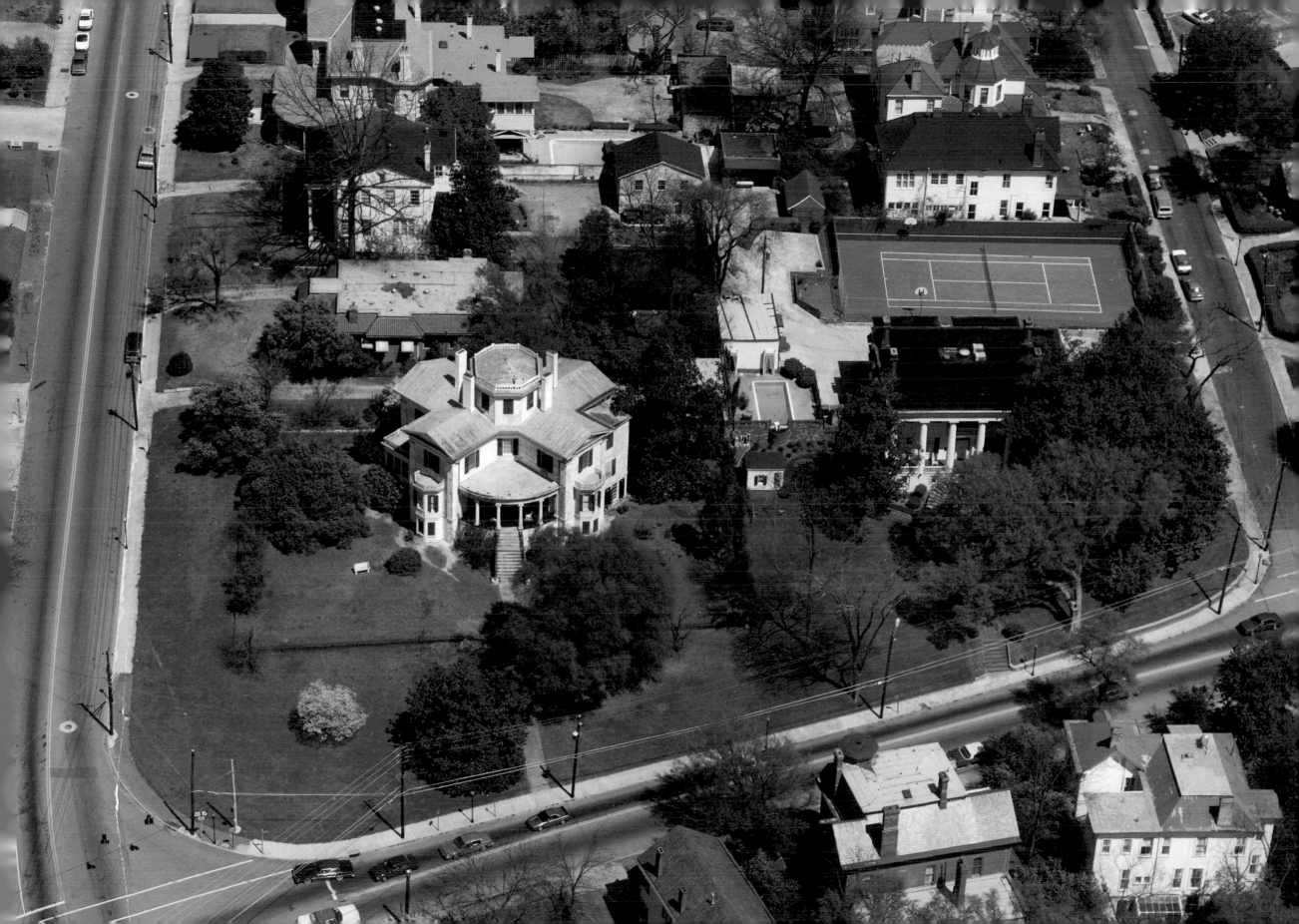

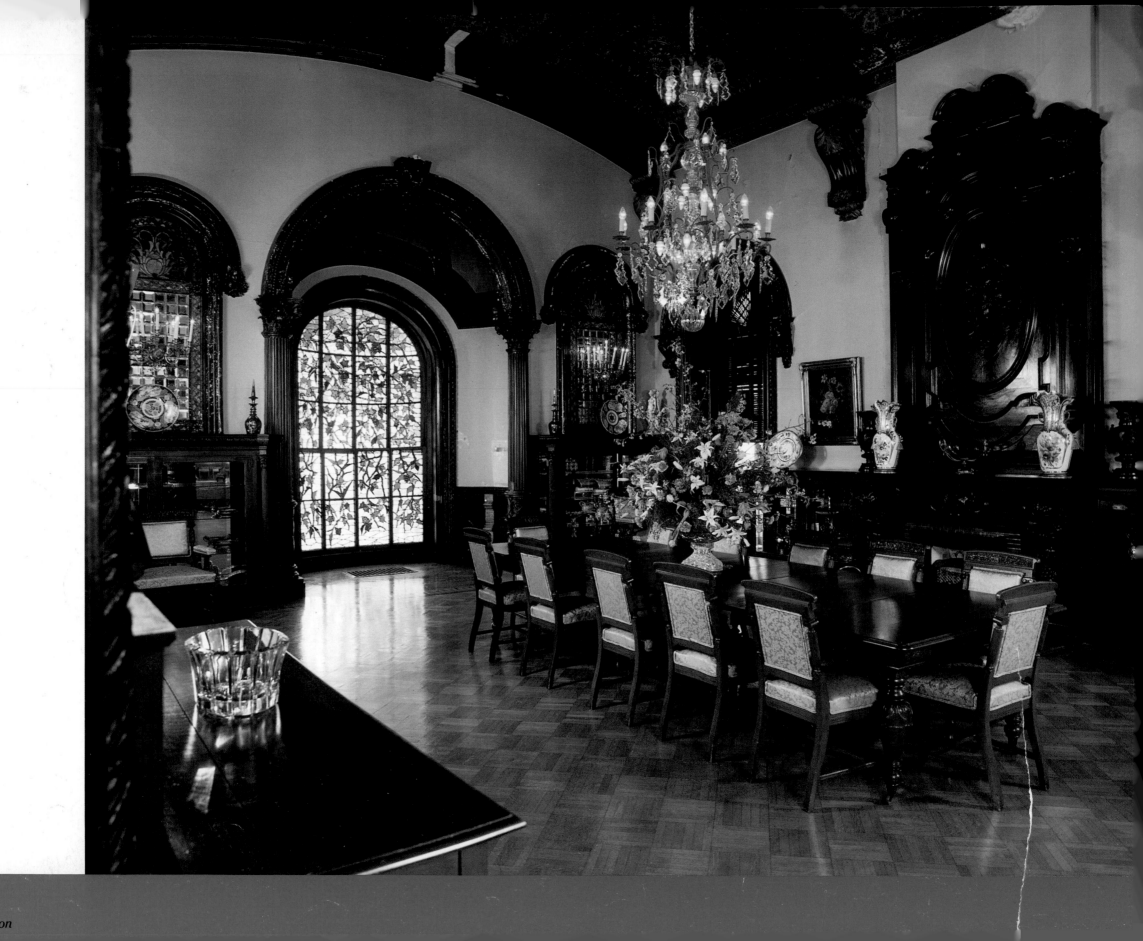

Hay House, 1861

Under construction from 1856 until the spring of 1861, the Hay House was envisioned as the finest house in Georgia by William Butler Johnston and his wife, Anne Clarke Tracy, while on their three-year honeymoon in Europe. Upon their return, they retained a New York architectural firm, Thomas Thomas and Son, to build a twenty-four-room Italianate mansion with eighteen thousand square feet under the roof.

Made of brick baked on a nearby Johnston plantation, the Hay House is a mansion of superlatives. The two hand-carved front doors are said to weigh five hundred pounds each. Carrara marble was carved by hand for the patterned floor for the portico, the nineteen mantelpieces, and the front steps. The double drawing room measures forty-one by eighteen feet, the dining room forty-two by twenty-four, and the picture gallery-ballroom fifty-four by twenty-four.

During the Civil War, Johnston was the premier of the treasury of the Confederate states. His house was a depository, perhaps accounting for the secret room that can be entered only from a hinged statuary niche on the staircase.

A Johnston heir sold the great house to Parks Lee Hay in 1926, and it was the residence of the Hays until the early 1960s. Following their deaths, the P. L. Hay Foundation opened the house to the public and in 1977 gave the house to the Georgia Trust for Historic Preservation, Inc.

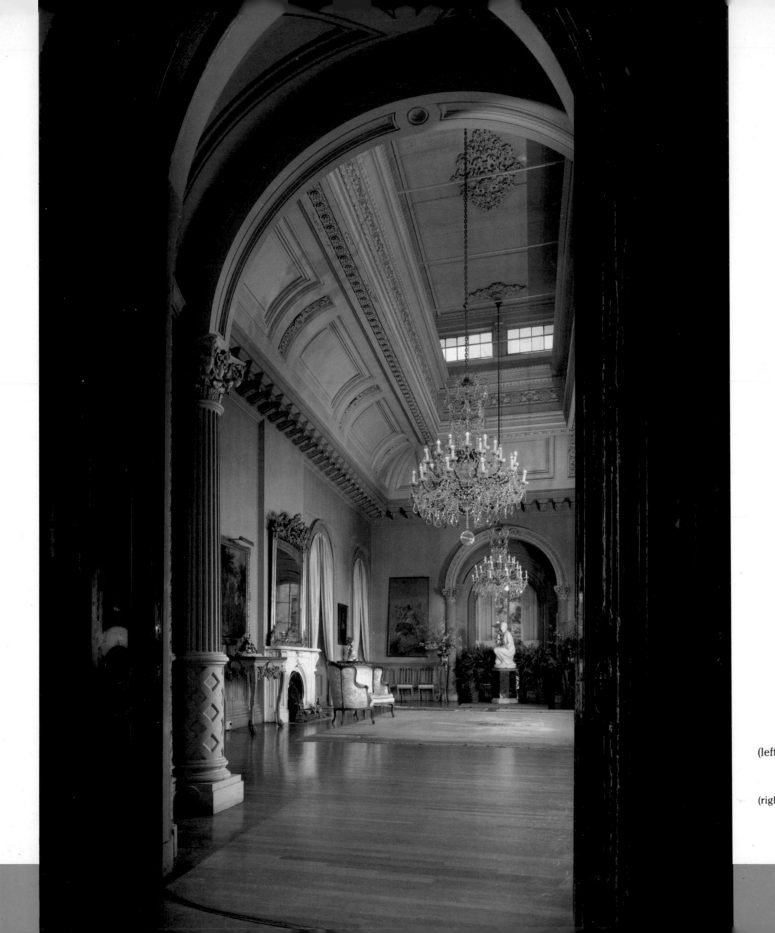

(left) The picture gallery-ballroom of the Hay House

(right) Bellevue at LaGrange

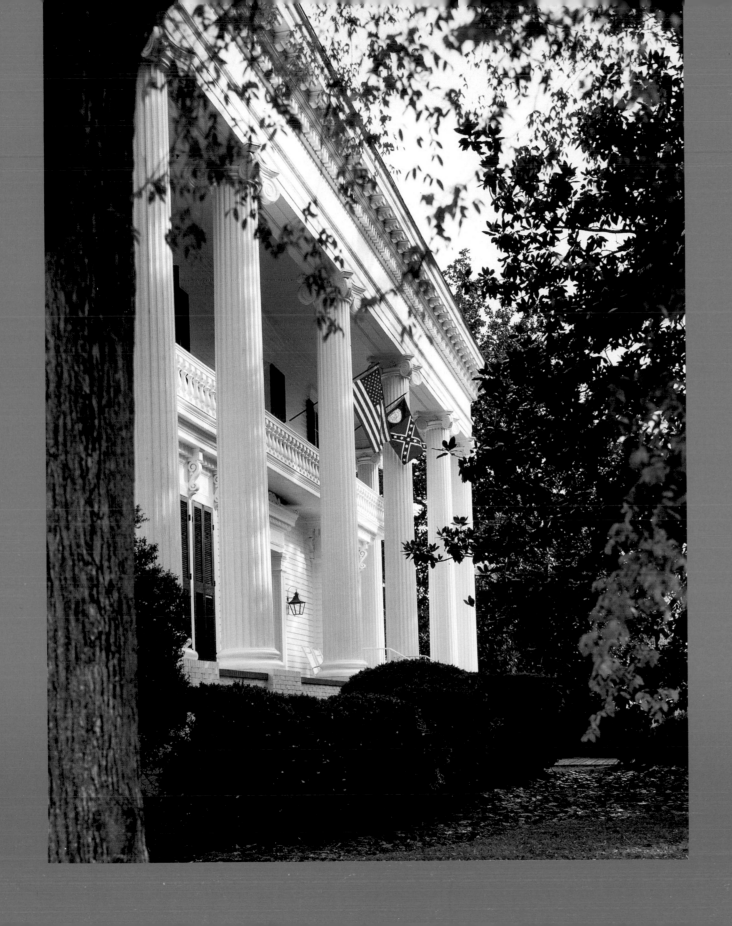

THE
WESTERN
SIDE

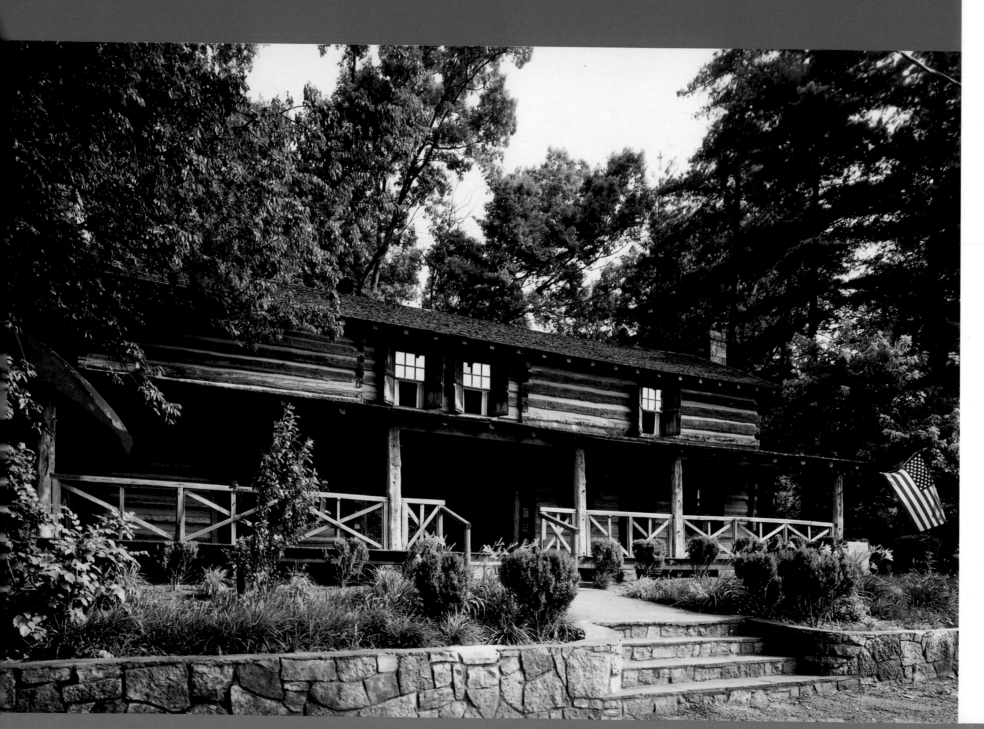

John Ross House, 1797

John Ross served as principal chief of the Cherokee Nation from 1828 to 1866 and led the tribe on the tragic Trail of Tears to the Oklahoma Territory in 1838. Chief Ross's maternal grandfather, John McDonald, built the two-story log cabin alongside the cool waters of Poplar Springs in 1797, in what is now the city of Rossville.

John Ross was seven years old when the house was built, and it served as his first school. His father, Daniel Ross, operated the trading post at Ross's Landing (Chattanooga) and brought in a tutor for his nine children and other Cherokee children in the area.

The house served as Ross's home and headquarters during his young adulthood, and from it he operated a supply depot and warehouse at Ross's Landing and a slave-tended farm of extensive acreage near the Tennessee River.

In 1826, Ross sold the house to the husband of his niece and moved to Rome, Georgia, where he had established a large plantation. On the Trail of Tears, Quatie, his wife, died of pneumonia after, according to legend, she had given her own blanket to a sick child.

During the battle of Chickamauga, the house was headquarters for General Gordon Granger, Union Reserve Corps commander.

The John Ross House was moved from its original location in 1963 when it was faced with demolition because of commercial expansion. Only ten logs, the second story and porch flooring, and the shingles on the roof were replaced. The John L. Hutcheson estate donated the property on which the John Ross House, a National Historic Landmark, now rests. It is administered by the John Ross House Association.

Gordon-Lee House, 1847

During the bloody battle of Chickamauga, which accounted for over thirty-four thousand casualties in a two-day period in September, 1863, the Gordon-Lee mansion was headquarters for the Union army and then its field hospital for the army's right wing, with the library serving as operating room. Crawfish Springs, just across the road from the Gordon-Lee House, was the major water source for the northern forces.

Two days before the famous battle, Union General William S. Rosecrans expropriated the house for his own field headquarters. He is said to have moved the owner's family into a nearby slave cabin and ordered the plantation's supplies of food and livestock confiscated.

The great house was originally built with upper and lower galleries that extended across the front of the house, supported by fluted cypress columns that were replaced by larger masonry columns in a renovation at the turn of the present century.

James Gordon, a Scotsman who moved into the newly opened northwest part of Georgia after the Cherokees were sent to Oklahoma, had prospered in Gwinett County, Georgia, and then acquired 2,500 acres of lottery tracts around Crawfish Springs.

He farmed part of his acreage and opened the Gordon Mill nearby to grind corn and other grains. In 1840, he began construction of the big house, which was not completed until 1847.

Gordon's daughter Elizabeth married his partner, James Lee, and following Gordon's death in 1863, the house became the home of the Lees. Their oldest son, Gordon, was four years old during the battle of Chickamauga. He married Olivia Emily Berry of Newnan, Georgia, on June 27, 1900, and became a United States congressman in 1904, serving until his retirement twenty-two years later.

The Gordon-Lee House remained in the same family until it was purchased in 1974 by Dr. Frank A. Green, a Chattanooga dentist, who undertook a major restoration (financed without federal funds or grants) of the great house, the only structure surviving from the Chickamauga battleground.

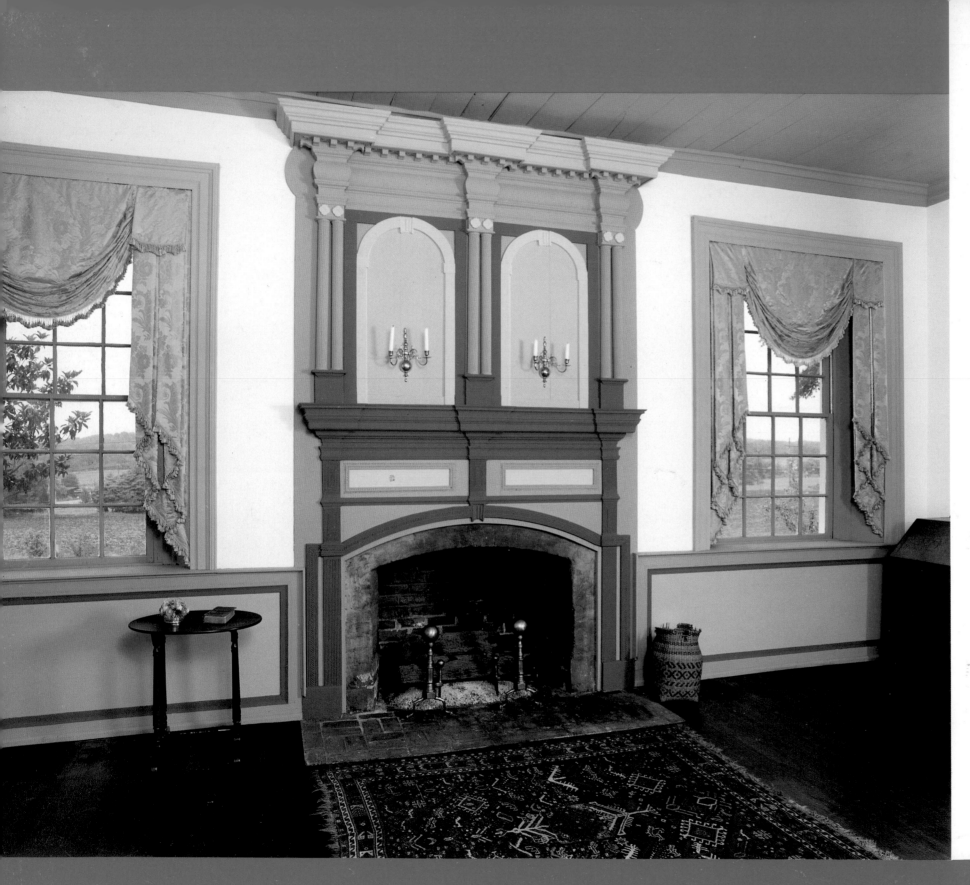

Chief Vann House, 1805

On a hill of red clay in northwest Georgia stands the stately brick home built by a Cherokee Indian chief, James Vann, in 1805. His father, Clement, was a Scottish trader who married a Cherokee woman and founded Spring Place Plantation, on which the Vann House was built.

James Vann was killed by a shot fired from ambush in 1809 and left his house to his son Joseph. The Cherokees, however, ruled that James's wife Peggy be given the house and that the property be divided among Joseph and his other children.

Joseph soon displayed a good head for business. He eventually acquired Spring Place Plantation, as well as property in Tennessee, and was called "Rich Joe Vann" by Cherokee and white alike.

Dispossessed by the Georgia Guards in 1834, Vann and his family moved to Oklahoma, where he raised race horses, built a similar house, traded in slaves, and operated a steamboat line. Racing another steamboat on the Ohio River, he was killed in the explosion of his fastest boat, the *Lucy Walker*, in October, 1844.

The state of Georgia settled with Joseph Vann in the early 1840s, paying him, following considerable litigation, $19,605 for his Georgia property, which included the brick house, 40 cabins, 6 barns, 5 smokehouses, a sawmill, foundry, blacksmith shop, trading post, 1,133 peach trees, 147 apple trees, 800 acres of cultivated land, and a still.

The Vann House passed through the hands of seventeen subsequent owners until Dr. J. E. Bradford, who had bought it in 1920, sold it to the Georgia Historical Commission in 1952. The badly deteriorated mansion underwent a thorough restoration, was repainted in its original color scheme, and was dedicated in 1958. It is administered by the Parks, Recreation, and Historic Sites Division of the Georgia Department of Natural Resources.

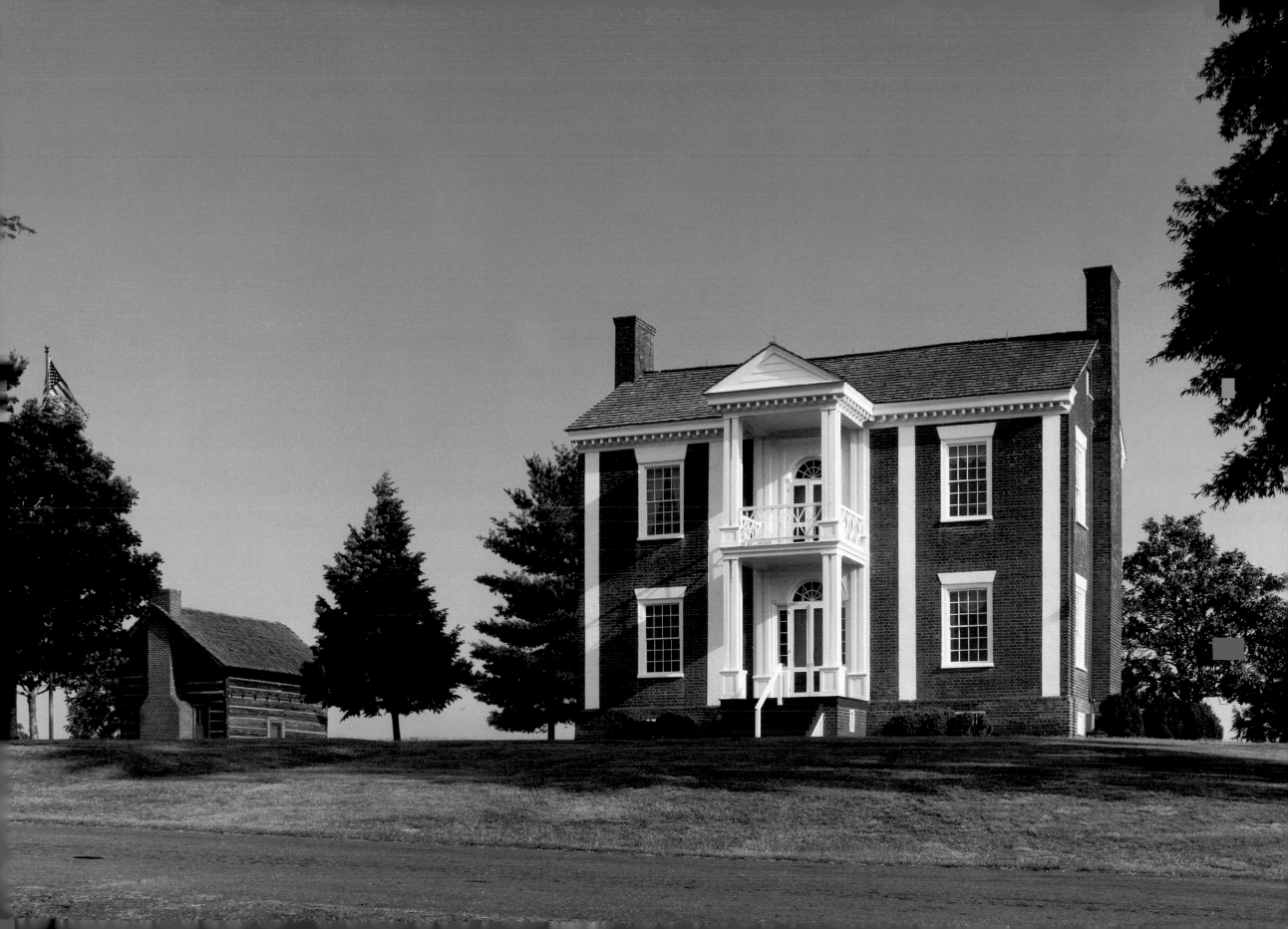

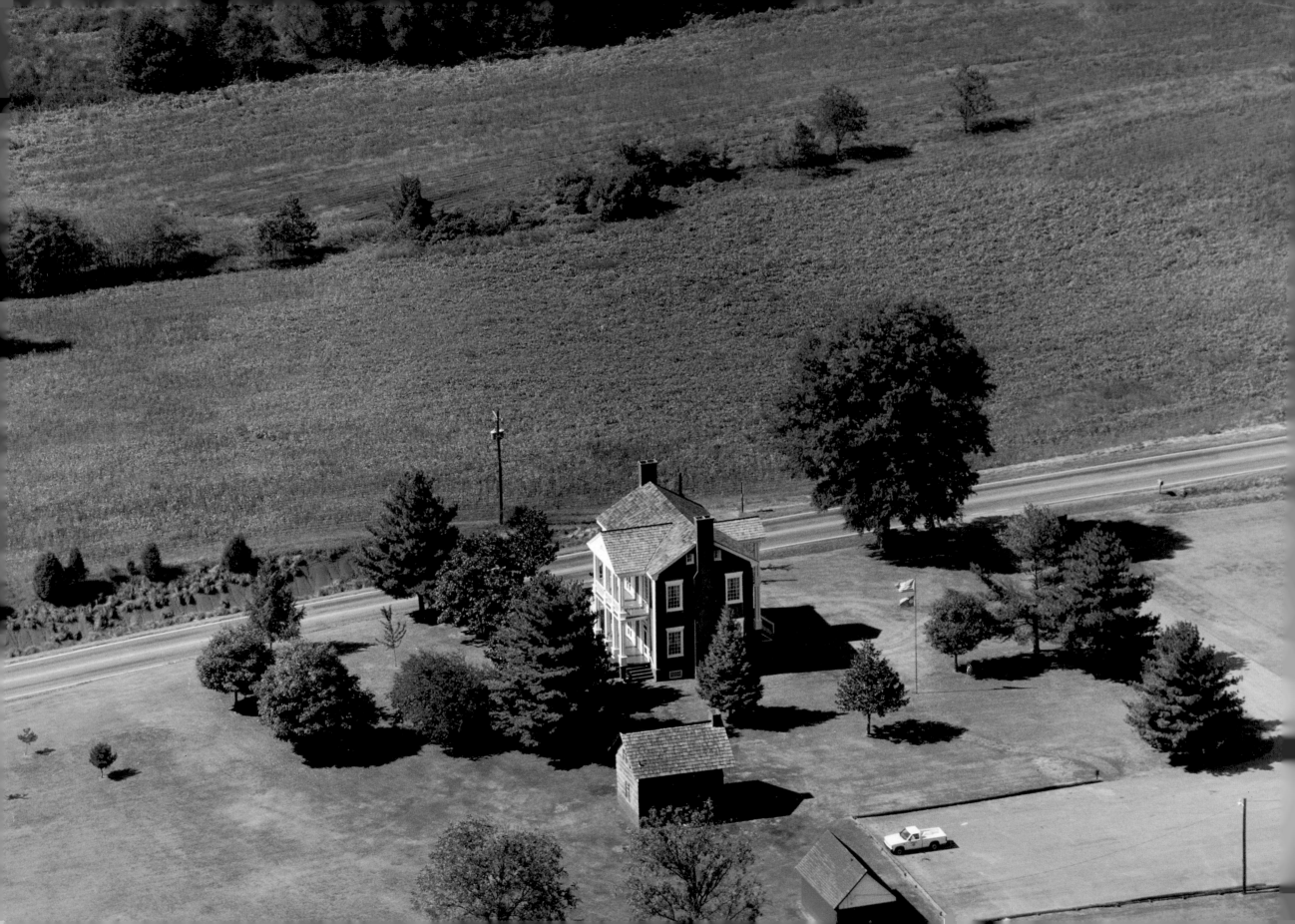

(left) Aerial view of Chief Vann House

Carter's Quarters, early 1800s

Chief John Martin, a wealthy "mixed blood" and treasurer of the Cherokee Nation, owned 80 slaves on his Coosawattee Plantation when Colonel Farish Carter first saw the 15,000-acre property in the valley of the Coosawattee River. Later, when the Cherokees were forced to move to Oklahoma, John Martin became chief justice of the Supreme Court of Indian Terrritory, and Farish Carter acquired Coosawattee Plantation, reassembling the original 15,000-acre complex by spending $40,000 to buy 160-acre lottery plots from their new owners.

Colonel Carter's home plantation was located in Baldwin County, near Milledgeville, Georgia. In 1817, he owned 557 acres and 50 slaves. His property expanded in the next thirty years to include over 30,000 acres and more than 400 slaves on plantations in Baldwin and Murray counties in Georgia and in Macon County in Alabama. For a time, Carter owned a sugar plantation in Louisiana as well.

The original house at Carter's Quarters, built in the early 1800s, now forms the southern third of the mansion, added to over the years by Carter's descendants. The two-story center section was added in the 1930s, and the wing on the northern end of the house, which echoes the original building, was added still later.

Oak Hill, 1847

Captain Thomas Berry, descendant of a line of plantation owners in Virginia, was one of the early settlers of Rome, Georgia. He married Frances Rhea from Alabama and brought her as a bride to his mansion near Rome. There, they raised eleven children, including three adoptees whose parents died in a yellow fever epidemic.

Martha Berry, one of six daughters, inherited the house and a tract of eighty-three acres, which became the nucleus for the campus of Berry College, established by Miss Berry in 1902. It is now surrounded by its own twenty-eight thousand acres of forest, farmlands, and field.

For her lifetime of dedication to the young people of Berry College, Miss Berry was honored by United States presidents from Theodore Roosevelt to Franklin Delano Roosevelt and by major colleges and universities, from which she received eight honorary degrees. She died in 1942.

Oak Hill, Miss Berry's residence for more than seventy years, is maintained in her memory by Berry College substantially as it was in her lifetime.

Thornwood, 1848

On a hill near the Coosa River in present-day Rome, Georgia, Alfred Shorter built Thornwood in 1848, using not a nail in the construction but wood pegs and wedges.

Shorter, one of the first settlers in the Rome area, came to Georgia with only a satchel and a pet parrot when he was sixteen. He found employment at Baldwin's Store in Monticello, Georgia, and he eventually became a partner in the business.

In 1837, he moved to Rome, retaining ownership in a plantation in south Georgia, and by 1847 was known as Rome's leading financier and businessman. Thornwood was twice occupied by Union troops during the Civil War, and the marble mantels were destroyed, virtually "stomped into dust," according to one report.

Following the war, Shorter's heirs, three generations of the Hamilton family, lived at Thornwood until it was sold in 1944 to Mr. and Mrs. William DuPre.

Thornwood is now the elementary school campus of Darlington School.

Chieftains, 1794

Cherokee Indian leader Major Ridge, who received his
commission from Andrew Jackson, built a log cabin on
the banks of the Oostanaula River, where he operated
a trading post and ferry, and made the regularly
enlarged house the headquarters for his plantation.
His children were educated in schools operated by
Moravian missionaries, and his son, John, attended a
mission college in Cornwall, Connecticut. The house
was later expanded to a fifty-two by twenty-eight foot,
two-story frame structure.

By the 1830s, the Cherokees were under intense
pressure to move west, and Major Ridge and his son
John were signers of the Treaty of New Echota, which
exchanged the Indians' north Georgia land for acreage
in Oklahoma and led to the tragedy of the Trail of
Tears. Survivors of that march later executed Major
and John Ridge for their participation in negotiating
that treaty.

A succession of owners followed. In 1969, the
Celanese Corporation, which operated a nearby textile
mill, gave the property to the Junior Service League,
which converted Chieftains into a house museum. In
1971 Chieftains was placed on the National Register of
Historic Places. It was named a National Historic Land-
mark in 1974.

Home-on-the-Hill, 1832

Also known as Alhambra, Darlington School's Home-on-the-Hill is older than the city of Rome, Georgia. It is the oldest home in Floyd County.

Major Phillip Walker Hemphill bought land in the Cherokee Indian Nation in 1832, floated logs down the Coosa River, and built his home on the crest of a hill overlooking the present campus of Darlington School.

Home-on-the-Hill passed through the hands of a number of owners in the ensuing years, including William T. Price; Samuel G. Mobley, who in the 1870s renamed it Mobley Park; Benjamin C. Yancey and the Rome Land Company; and the City Electric Railway, which operated the estate as a recreation area. In 1921, Mr. and Mrs. John Paul Cooper deeded the property to the greater Darlington School, and Home-on-the-Hill became the president's mansion.

Dr. Ernest L. Wright, school president in 1955, led a movement to restore the house, which was in poor condition after the succession of owners. The renovation took twelve months, with architect James Godwin of Atlanta taking particular care to preserve as much of the original work of the house as possible, including its spiral staircase and carved mantels in the living room and the dining room.

Arcadia, 1850s

A house unique in design to the hills of Rome, Georgia, is Arcadia, built before the Civil War by Colonel Daniel S. Printup. It was sold in 1860 to Samuel Gibbons from Luray, Virginia.

Originally, a front staircase rose to the main (second) floor, where the doorway to the center hall is off-center. Each of the three rooms that front the veranda has floor-length windows that rise into the walls above, allowing good ventilation and easy access to the porch.

Printup, born in 1823, left his home in New York state when he was fourteen and came to Georgia when he was sixteen, working as a clerk. He saved enough money in two years to enter an academy in Cedartown, near Rome, where within nine months, its principal recommended him for college. Accepted at Advance Union College in Schenectady, New York, he graduated Phi Beta Kappa and returned to Rome, where he entered the profession of law in 1847. When the Civil War began, he joined the 55th Georgia Regiment, rising to the rank of colonel.

Samuel Gibbons took his family and slaves to South Carolina after Sherman's troops occupied Rome in May, 1864. The house survived with only minor damage.

Gibbons owned the house for a decade, selling it to Captain James W. Elliott, whose daughter, Virginia Tennessee (named after states in which her parents had lived before coming to Georgia) later married Captain John C. Printup, son of the builder.

Later converted into apartments, Arcadia was acquired by Rome businessman James Birdsong in the early 1980s. He gave it a long-needed restoration and made it the headquarters for his insurance company.

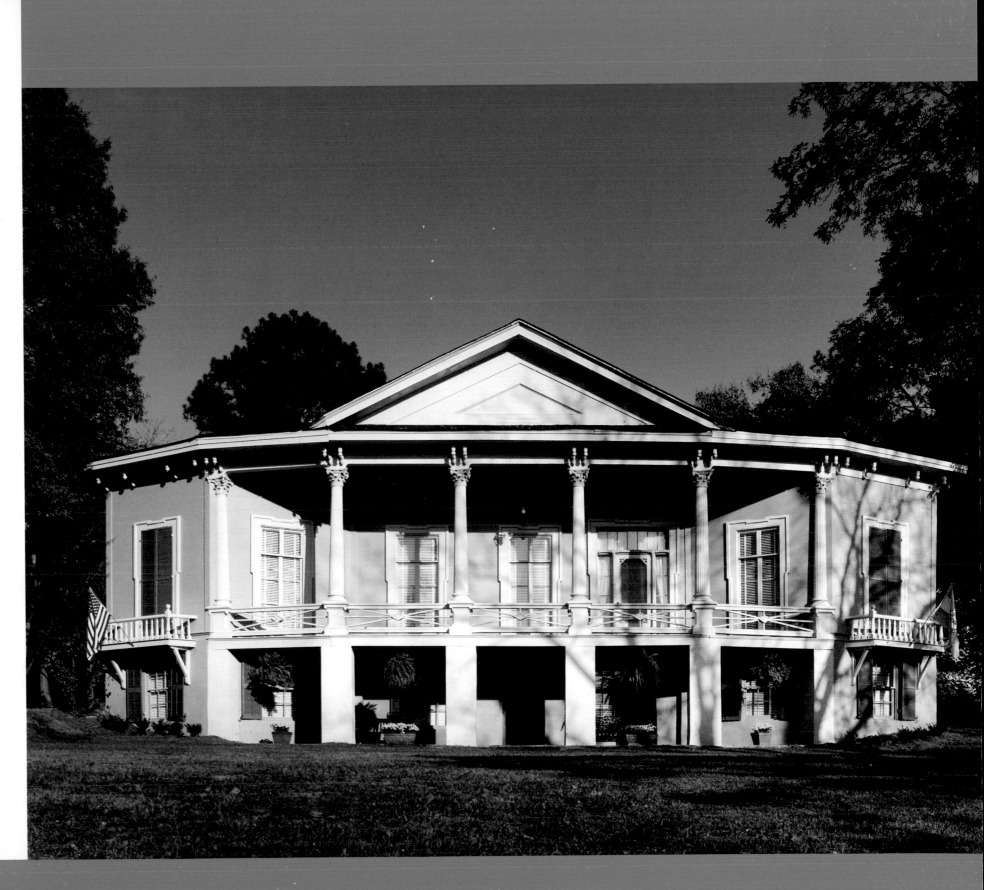

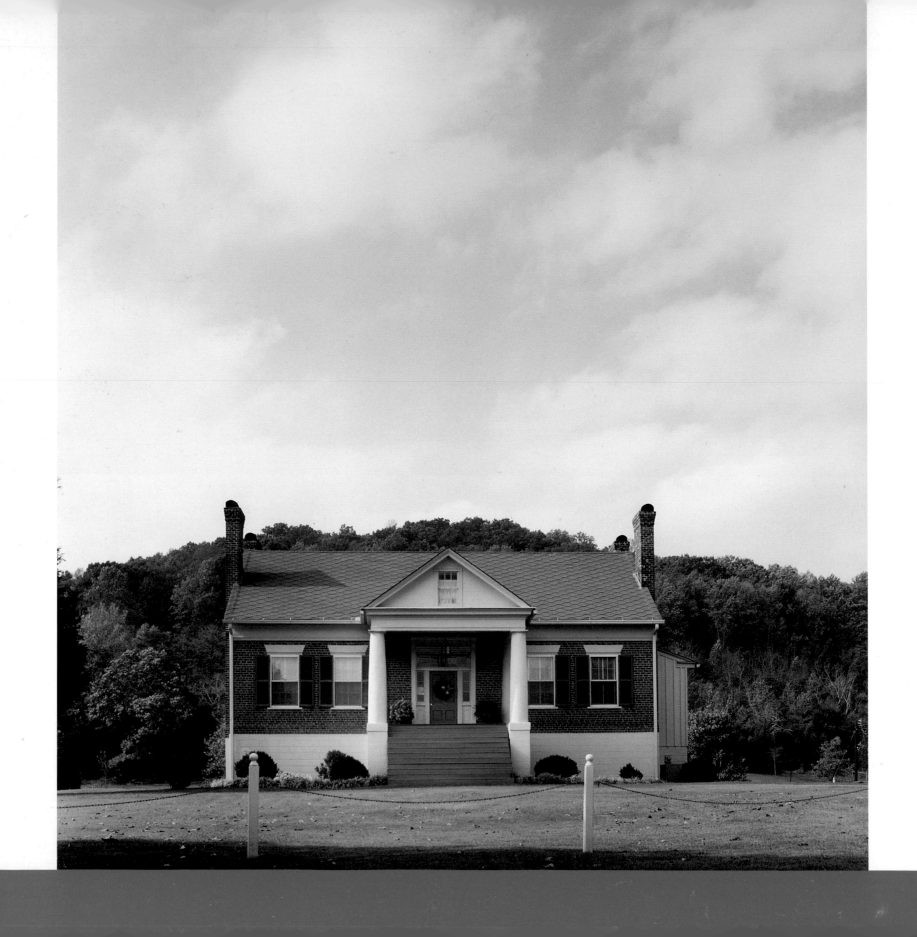

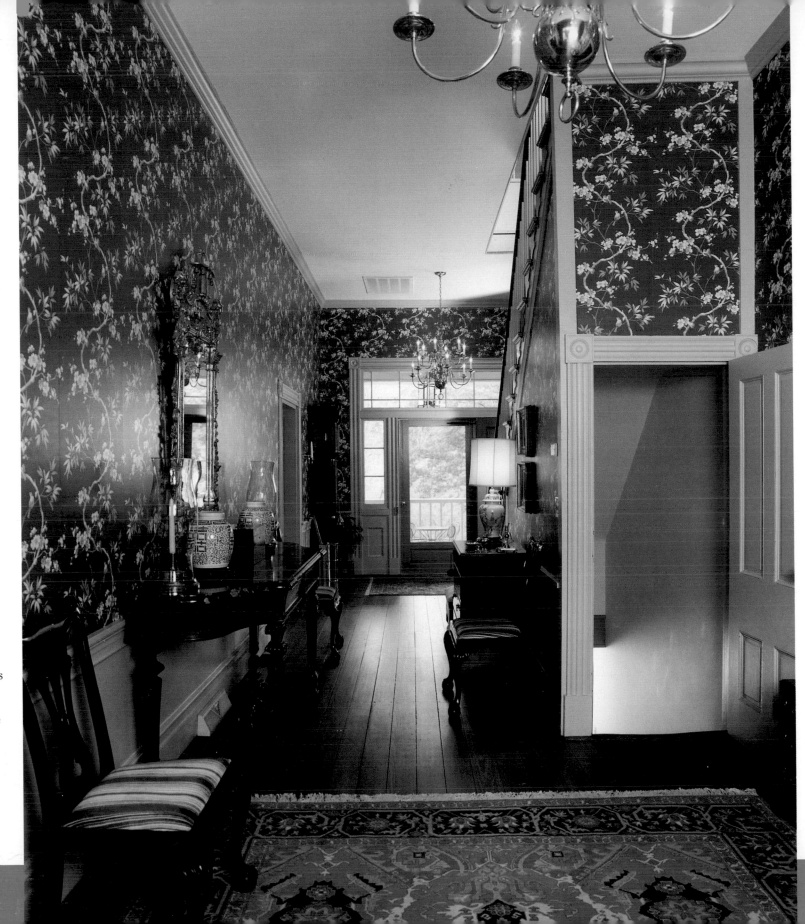

Colonial Heights, late 1850s

Originally the centerpiece of a fifteen-hundred-acre
plantation at the entrance to Van's Valley on Booze
Mountain Road south of Rome, Georgia, Colonial
Heights was built by Joseph Ford in the late 1850s.
His raised-basement house has twelve-foot ceilings on
the main (second) floor and brick walls fourteen inches
thick.

In 1872, Joseph Ford died in a train wreck on the
Rome, Selma, and Dalton Railroad. He is buried in the
plantation's own cemetery.

In 1873, the Gibbons family acquired the property,
and it remained in the hands of the same family until
it was purchased in 1978 by James and Cherrye
Birdsong. They gave the house an extensive restora-
tion and now make it their residence.

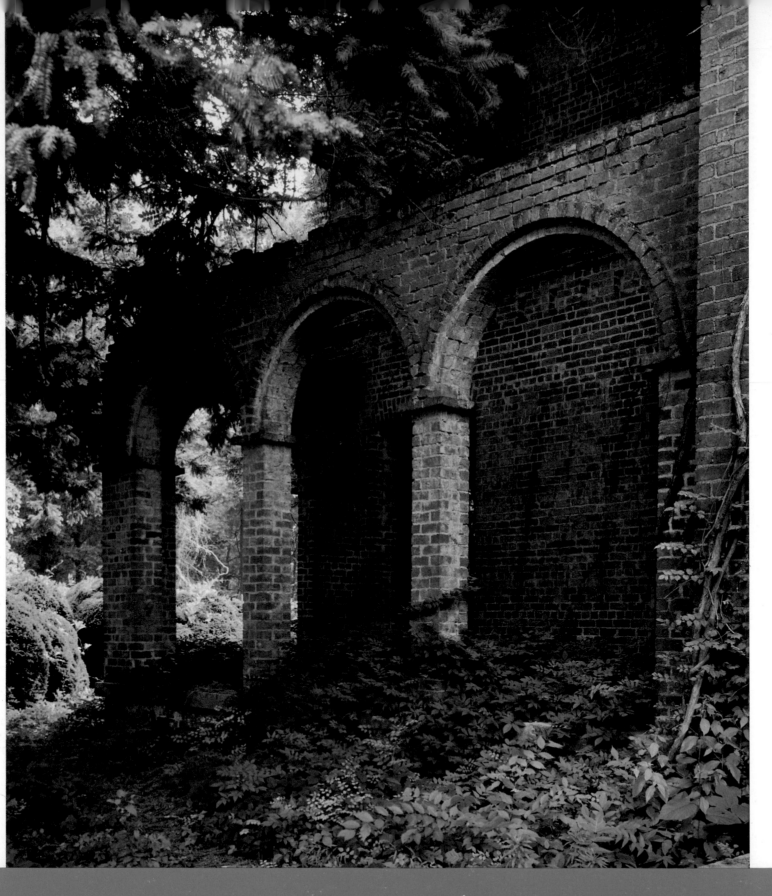

Barnsley Gardens, 1861

Still under construction at the advent of the Civil War, Barnsley Gardens was never completed, although the builder, Godfrey Barnsley, did live in the partially finished house until the end of the war, when he moved to New Orleans to attempt to recoup his fortune.

Godfrey Barnsley arrived in Savannah from Derbyshire, England, when he was eighteen. He built a virtual empire in the cotton exporting business, with his own fleet of ships operating between his warehouses in Liverpool, England, and New Orleans, Mobile, and Savannah. In 1828, he married Julia Scarbrough, daughter of the great Savannah cotton factor William Scarbrough.

In the 1830s, Barnsley assembled an estate of ten thousand acres in Bartow County, near Kingston, and began planning the house and gardens (to be staffed by English indentured servants, not slaves) for use as a summer retreat from the heat and yellow fever of the coastal areas. The first of three associated buildings was begun in 1844, but Julia Barnsley died in 1845, and the great twenty-seven-room Italianate house was incomplete when the war began. The staircase was intercepted by Federal forces in Nashville, and the Italian statuary for the gardens was never uncrated.

Barnsley descendants continued to occupy the property until 1942, when the remaining two thousand acres were purchased by Mr. and Mrs. G. C. Phillips of Birmingham, Alabama. Barnsley Gardens is now owned by the W. Earl McCleskey family.

Valley View, mid-1840s

Overlooking the Etowah River west of Cartersville is Valley View, built by slaves, occupied by Sherman's troops, and owned by descendants of the same family that built it.

Colonel James Sproull of Abbeville County, South Carolina, came to the banks of the Etowah in the mid-1840s, building his house using slave labor and a few skilled carpenters, with materials native to north Georgia: heart pine, bricks baked from native clay, and mortar from nearby limestone quarries.

When Mrs. Sproull came to Valley View from South Carolina, she brought the boxwood plants that still form the garden in the front of the house. Also coming from South Carolina was a German cabinetmaker, who made furniture for the house. Over a dozen of those original native walnut pieces remain.

During the Civil War, Union General James Scofield, one of Sherman's three division commanders, made his headquarters at Valley View for three months. The front parlor was turned into a stable (to protect Union horses from Rebel sharpshooters); the piano was used as a watering trough. The piano, now a desk, still stands in the same room.

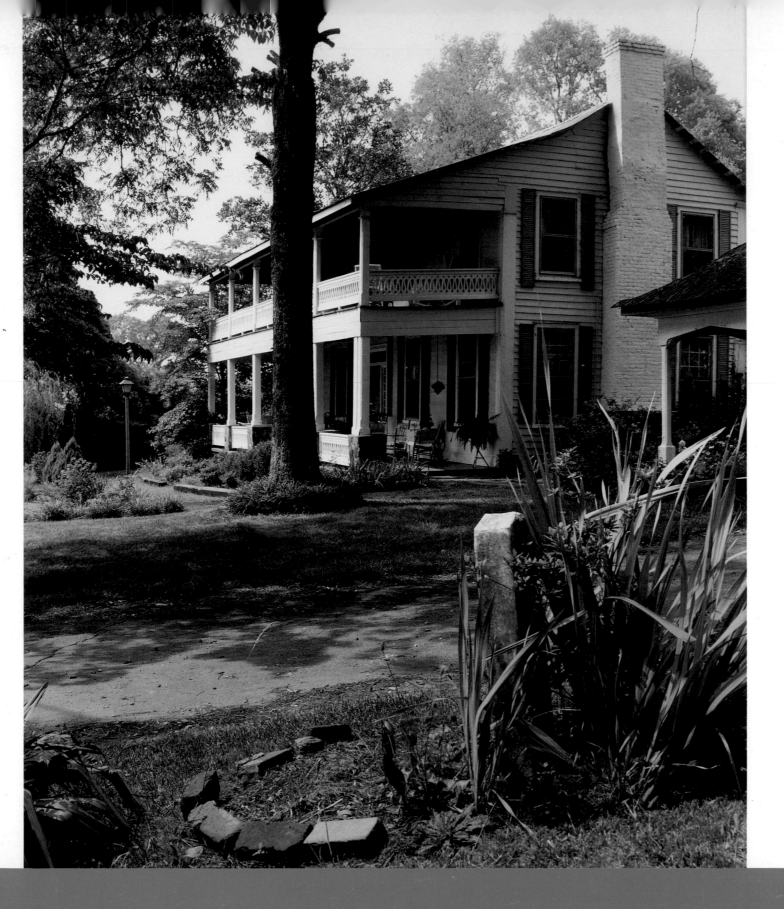

John Clayton House, *ca.* 1860

Built before the Civil War, the John Clayton House
was the scene of a spirited engagement fought during
the battle of Allatoona, October 1, 1864, when 1,505
casualties were reported out of 5,413 troops involved.
The house was occupied during the battle by the
builder and his family, and still has minié ball holes
in the upper right bedroom walls.

 The house was used as a field hospital during and
immediately after the battle. In the front yard is a
marker dedicated to the memory of twenty-one
unknown Confederate soldiers killed in the neighbor-
hood of the John Clayton House.

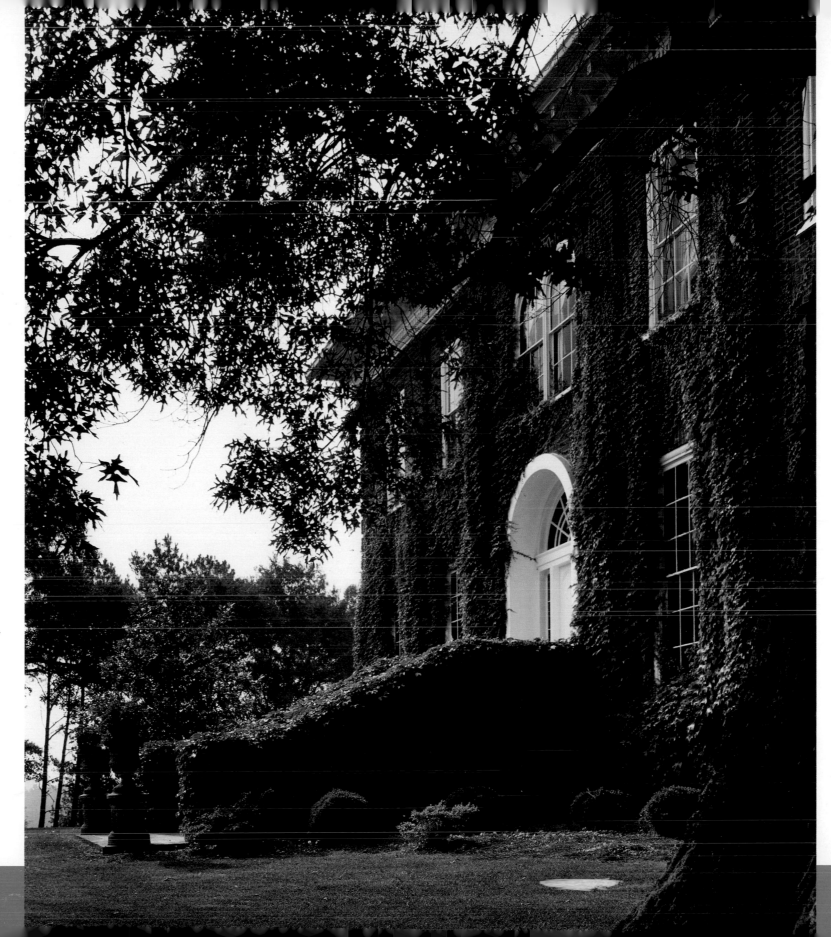

Ryals-Davis House, 1854

In 1854, the Reverend James Gazaway Ryals built a stately mansion overlooking his six-hundred-acre plantation near Cartersville. The house is distinguished by its original walnut staircase carved from trees found on the property. The blinds are also original.

The Reverend Ryals, in addition to managing his plantation, found time to serve as minister for three Baptist churches and fill in as a teacher at Stilesboro Academy, built in Bartow County in 1859.

By 1953, the then-unoccupied house was nearly in ruins when it was purchased by Judge and Mrs. J. L. Davis, who lovingly restored the house and grounds and furnished it to reflect the period in which it was built.

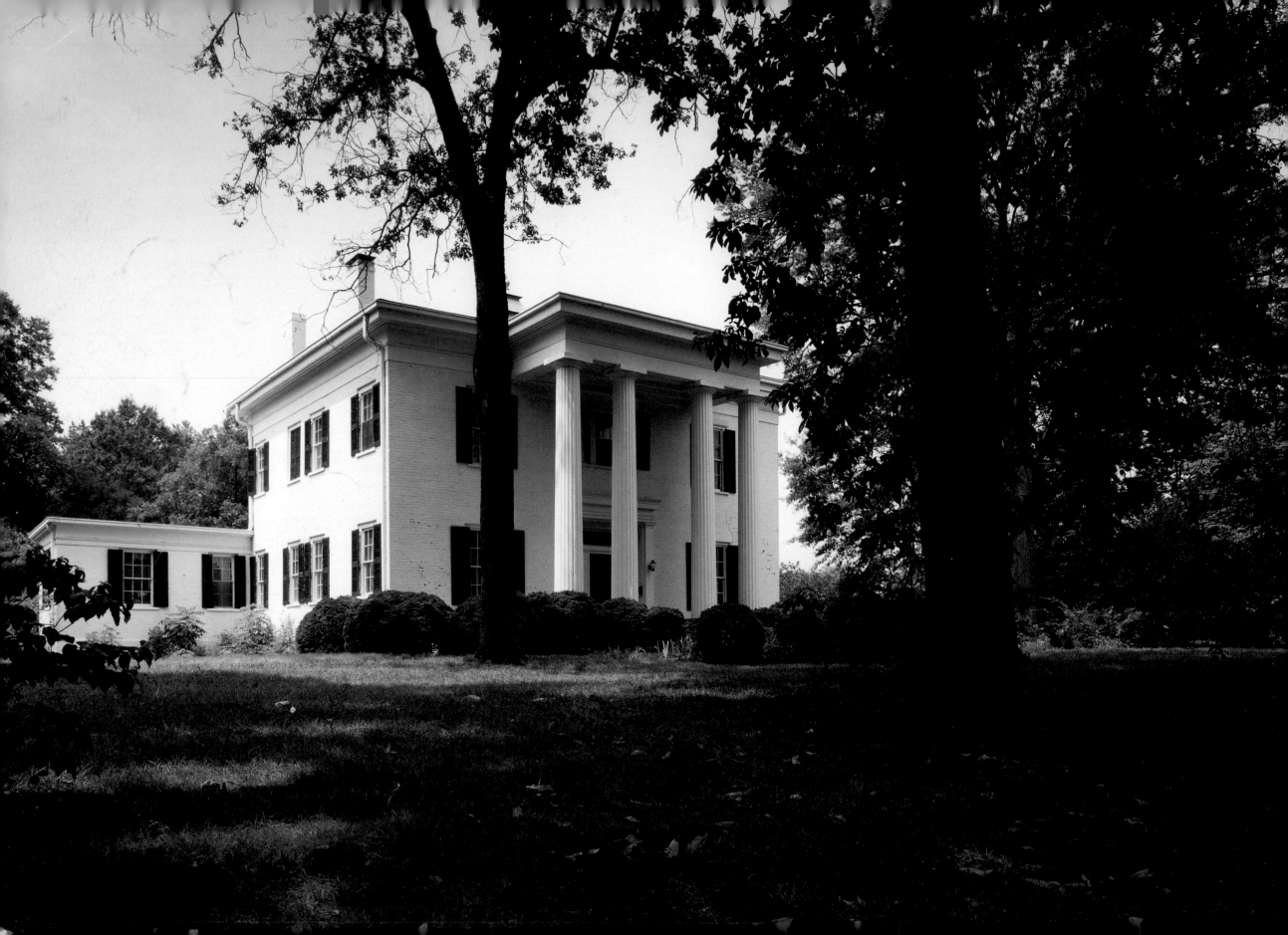

Tranquilla, 1849 (left)

Facing Kennesaw Avenue in Marietta is Tranquilla,
built in 1849 by General Andrew J. Hansell. Before
the Civil War, General Hansell was a state representa-
tive and state senator from Cobb County. During the
war, he was Georgia's adjutant-general.

Federal troops occupied the house during the cam-
paign for Atlanta, but Mrs. Hansell, her two children,
and their nurse refused to leave, probably saving the
house from further damage.

Later, after the Yankee troops had left, Mrs. Hansell
defended her house from a band of drifters with only
a small derringer, threatening to shoot the first man
who advanced. Apparently they sought easier pick-
ings, for Mrs. Hansell, her family, and her house sur-
vived intact.

In 1871, George H. Camp, president of Roswell Man-
ufacturing Company (burned by Sherman's troops in
1864) bought and restored Tranquilla. Its present own-
ers, the Keeler family, are direct descendants.

Archibald Howell House, *ca.* 1848

Near downtown Marietta, Major Archibald Howell built
an imposing Greek Revival town house in the late
1840s. The house later served as the headquarters for
Union General H. M. Judah during the summer of
1865.

The four massive Doric columns are over eleven
feet in circumference at the base, and the porch is sur-
faced with granite slabs cut from Stone Mountain.
Walls are twenty-eight inches thick. The original
design included a widow's walk atop the house, where
sentries paced during the Union occupation.

General Judah is well remembered in Marietta for
his orders to issue corn and bacon to the hungry peo-
ple of the town, tiding them over until they could
make a crop at the end of hostilities. In 1887, Major
Howell sold the house to a group who established a
school for girls in the mansion, Harwood Seminary.

The widow's walk was removed and the roof line
itself was changed in the 1890s by owner Moultrie M.
Sessions, who also added the carriage portico on the
north side.

Also called the Howell-Sessions-Touchton House, the
property was purchased in 1972 by the Al Hallman
family, who have made it their home since then.

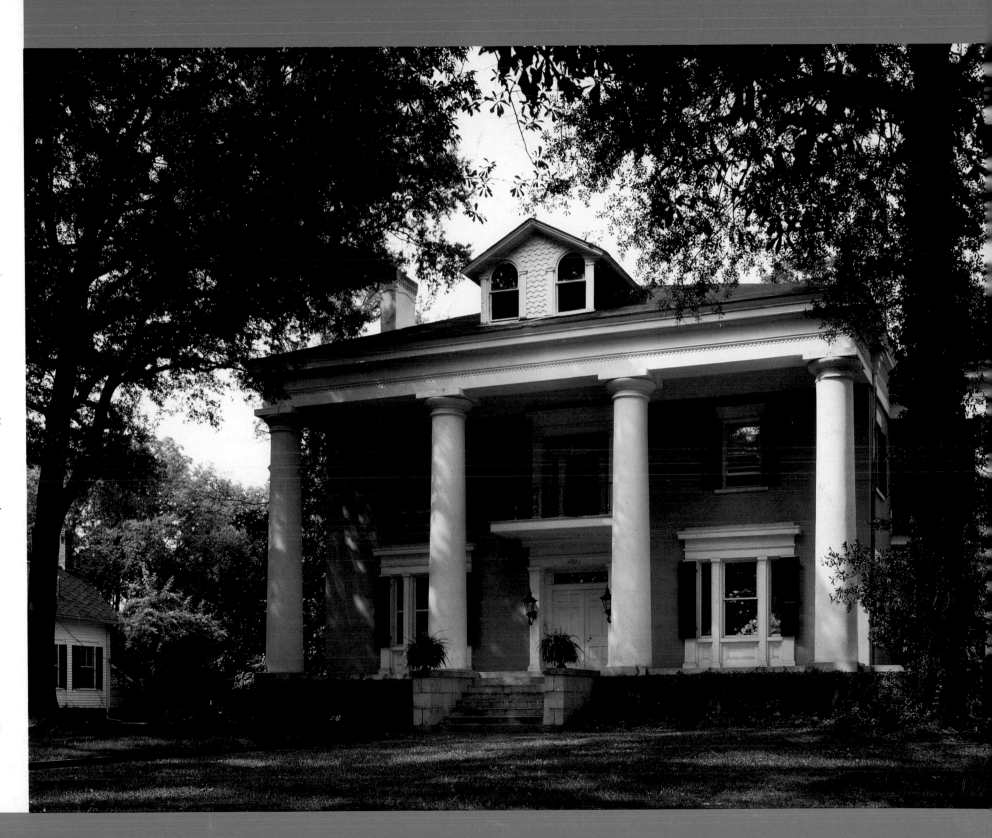

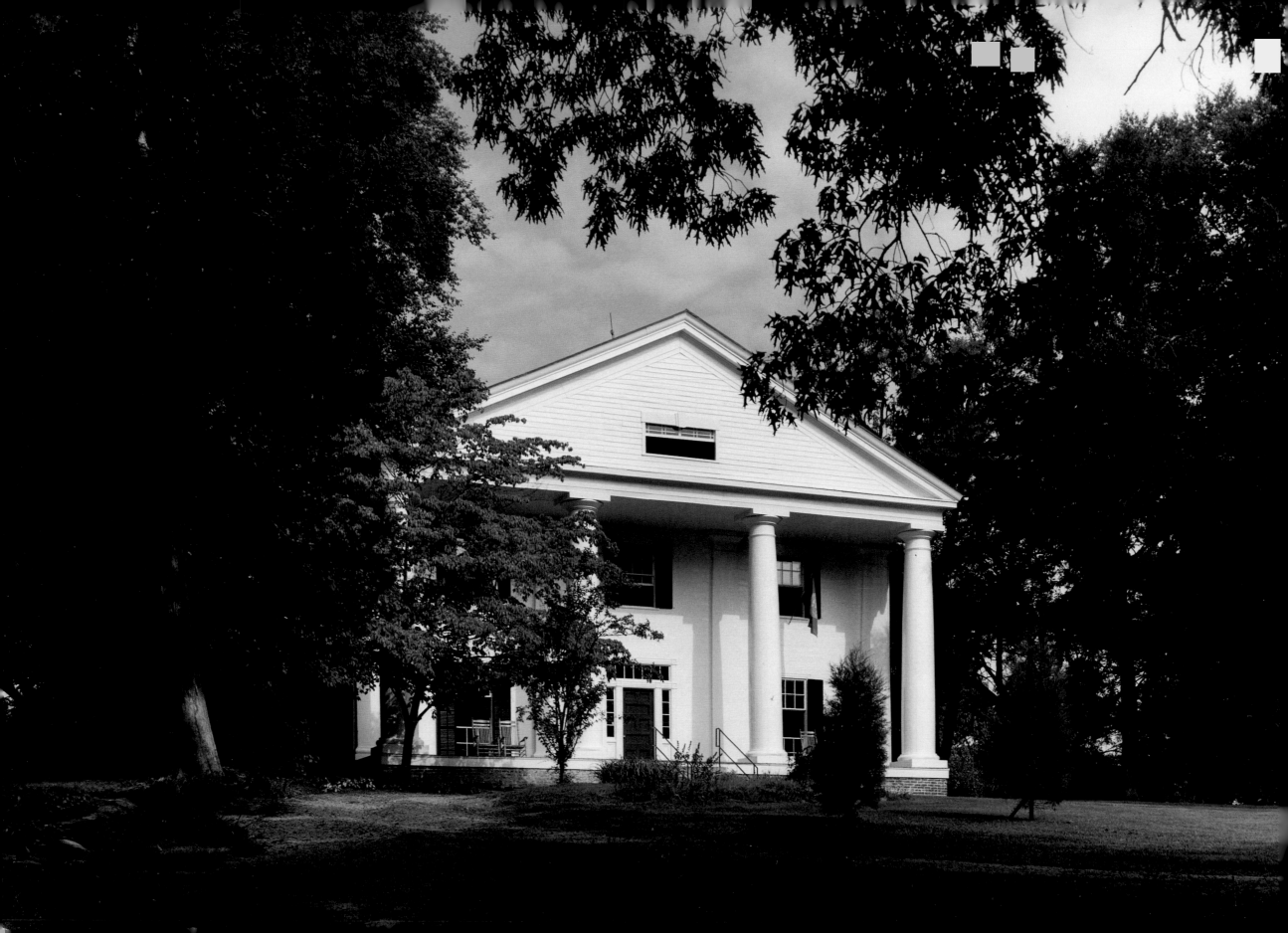

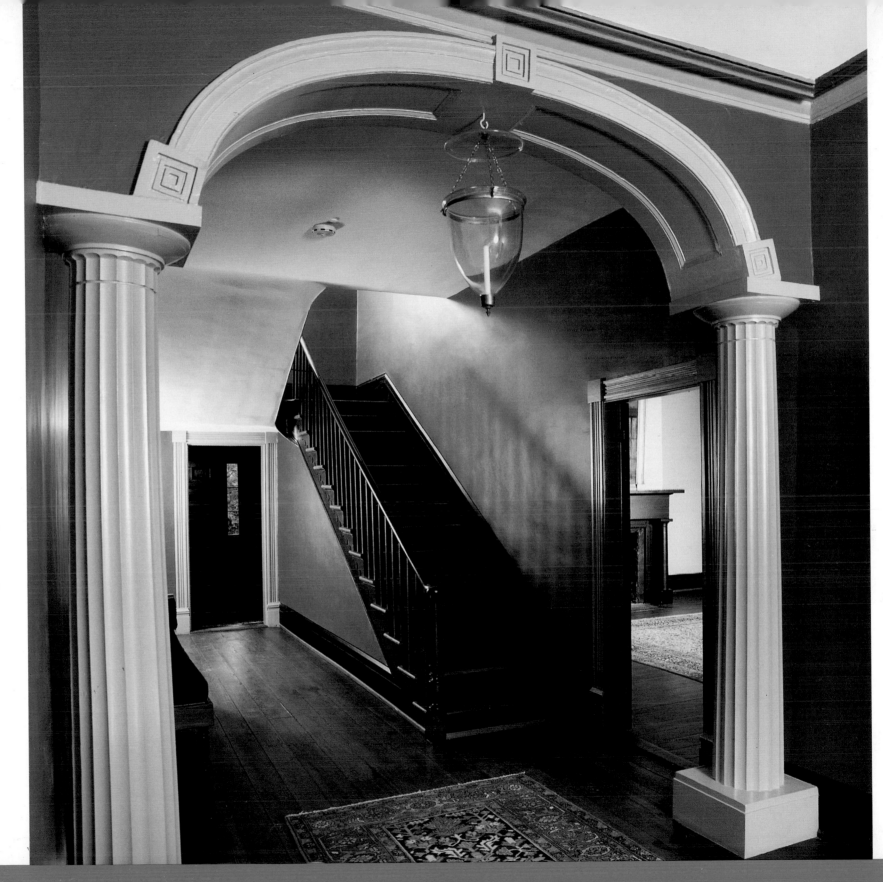

Bulloch Hall, 1840

Major James Stephen Bulloch, grandson of Archibald Bulloch, who was governor of Georgia during the Revolution, was a grandfather of President Theodore Roosevelt.

One of the founders of Roswell, he built Bulloch Hall in 1840 but died before the wedding of his daughter Martha (Mittie) to Theodore Roosevelt, Sr. On her wedding day, December 22, 1853, Mittie descended the stairs at the rear of the center hall and married Roosevelt in front of the fireplace in the dining room.

Their son Theodore Roosevelt, Jr., became the twenty-sixth president of the United States. Another son, Elliott, was the father of Eleanor Roosevelt, wife of Franklin Delano Roosevelt.

Owned by the city of Roswell, Bulloch Hall is considered an adaptive use preservation project, now operated as a cultural center. Not only has the great Tuscan-columned house been restored, but the immediate grounds have been returned as accurately as possible to their naturalistic mid-nineteenth-century English garden appearance.

Great Oaks, *ca.* 1842

Another of Roswell's founders was the Reverend Nathaniel Pratt, minister of the Roswell Presbyterian Church. His home was Great Oaks, the manor house of a plantation that produced sorghum, corn, and wheat.

The first brick residence in Roswell, Great Oaks features an unusual divided "good morning" staircase, which has four separate flights of stairs leading from a common landing located between the first and second floors. Two flights ascend, east and west, to the upstairs bedrooms. One flight descends east from the landing to the center hall, while another goes north from the landing downstairs to the kitchen. The arrangement affords privacy to a family member who might wish to go from the upstairs to the kitchen without facing possible guests in the parlor.

During the Union occupation of Roswell, Great Oaks was the headquarters for Garrard's cavalry, which captured the textile center, burned the cotton and woolen mills, and on orders from General Sherman, packed the white textile workers, male and female, women with children, off to the mills of the North.

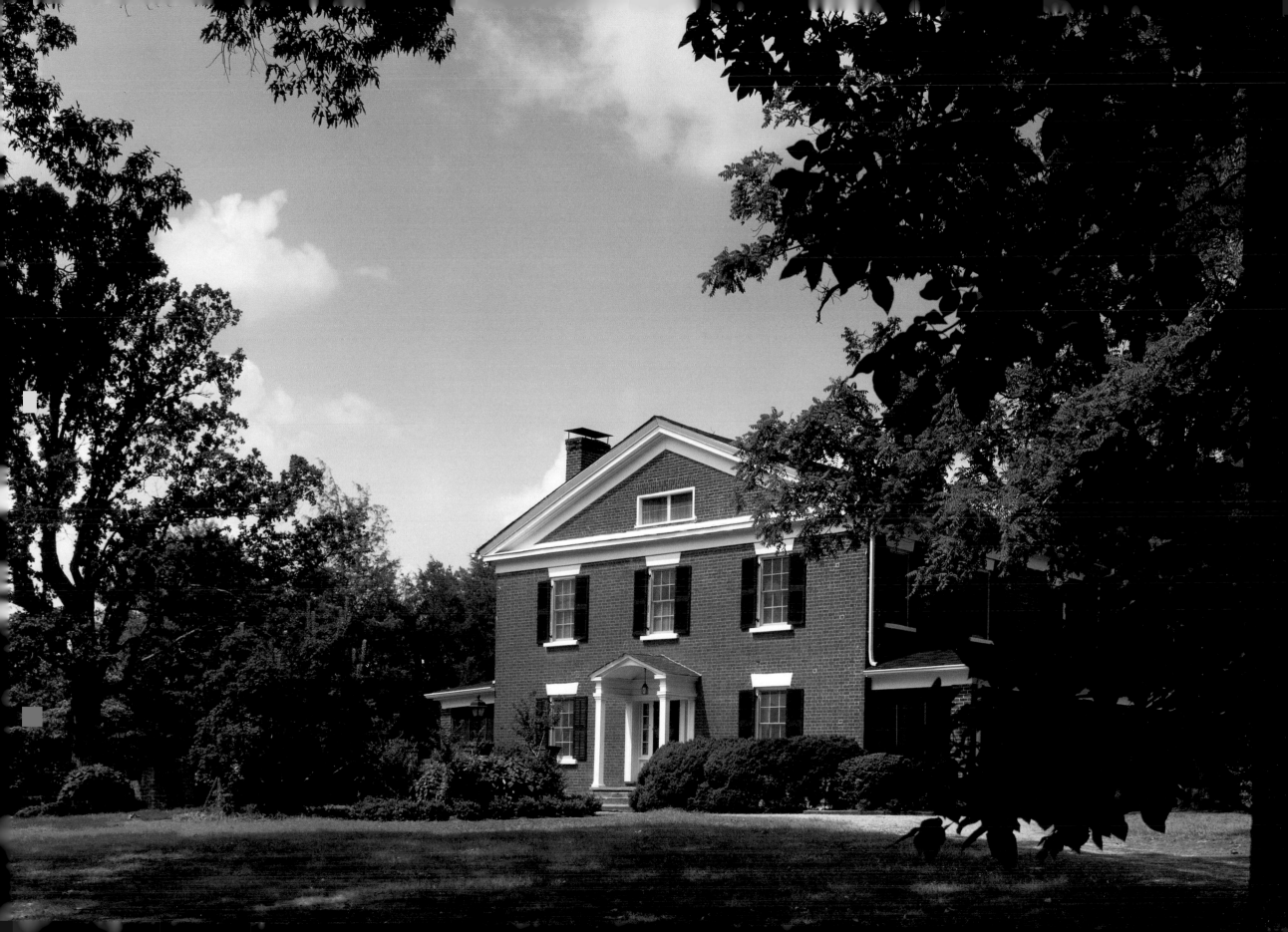

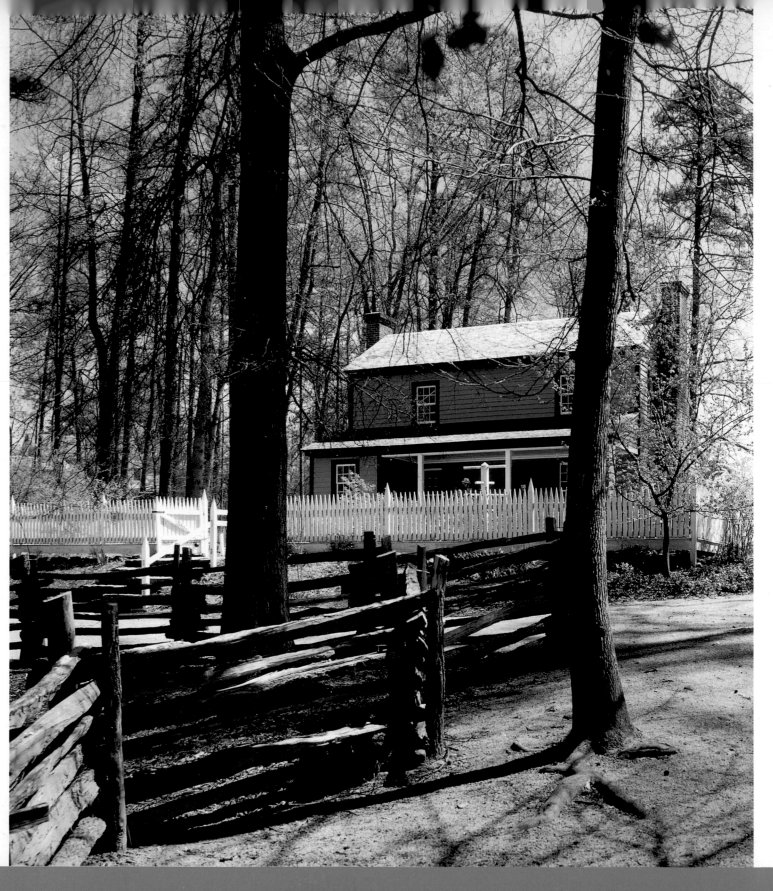

Tullie Smith House, 1830s

Once the center of an eight-hundred-acre farm outside of Atlanta, the Tullie Smith House was moved from its original location in nearby DeKalb County on Druid Hills Road to the grounds of the Atlanta Historical Society in the Buckhead area of Atlanta.

The house was remodeled in the 1840s, when a parson's room (traveler's room) was added. The colors it received at that time have been faithfully recreated.

The Georgia colony was originally conceived as populated by yeoman farmers, and the Tullie Smith House echoes that heritage. The furnishings are functional, reflecting the life of a Georgia Piedmont farmer's family of the 1840s.

The outbuildings, collected from Sparta to Kingston, include a log barn from the 1850s, a corncrib, a smokehouse, and an authentic working smithy, creating a faithful impression of farm life in antebellum Georgia.

Lovejoy, 1836

Said to be the inspiration for Ashley Wilkes's Twelve Oaks in *Gone With the Wind*, Lovejoy Plantation is located in Clayton County, near Jonesboro, site of one of the decisive battles in the Atlanta campaign and the home county of Margaret Mitchell's maternal grandparents.

Lovejoy Plantation, now home of Betty Talmadge, was built by Thomas Crawford in 1836. The original building was probably of the Plantation Plain style, a two-story gabled farmhouse. As his prosperity grew, Crawford added, in 1852, a twelve-foot extension and columned portico to the front. By 1860, Crawford owned about one thousand acres of cotton land and forty-six slaves.

During the campaign for Atlanta, much fighting took place on or near the plantation. Local legend has it that Crawford filled the tall columns on his porch with grain to secure it from the Federal troops. When Mrs. Talmadge was restoring the house in 1946, she discovered mute evidence of nearby fighting: minié balls still lodged in some of the walls.

The basic structure of the antebellum home, with its hand-hewn framing timbers and heart-pine floors, walls, and ceilings, has been left largely unchanged.

Gordon-Banks House, 1820s

In the 1820s, cotton planter John W. Gordon retained the services of architect Daniel Pratt to build his manor house in Jones County near Haddock, west of Milledgeville, then the capital city of Georgia. Pratt was well known for his design of several houses in the Milledgeville area, and he had established the style of architecture now referred to as Milledgeville Federal.

The finely detailed house escaped damage during the Civil War. It was unoccupied except on the weekends for many years. It was finally purchased by William Banks of Newnan, Georgia, who in 1969 moved the entire house to Newnan, placing it in his existing "English Park" of three hundred acres designed in 1929 by Atlanta architect William C. Pauley.

The house survived the one-hundred-mile journey with little damage. It was given a careful restoration along with the addition of matching one-story wings, designed by Robert L. Raley in 1970, on either side.

Near the house is a Carrara marble fountain that originally rested on the grounds of Barnsley Gardens, near Kingston, Georgia. Damaged by Union troops, the fountain was also restored by Mr. Banks.

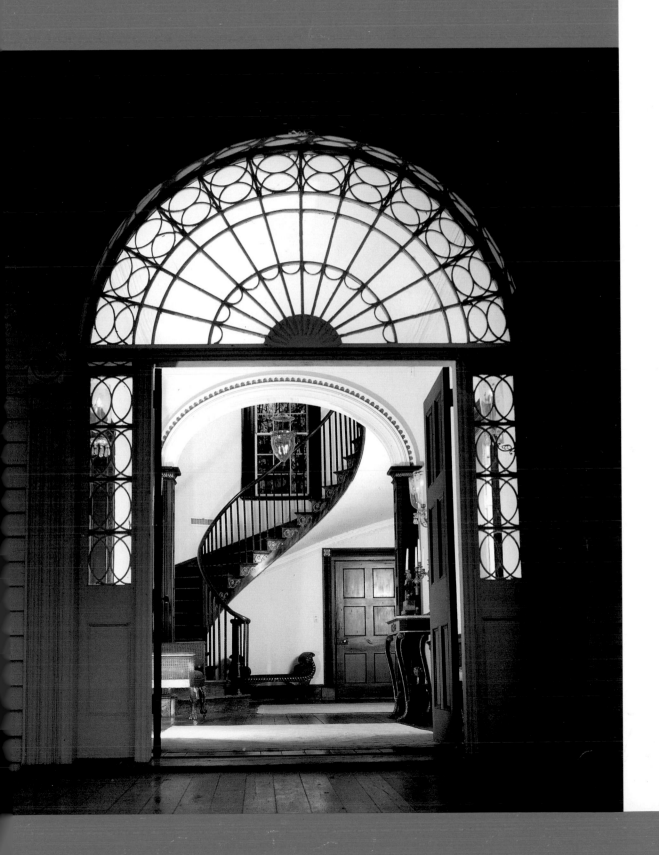

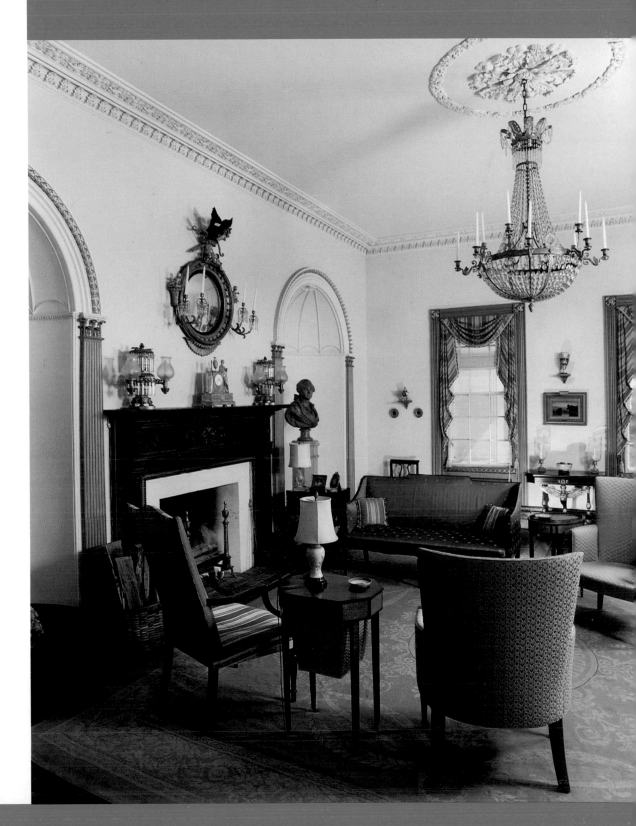

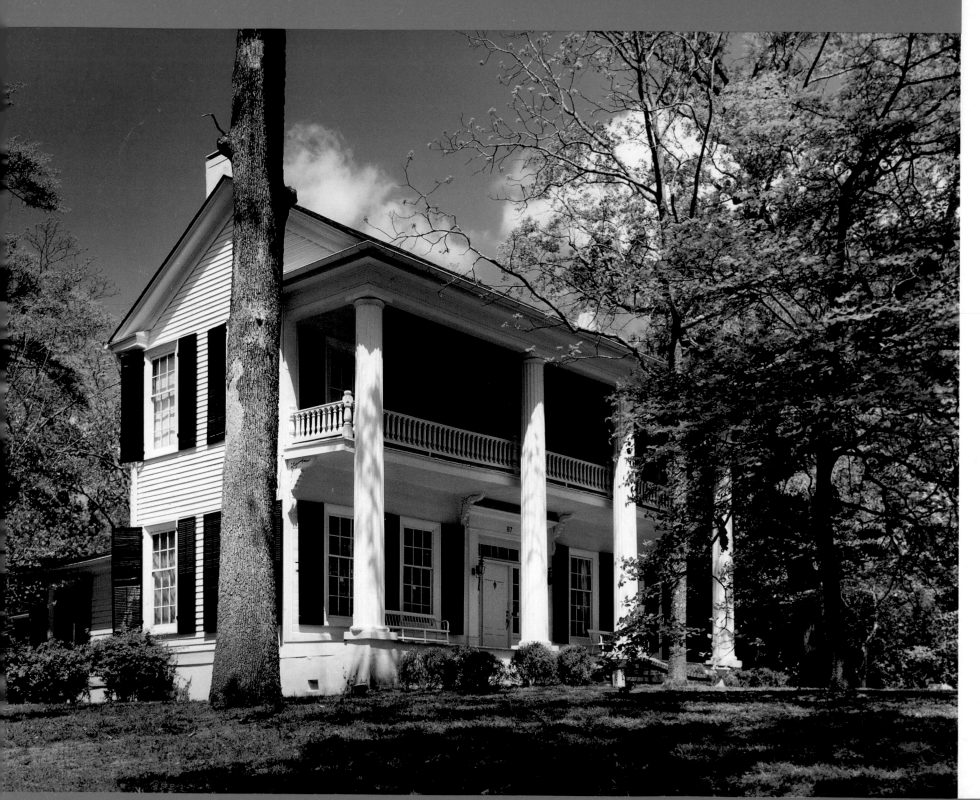

Buena Vista, late 1820s

One of the Newnan, Georgia, area's most historic homes, Buena Vista was built in the late 1820s by Edward S. Storey, who left for Texas not too long after its construction. His brother-in-law, Colonel Hugh Buchanan, enlarged the house in 1850, adding the two-story Doric columns and cantilevered balcony.

After the Civil War, Storey, who served as a colonel in the Georgia militia during that unhappy period, became one of the area's most respected judges and was later elected to the United States House of Representatives.

Buena Vista, also known as the Storey-Buchanan-Glover House, was used as a headquarters by Confederate General Joseph Wheeler during the battle of Brown's Mill, where he inflicted a punishing defeat on Union General McCook's cavalry. After the battle, he is said to have fallen asleep at the plantation desk in the study at Buena Vista. General Wheeler later was named a major general in the United States Army during the Spanish-American War.

In 1936, the house was purchased by Mr. and Mrs. Tom Glover, who gave Buena Vista a major restoration.

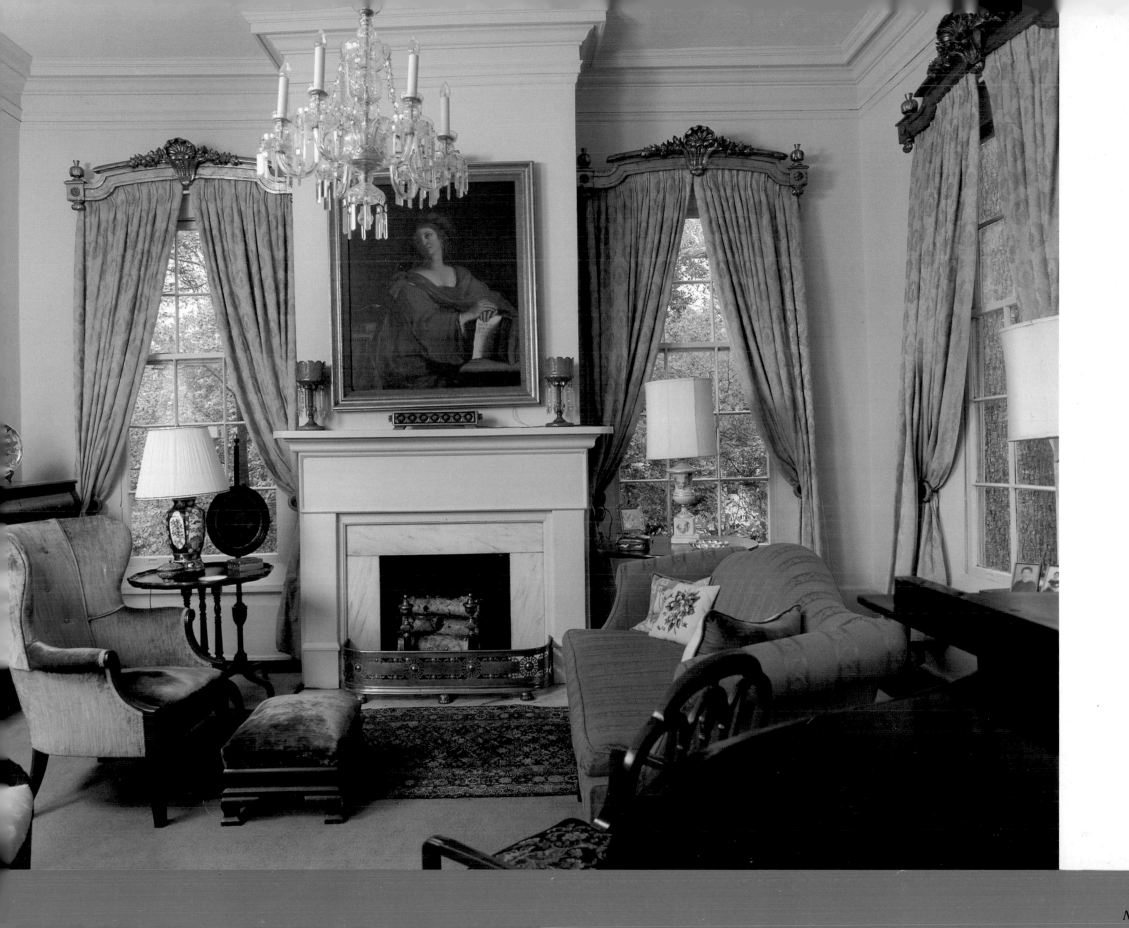

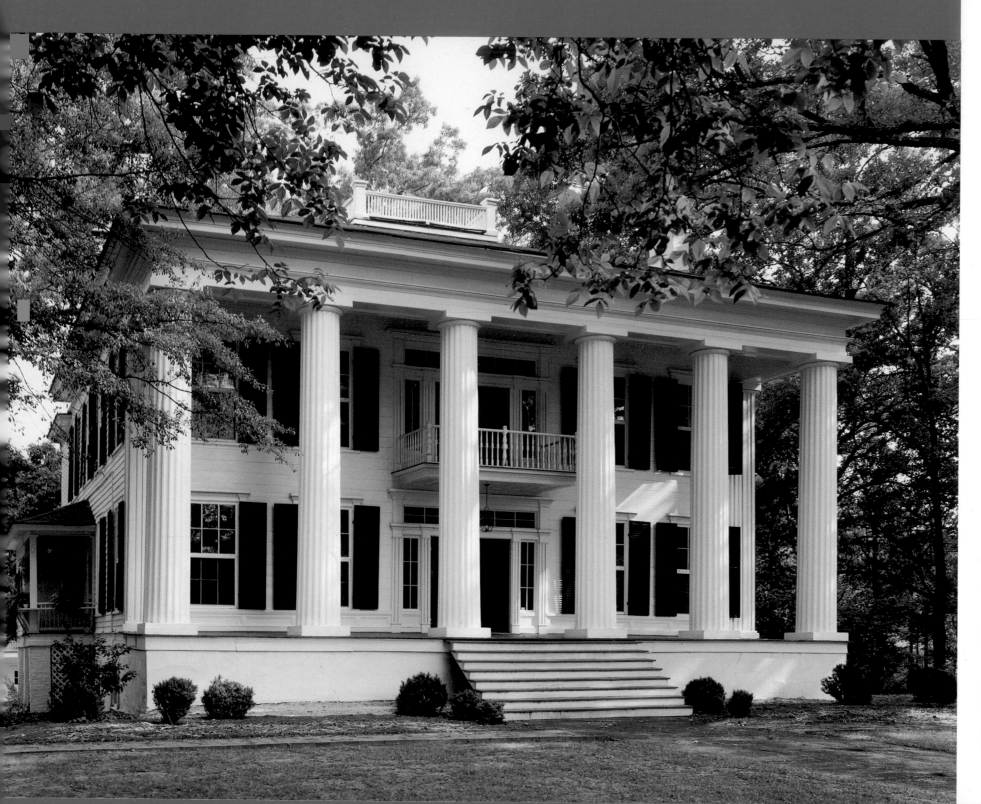

The Oaks, 1843

On Vernon Road, on the west side of LaGrange, Georgia, is an imposing white-columned mansion that has been called the house that love built.

Philip Hunter Greene was a Troup County planter who owned over one thousand acres to the west of LaGrange. His first home was on the east side of town. In those more formal days before the Civil War, Greene and his wife, Mildred Washington Sanford, felt required to dress formally before taking the carriage drive across town to their plantation, which they called "the farm."

In 1848, Greene built a new house on the other side of town for his wife, thus allowing a shorter and somewhat more casual drive to "the farm."

The Oaks still contains its original four black Carrara marble fireplaces on the main floor and a graceful spiral staircase.

In 1914, W. Grover Cleaveland bought the house for his sister Mrs. Frances Jefferson Dodd, and it became the boyhood home of Lamar Dodd, well-known Georgia artist.

Dr. and Mrs. Stanley W. Hall, Jr., of LaGrange bought The Oaks in 1978, undertook a two-year restoration project, and made the house their residence.

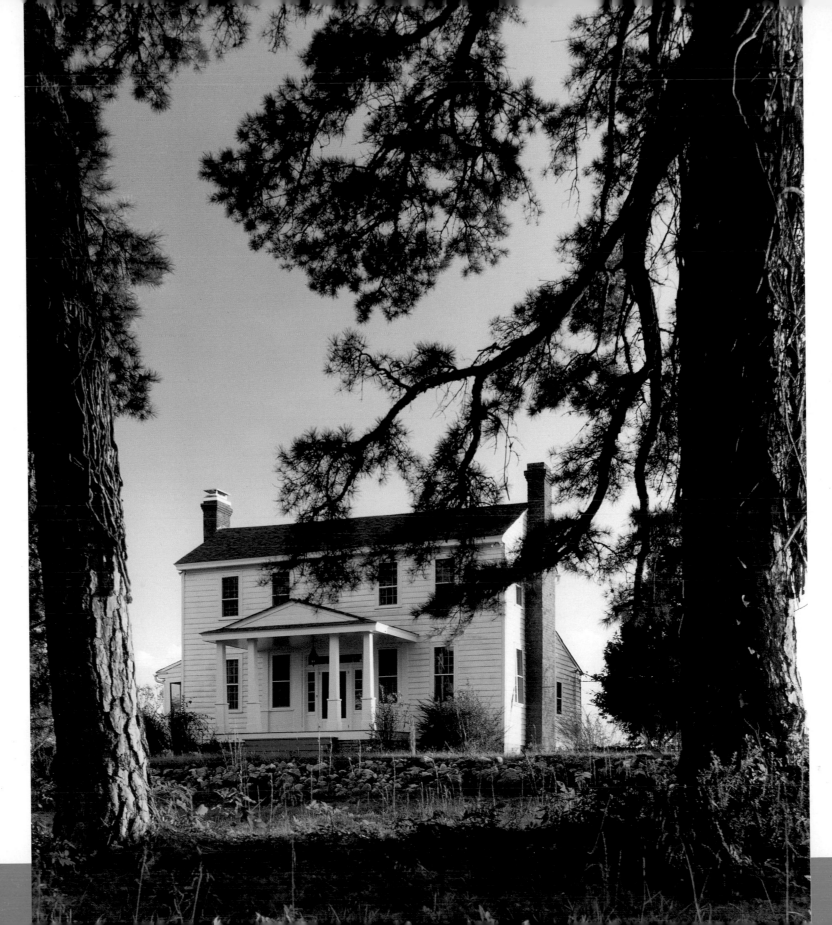

John Hill House, late 1830s

Facing the Cannonville Road at Long Cane, southwest of LaGrange, stands the boyhood home of United States Senator Benjamin Hill, who later built Bellevue in LaGrange. After the Civil War he also owned the mansion in Athens, Georgia, that is now the home of the president of the University of Georgia.

John Hill, Benjamin Hill's father, brought his family to the Long Cane area from Hillsborough, in Jasper County, Georgia, in 1833, established his plantation, and built this Plantation Plain style house overlooking the property within the next few years.

John Hill also donated several acres of land to the Long Cane Methodist Church, which was established in 1841.

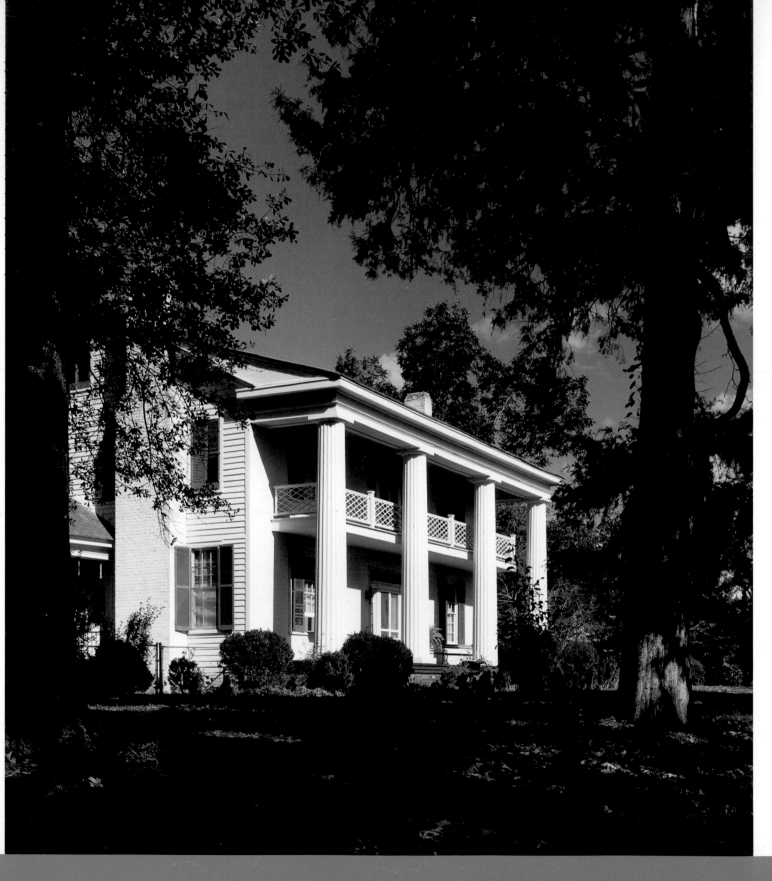

Forest Home, 1851

A gift for a daughter, Forest Home was built in 1851 by Colonel Charles Cabaniss Bailey for his daughter Mary Elizabeth, who married John Humphrey Traylor. Both families were originally from Virginia. Mary Elizabeth and John Humphrey were twenty-one and twenty-two respectively when they were married in 1844. She died in 1903, and he in 1907. The Traylor family retained possession of the house until 1959.

Colonel Bailey, his wife Martha, and their three children left Virginia in 1824 in their own wagons, bringing their furniture, other property, and slaves to a land grant near LaGrange, Georgia, in Troup County. With additional acreage acquired in the Georgia Land Lottery in 1827, Bailey's holdings ultimately amounted to eighteen hundred acres.

Jefferson Davis, a cousin of Mary Elizabeth, visited Forest Home before the Civil War. The house was later called Rosemont, the name of Jefferson Davis' boyhood home in Woodville, Mississippi, below Natchez.

Before the Civil War, eight extra rooms were added to the original eight at Forest Home. Following the war, the addition was removed to save the expense of heating and keeping up the house.

In 1959, Mrs. Joyce Parham Harper and son Joseph Parham purchased the house and restored it, giving it the name Rosemont.

Nutwood, 1833 (right)

Joel D. Newsome planted the first pecan tree in the area on his property near the white-columned house he built in 1833 in Troup County near LaGrange. The tree attracted visitors from around the county and resulted in the name Nutwood being given to the house.

Later owned by Mr. and Mrs. A. E. Mallory, Nutwood was purchased in 1980 by Delta Airlines pilot Dan Bridges and his wife Diane, who have made it their home and embarked on a long-term project of restoring the house and outbuildings. The original smokehouse still stands in the back yard.

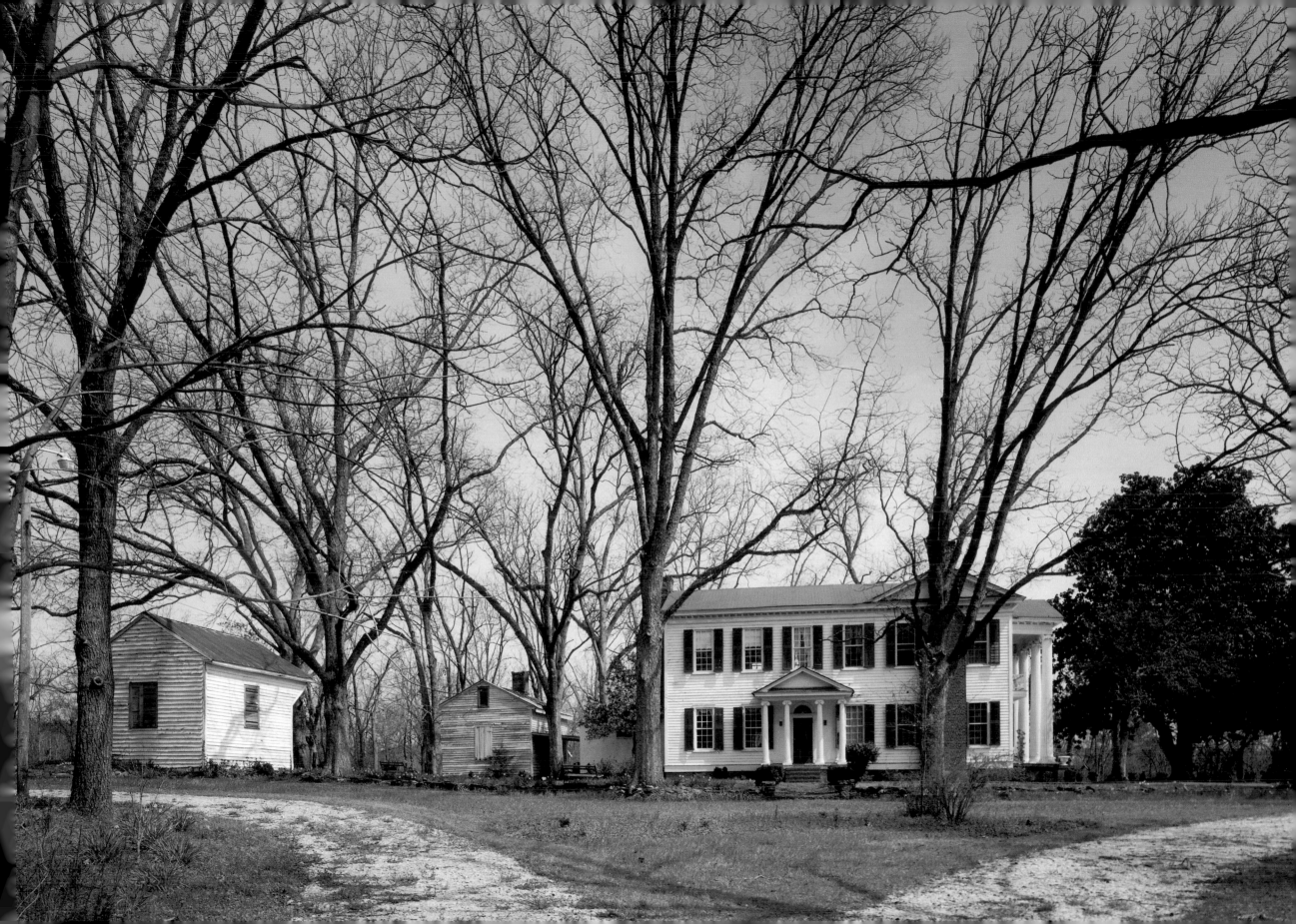

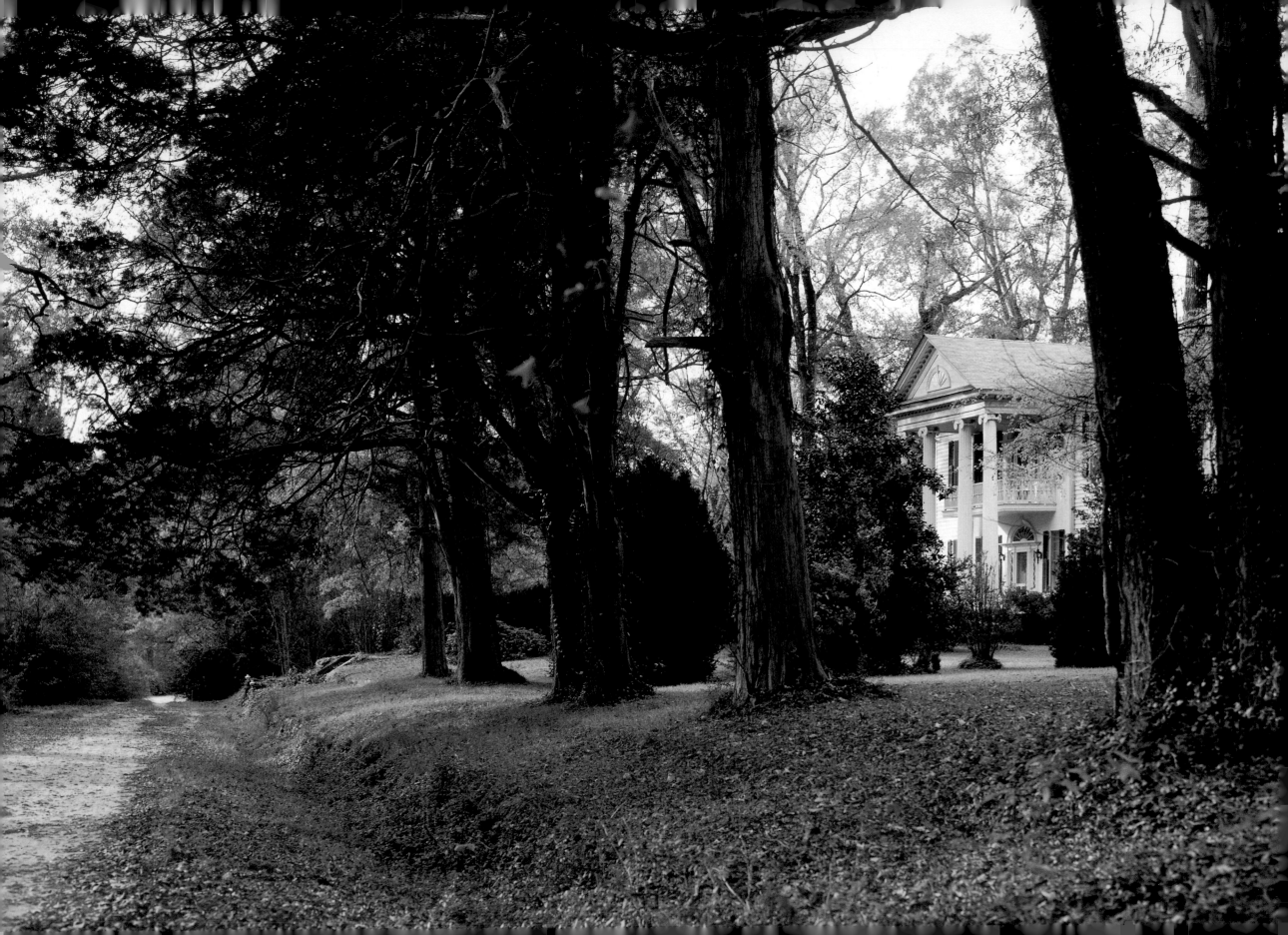

Boddie House, 1836 (left)

Built between 1833 and 1836, the Boddie House is owned by Colonel and Mrs. James W. Boddie, descendants of the builder, Nathan Van Boddie, who is said to have owned several thousand acres in Troup County and over one hundred slaves. The house was probably designed and constructed by architect Collin Rodgers.

Overlooking the old Greenville road about seven miles east of LaGrange, the Boddie House, originally named Evergreen, has unusually well designed hand-carved wooden Ionic capitals on wooden columns. The house served both as the manor house for the Boddie Plantation and as a way station for travelers. For their convenience, a forty-foot-long dining room was added around 1844.

St. Elmo, 1833

Colonel Seaborn Jones came to the Columbus area when he accompanied the Marquis de Lafayette on his grand tour as a member of the staff of General Troup in 1825. A lawyer and planter from Richmond County, Jones also built a warehouse and owned a ferry on the Chattahoochee River. Later he represented his area for three terms in the United States House of Representatives.

In 1833, after the house was five years in the making, Colonel Jones moved into his classic Greek Revival mansion, El Dorado, on the Old Stagecoach Road. The walls of the three-story house are eighteen inches thick, of brick made on the property, and the columns on three sides are three feet in diameter and forty feet high.

In 1875, the house acquired a new name, St. Elmo, after the novel of the same name that was written while its author, Augusta Evans Wilson, a niece of Mrs. Seaborn Jones, was a guest of the house.

Other famous visitors to the stately mansion included Presidents James K. Polk and Millard Fillmore, Henry Clay, and General Winfield Scott.

Colonel Jones's daughter, Mary, married Henry Lewis Benning, later a Confederate general, after whom Fort Benning in Columbus was named in 1918.

Dr. and Mrs. Philip T. Schley bought St. Elmo in 1966. It is on the National Register of Historic Places.

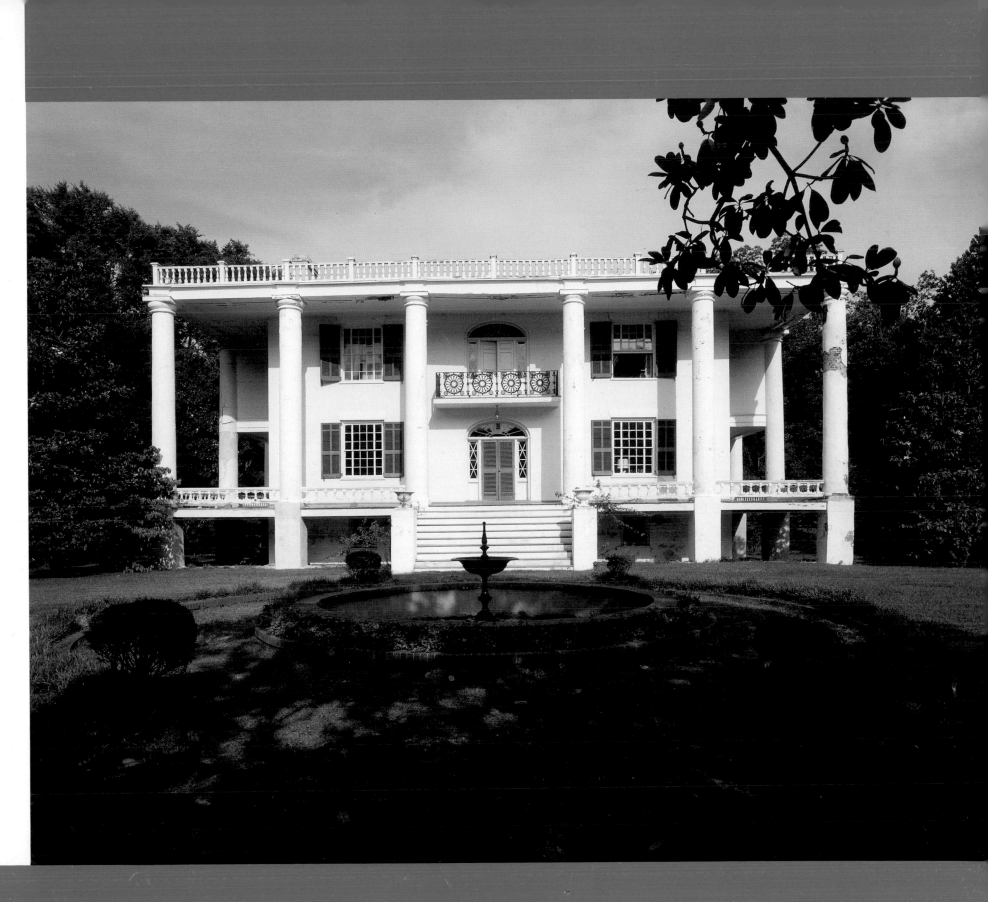

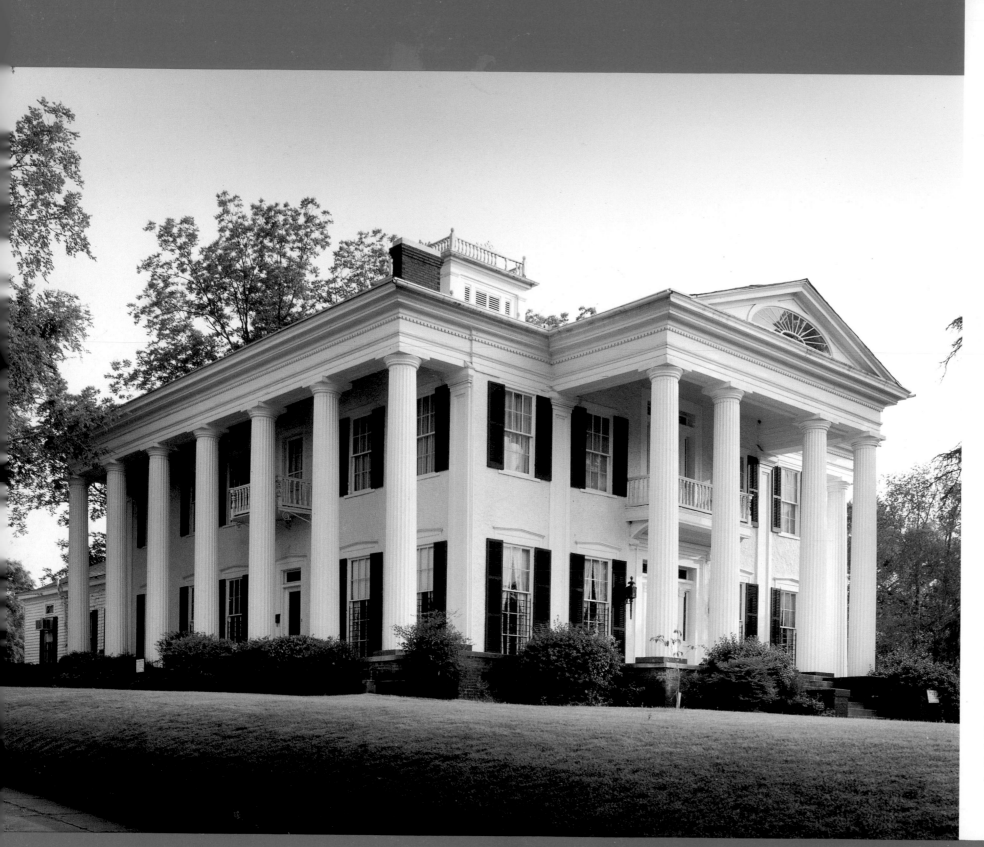

Wynn House, 1839

On the crest of a hill near downtown Columbus, Georgia, stands the Wynn House, built by Colonel William Wynn in 1839. The section of Columbus in which it is located is now called Wynnton.

The second owner, Henry Hurt, is said to have bought the house for his prospective bride, but the wedding never took place. In 1855, Hines Holt bought the great house, then called Oakview, for $14,000. Holt was a member of the first Confederate Congress.

In 1910, J. T. Cooper, then owner, moved the house to its present location, three hundred feet closer to the edge of the hill. He retained an Atlanta mover, W. C. Pease, who braced the columns and, using greased poles and mule teams (some reports mention a railroad track and one horse), relocated the house without damaging one column or cracking the plaster on the inside walls.

The Christian Fellowship Association, founded in 1946, owns Wynn House, which has been placed on the National Register of Historic Places.

Dinglewood, 1858 (right)

Using slave labor from his plantations in Alabama, Joel Early Hurt built an Italianate villa styled house in Wynnton, then outside Columbus, on thirty acres he had bought from John Woolfolk for $5,500.

Designed by Barringer and Morton, Columbus architects, the house has statues of Spring and Summer on the veranda and Fall and Winter in niches in the entrance hall.

When the house was built, Hurt installed his own gas and water works. Dinglewood still has its original candle-lit chandelier, silver doorknobs, and cupola. Because that small room atop the roof had the best light in the house, it was used as a sewing room.

Hurt's daughter, Julia, married Captain Peyton Colquitt during the Civil War in a ceremony held at Dinglewood. Her husband died at the battle of Chickamauga. Following the war, she visited Paris with her parents and rejected the hand of Jerome Napoleon Bonaparte, the emperor's great-nephew, who had been her husband's roommate at West Point. Later, Julia returned to the South and married Lee Jordan of Macon, one of Georgia's richest men.

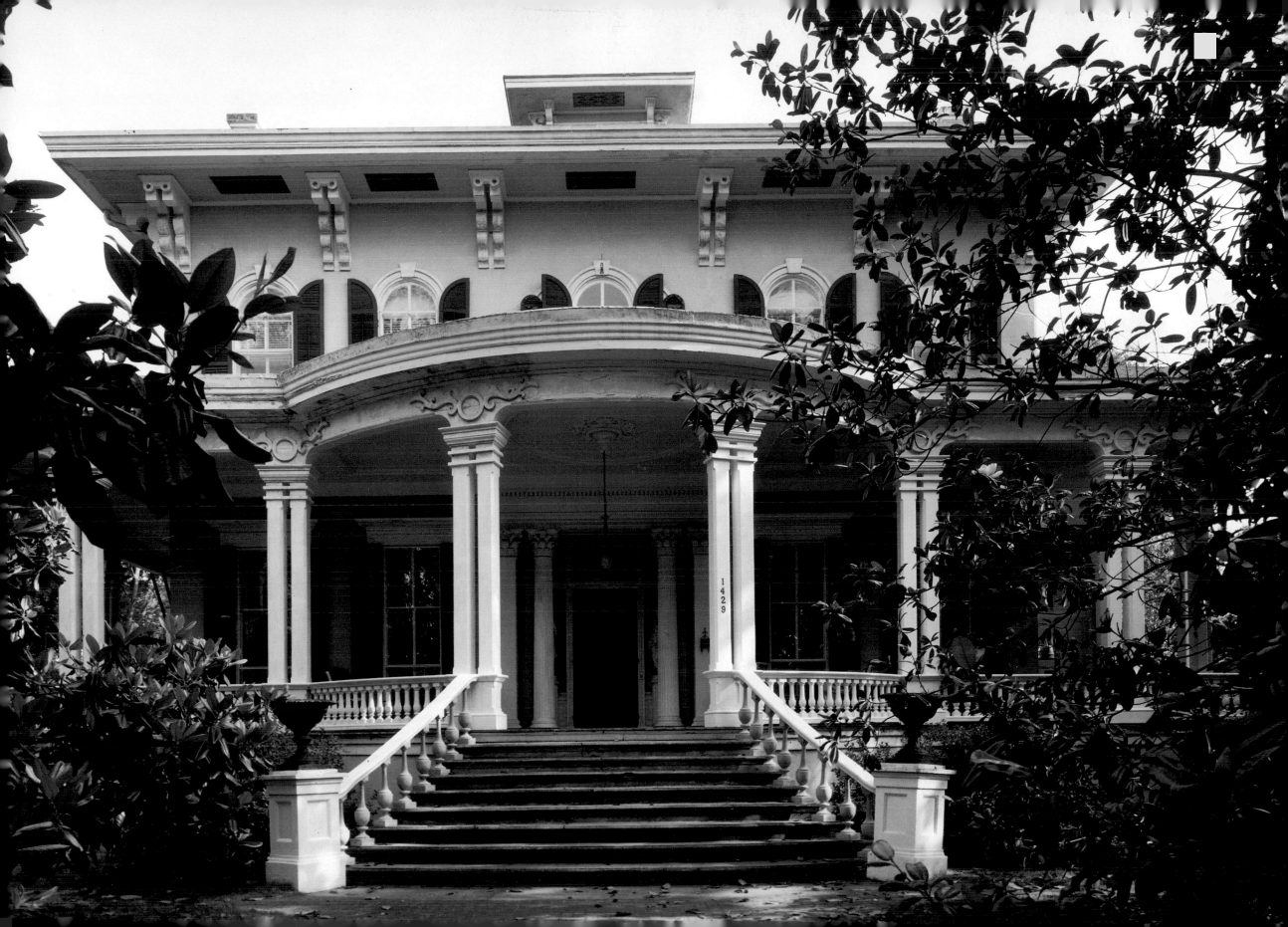

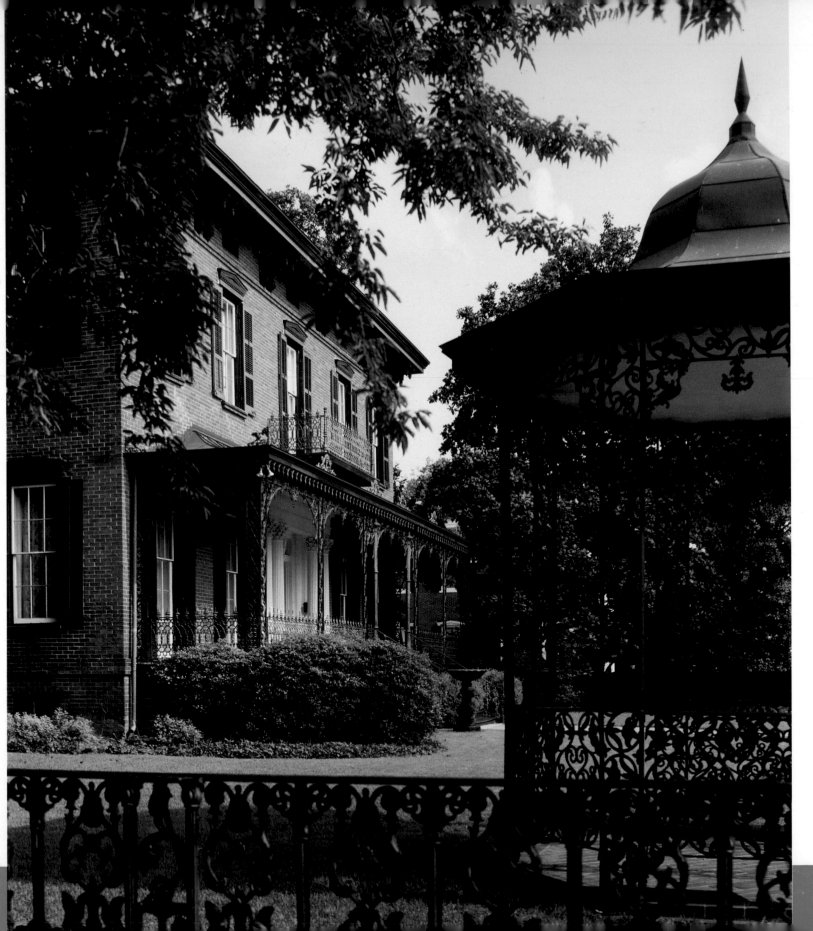

Rankin House, 1860, 1867

James Rankin, planter, hotel owner, and realtor of antebellum Columbus, began construction on the Rankin House just before the Civil War. Rankin had moved to the Columbus area from Ayshire, Scotland, acquired a fortune, and retained the services of Lawrence Wimberly Wall, a Savannah brickmason, to construct one of the finest mansions in Columbus.

The Empire-style Rankin House, completed after the war was over, is noted for the iron grillwork on its lower veranda and its flying balcony. The marble mantels in the north parlor and the dining room are original, along with nine pairs of silver doorknobs, hand-carved cornices and door frames, and a graceful solid walnut double staircase.

The Rankin House remained in the family of its original owners until 1958. In 1968, Emily Woodruff donated the house to the Historic Columbus Foundation as a memorial to her father, Columbus native James Waldo Woodruff, Sr.

The Rankin House has been restored as a house museum of the 1850–1870 period in a combined effort by the foundation, the Junior League of Columbus, the Columbus Town Committee of the National Society of the Colonial Dames of America in the State of Georgia, and a number of individuals. It was placed on the National Register of Historic Places in 1972. Restoration architect was Edwin W. Neal, and the interior designer was Mrs. Charles M. Woolfolk.

Gordonido, *ca.* 1837

John R. Dawson, an early resident of Columbus, was a supply merchant to surrounding plantations. In 1837, he built Gordonido, originally known as Dawson's Place, in Wynnton, then a village outside Columbus.

In 1913, Frederick B. Gordon of the Columbus Manufacturing Company purchased the house and grounds, and he and his wife (who supervised the extensive remodeling, preserving the original character of the house) gave it the name Gordonido, Spanish for Gordon's nest.

The house was restored once more in 1949 by Mrs. Walter Alan Richards, the Gordons' daughter, who devoted particular care to Gordonido's famous gardens, including its 145-year-old camellias. It was placed on the National Register of Historic Places in 1979.

Jerry and Marjorie Newman purchased Gordonido in 1985. They have planned still another restoration.

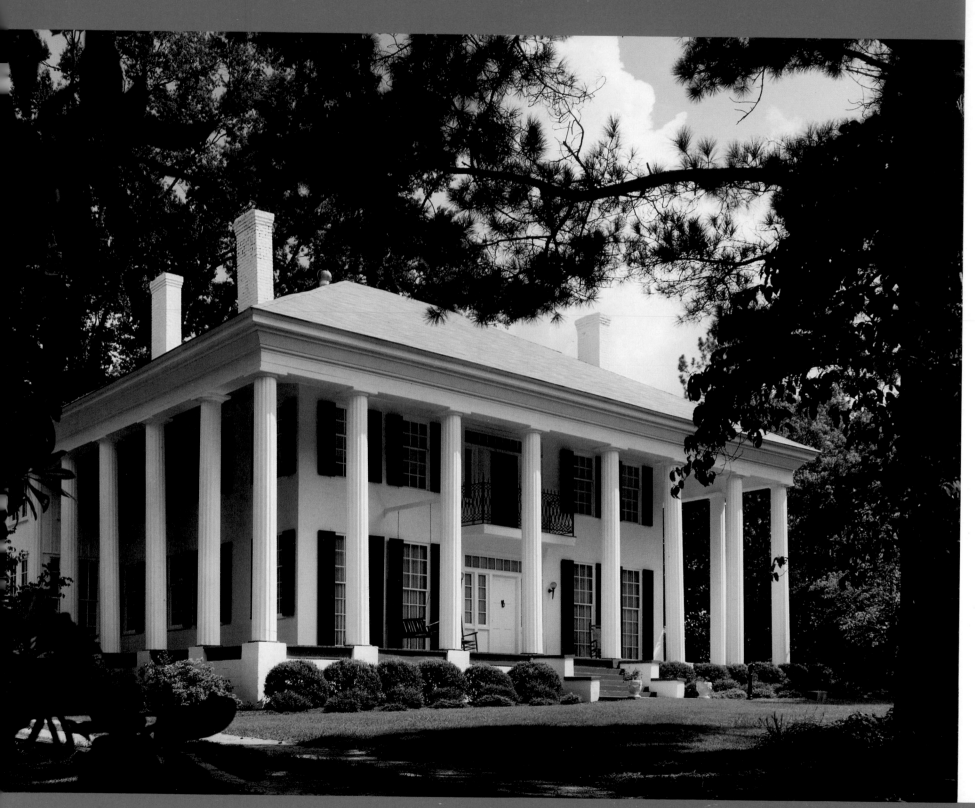

Rebel Ridge, 1837

David Shelton, born in Louisa County in Virginia in 1804, came to Talbot County, east of Columbus, Georgia, in the 1830s. By 1848 he owned over 50 slaves, with 1,500 acres (1,000 of which were cleared and fenced) surrounding the house he built in Talbotton, Georgia. This house is now called Rebel Ridge, or the Shelton-Kimbrough-Leonard-Mattox House.

By the time he died in 1855, Shelton owned 83 slaves, and in addition to his farmland, he also owned 3,500 acres of timberland and one of the finest sawmills in western Georgia.

Otis Nathaniel and Nora Lee Maddox bought the house in 1970 and restored it, giving it the name Rebel Ridge. They did not, however, replace the widow's walk on the roof, which was removed at some time after 1890.

Twenty-two Doric columns surround the two-story, Greek Revival house, with eight in front, and seven on either side. There are twelve rooms, but originally there were only eight—four up and four down—with a center hall on both floors.

Rebel Ridge was included in the Historic American Buildings Survey in 1936 as the Dr. Leonard House. It was placed on the National Register of Historic Places in 1980.

McDonald House, 1843

Near Lumpkin is a town named Westville where the calendar stopped at 1850. A "functioning living history village" composed of relocated but carefully restored buildings that create the environment of a pioneer Georgia town, Westville has a community of craftsmen who demonstrate the life and skills of a pioneer community of the first half of the nineteenth century.

The largest house in Westville is the McDonald House, built by Edward McDonald in 1843 and moved from Cuthbert, Georgia. The two rooms to the rear of the house were the first to be finished and were lived in while the rest of the house was being completed.

McDonald married Elizabeth Hannah Ross, and they had nine children, all born in their family home. By 1850, when he was thirty-six, he had entered the cotton business, owned five slaves, and was worth $4,000. In the next ten years, he built a cotton warehouse and accumulated 1,900 acres of land with a cash value of $12,000.

Edward McDonald saw service for the Confederacy during the Civil War and faced ruin afterward. However, he did manage to reopen his warehouse and regain part of his wealth before his death in 1878.

The formal garden alongside the McDonald House was inspired by a similar garden in Madison, Georgia. The summer house (the term *gazebo* was not used until after the Civil War) dates from before 1850 and came from the garden of a home in nearby Lumpkin, Georgia.

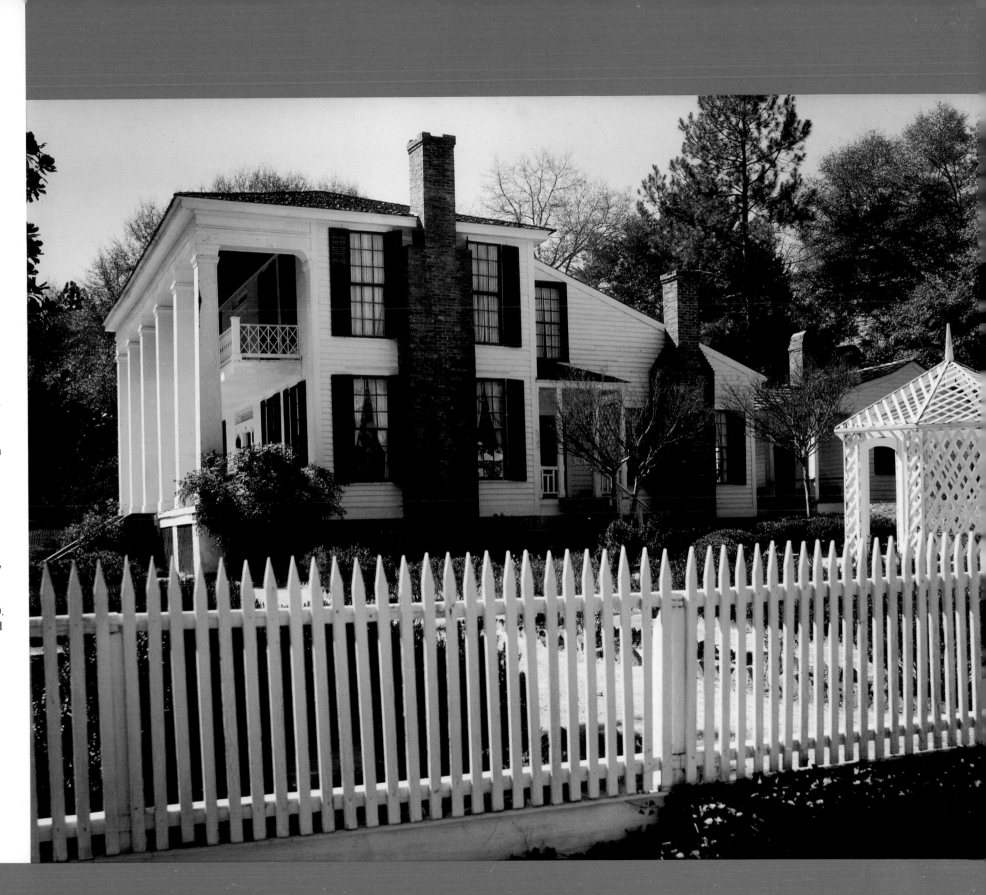

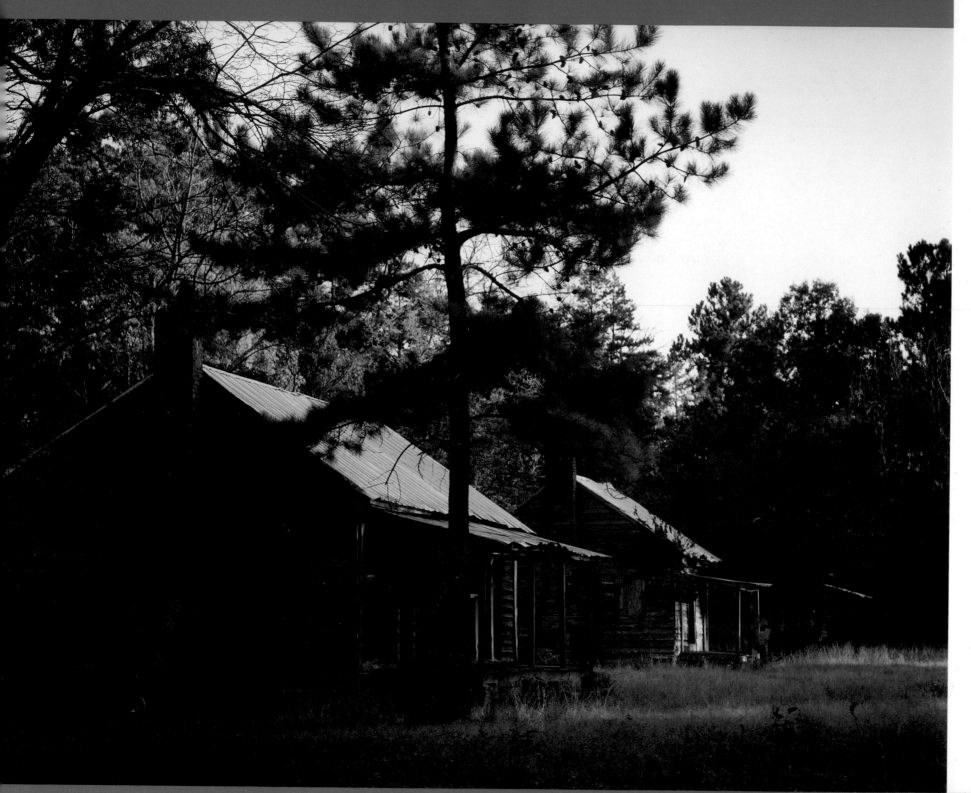

Moye Farms, 1836

David Harrell, from Wilkes County northeast of
Augusta, Georgia, established the plantation later
known as West Hill in Stewart County near Lumpkin
in 1838.

In 1853, William West, great-grandfather of the
present owner, L. M. Moye, bought West Hill after his
own house had burned. By 1860, West was numbered
among the top 10 percent of cotton planters in the
state. He owned some ten thousand acres and sixty
slaves.

The house was little bothered by either side during
the Civil War, being visited only by scouting parties.

West divided his land in 1871, giving two thousand
acres to each of his heirs. His daughter, Annie, inher-
ited the house and lived there until 1915. Her nephew,
L. M. Moye, Sr., acquired the house in 1929, and it is
now occupied by his son L. M. "Red" Moye, Jr., and
his family.

Moye Farms still has an exceptional number of its
antebellum outbuildings. The plantation's schoolhouse,
blacksmith's shop, cook's residence, commissary, privy,
and three slave cabins remain in good condition in
their original locations.

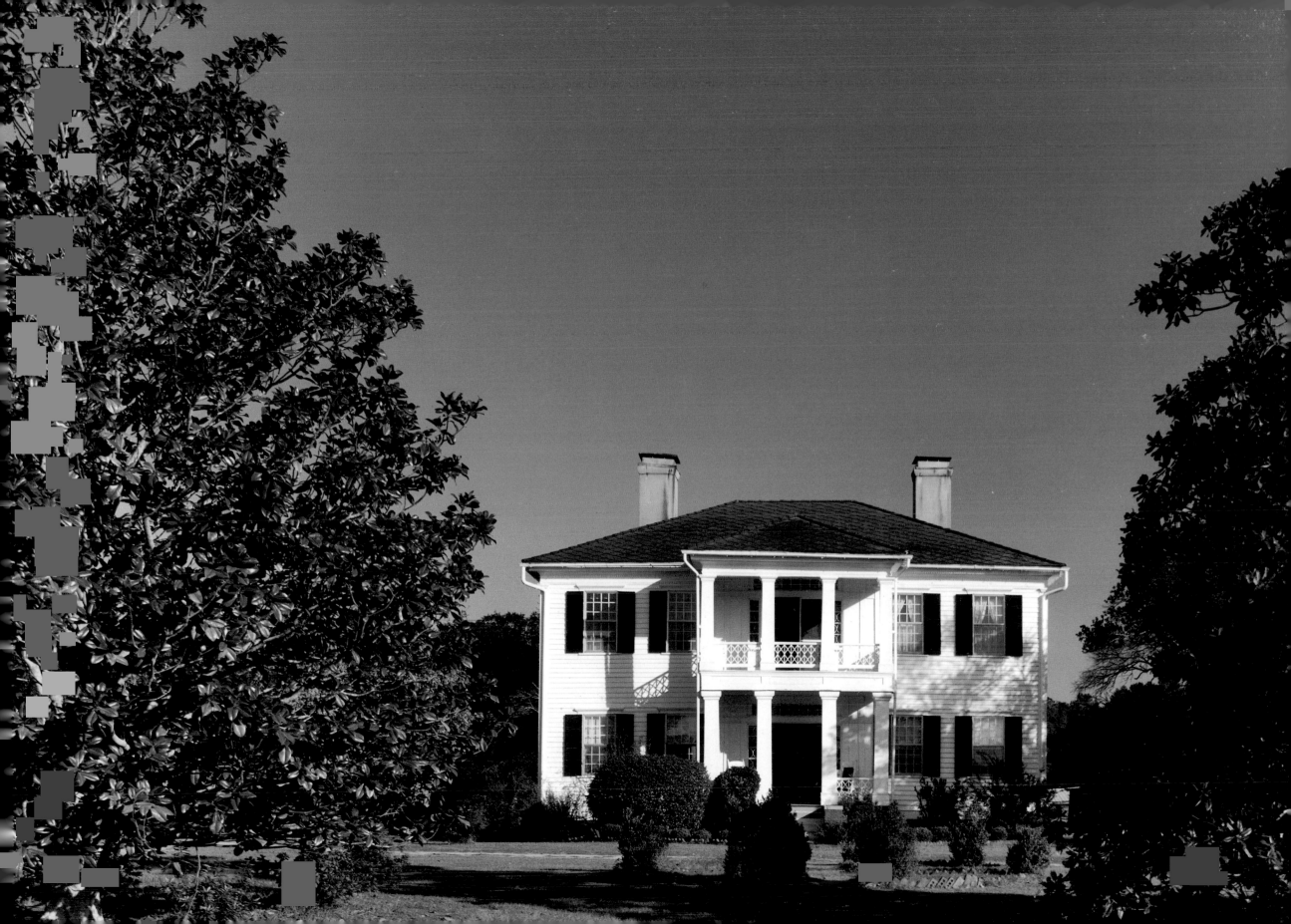

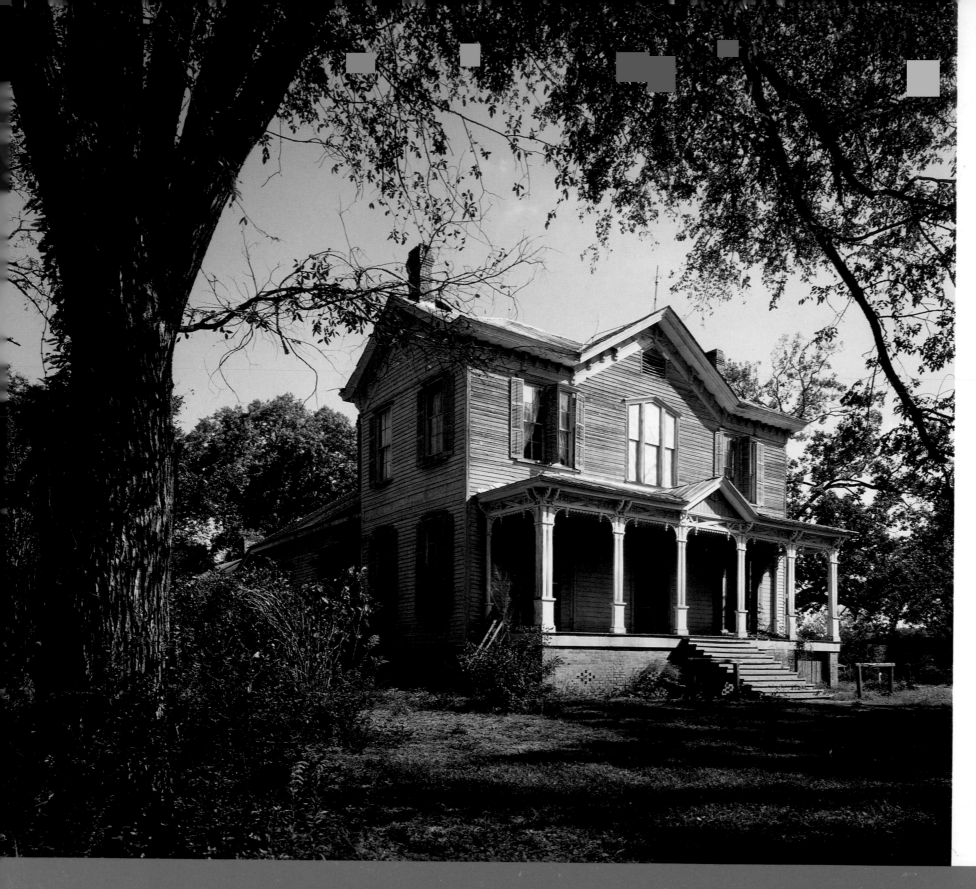

Fitzgerald Plantation, *ca.* 1845

The Fitzgerald family were among the earliest settlers in the Chattahoochee Valley near Omaha, in Stewart County, south of Columbus.

According to local legend, the last Creek Indian battle was fought on Fitzgerald Plantation property. The family's holdings are said to have amounted to over fifteen thousand acres, tended by three hundred slaves.

The present kitchen building, joined to the main Gothic Revival house, may have been the original house of James Fitzgerald and probably was constructed in the 1830s. The big house was built in the mid- or late-1840s, with Victorian additions and remodeling done in the 1880s.

John Fitzgerald married Nancy Hilliard, and they were the parents of twelve children. Nancy died in 1879, and her husband in 1880.

Fitzgerald Plantation, also known as Sylvan Grove, has a number of its original outbuildings still standing, probably slave cabins constructed in the 1840s, on the north side of the house.

Guerry House, 1833

Reflecting the raised West India cottage of south Louisiana is the Guerry House of Americus, Georgia.

Built by a planter, James P. Guerry, with Louisiana connections, the house was built on the edge of Guerry's plantation, near a well-known spring. The original name of the plantation was Spring Hill, and adjacent to the house is a water well dug in the 1830s. It is still working, as are the original springs on property to the rear of the house.

The Guerry House is built of hand-hewn timbers of heart pine that were pegged instead of nailed. Encircled by a wide veranda, the main floor is built over a raised basement that originally was probably open. It has since been enclosed, floored, furnished, and air-conditioned by Walter Stapleton, a student of the Civil War who acquired the badly deteriorated property in 1975 and embarked on a ten-year program of restoration.

Stapleton and his wife Pamela, both musicians and gourmet chefs, own and operate the Guerry House as a dinner club.

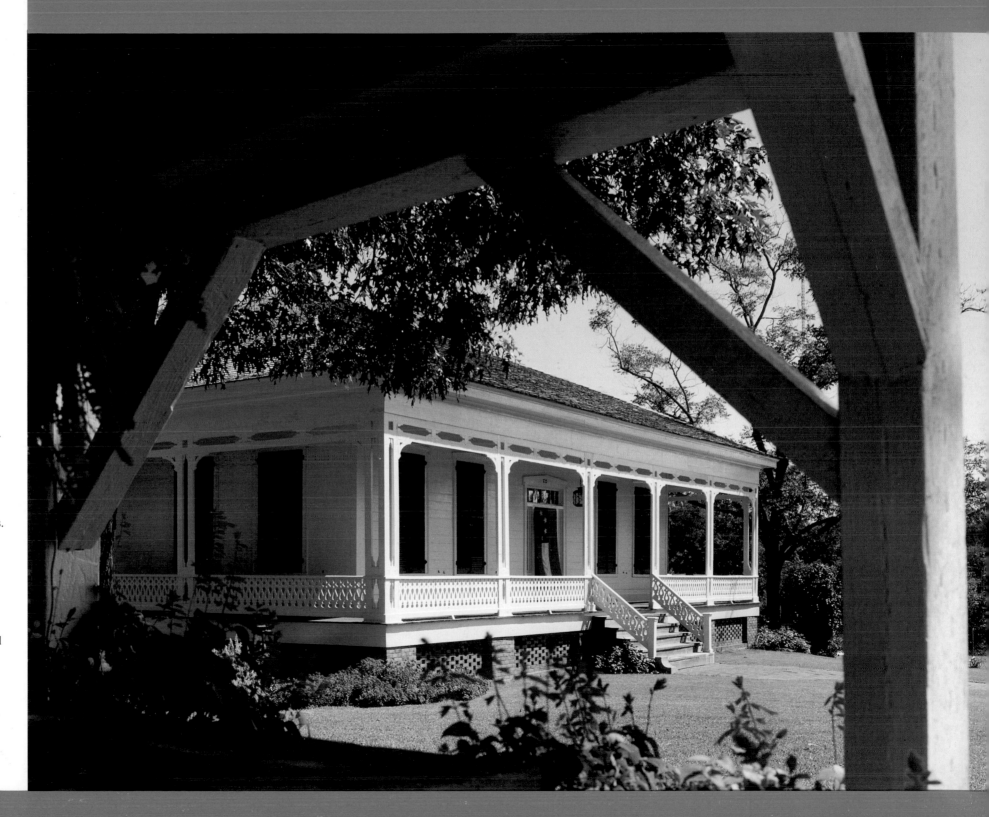

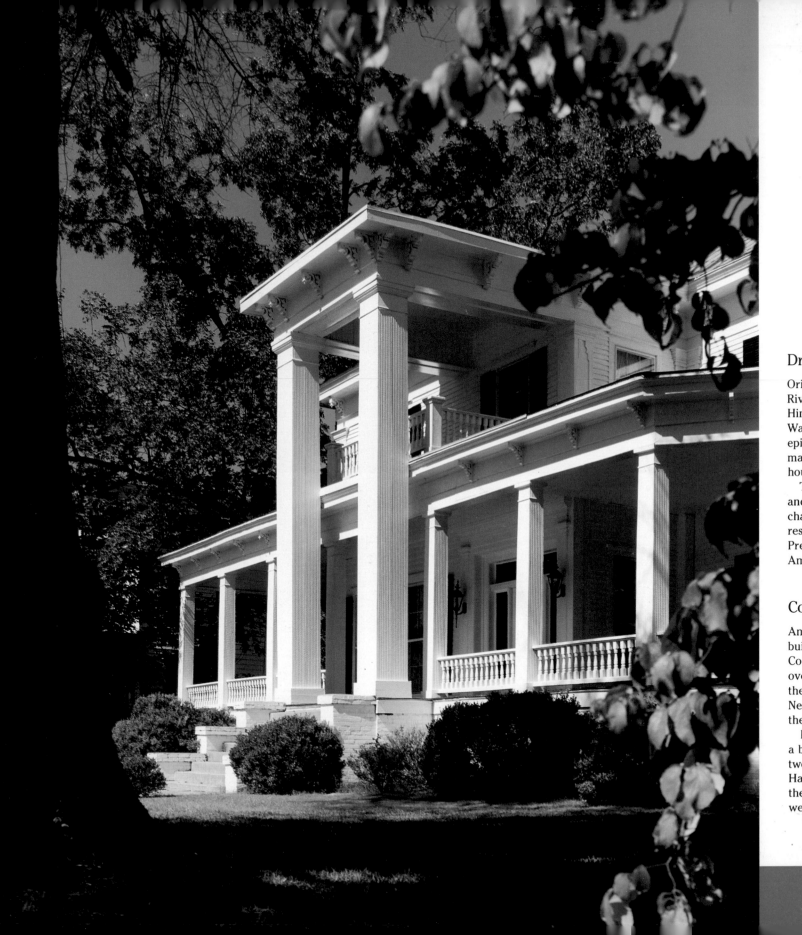

Dr. Hinkle House, 1850s

Originally built in Oglethorpe, Georgia, on the Flint River seventeen miles northeast of Americus, the Dr. Hinkle House was moved to Americus before the Civil War because of devastating yellow fever and smallpox epidemics in Oglethorpe. Frightened citizens burned many houses to stop the spread of disease; other houses were moved to nearby towns.

The house was later occupied in Americus by Dr. and Mrs. J. B. Hinkle, who may have made Victorian changes and additions in the 1880s. The house was restored in 1974 by Mr. and Mrs. Frederick Frick. Present owners are Mr. and Mrs. Jon Johnson of Americus.

Colonel Fish House, 1852 (right)

Another house moved from Oglethorpe was the one built for Colonel and Mrs. George W. Fish in 1852. The Colonel Fish House was not moved to Americus until over a century later, when it was moved to become the Americus residence of Mr. and Mrs. Donald Nelson. Dr. and Mrs. Ainsworth Gatewood Dudley are the present owners.

In its Oglethorpe years, the house was the scene of a brutal murder. Colonel Fish was killed in 1871, and two men were convicted in a sensational trial. William Hansell Fish, Colonel Fish's son, continued to live in the house until he was named judge of the Southwestern Judicial Circuit.

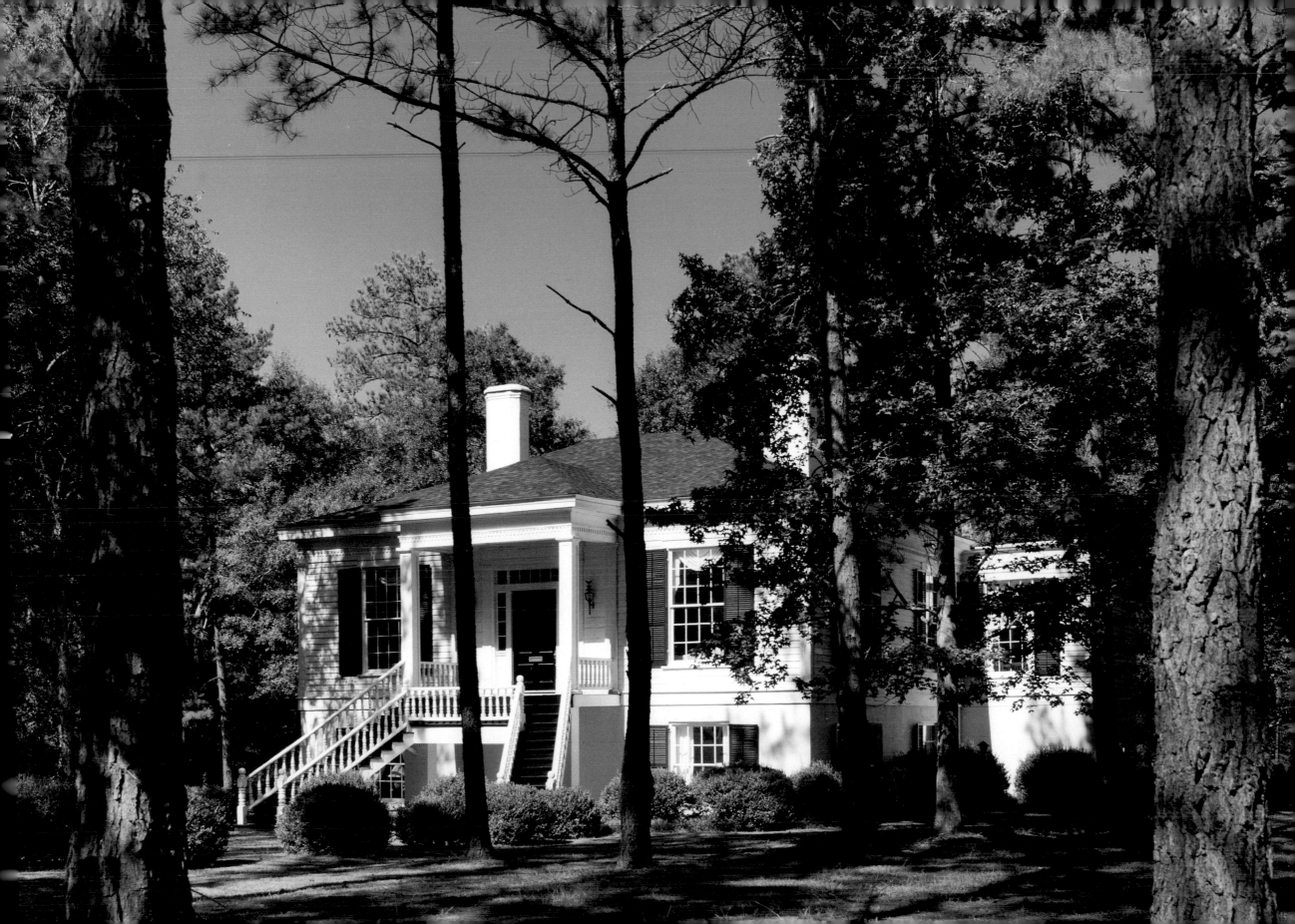

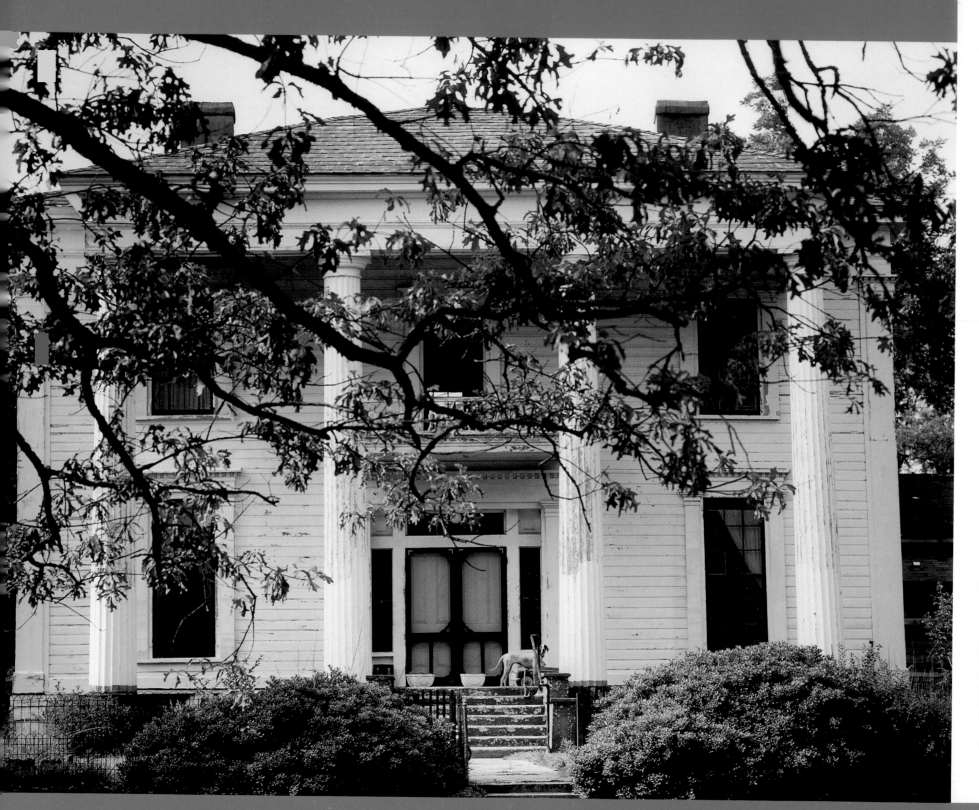

Liberty Hall, *ca.* 1864

In 1860, Simpson Plantation, in Sumter County near Americus, Georgia, included six hundred acres of cotton land, thirty-nine slaves, and fourteen outbuildings.

The house on the plantation, known as Liberty Hall, was built during the Civil War, and the only addition made since that time was the kitchen in 1888.

Four bays wide and two bays deep, the two-story house has pine walls, floors, and ceilings. In the front bedroom on the second floor, the wooden walls tell the story of the privations of the war. Instead of wide, long planks extending without a break from one side of the room to the other, a number of boards are spliced with shorter lengths, indicating a shortage of lumber. Their rough workmanship attests to the shortage of skilled labor.

Liberty Hall is in the process of restoration by its owners, Tom Johnson and Mary Baldwin of Americus.

Bagley House, 1860

Only a year before the beginning of the Civil War, Dr. David Bagley and his wife, Camilla Jane Hand, built a handsome two-story Greek Revival manor house in Sumter County east of Americus, Georgia.

Mrs. Bagley's family came to Georgia before the Revolution, and her grandfather, Henry Hand, went to war at age fifteen.

One of the county's first physicians, Dr. Bagley received his medical training in Cincinnati, Ohio, and came to Sumter County as a young man. He began buying land in 1844 and by 1850 owned 405 acres. By 1860 this had expanded to 1,374 acres, and his net worth was estimated at $18,000. In 1870, his holdings were valued at only $900, reflecting the devastating effects of the Civil War and Reconstruction.

Dr. Bagley served with the Confederate forces in Virginia, creating an awkward situation with northern relatives from his home state of New Hampshire. The Bagleys had seven children, and Bagley House remains in the family.

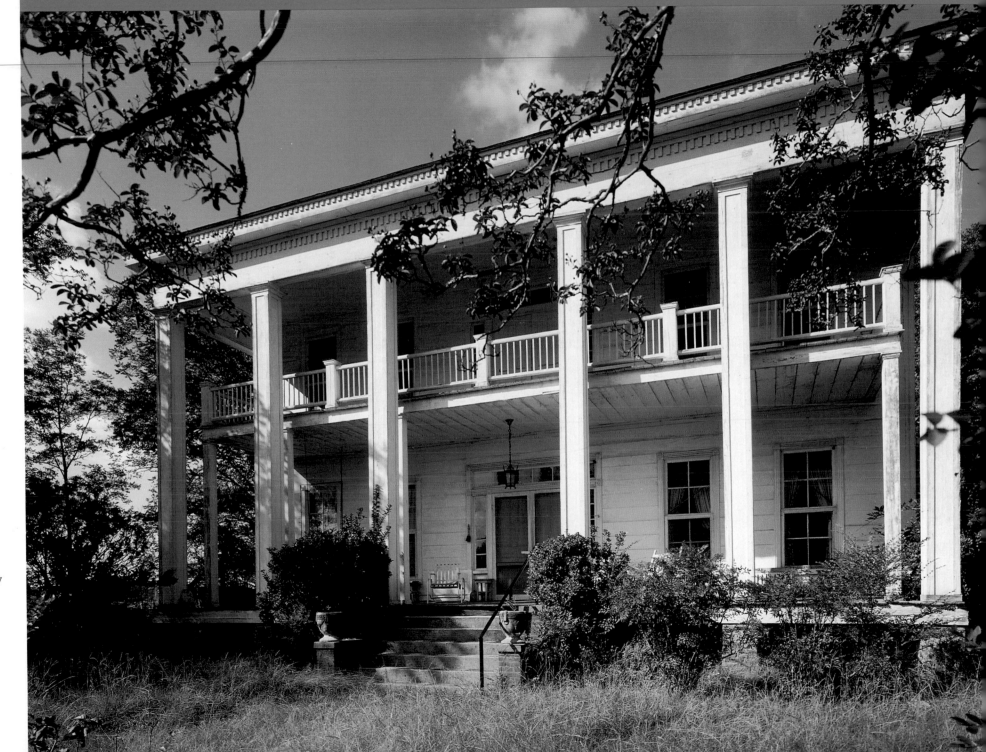

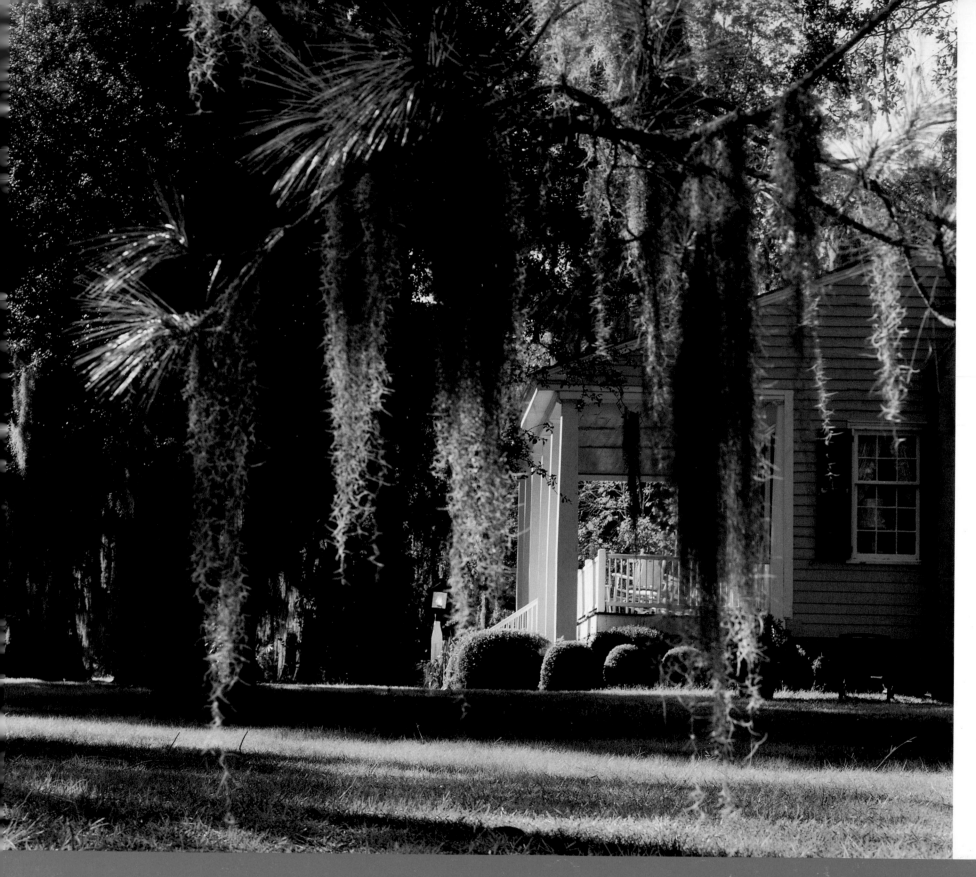

Grey Moss, 1830s

Approached through a circular drive that winds through moss-hung live oak and magnolia trees, Grey Moss looks as if it has always been part of the sandy southwest Georgia land.

Early records of Grey Moss Plantation are elusive, since the Lee County courthouse burned in the latter part of the nineteenth century.

John Green, born in 1747 in Cork, Ireland, had six children. Three descendants, Daniel, Benjamin, and Sara Elizabeth, settled in the Cherokee district that came to be known as the Green section of Lee County. The Green family built four or five houses in the county and are said to have owned 50,000 acres in the area. Descendants of the Greens operated Grey Moss Plantation until the early 1920s.

The Workman family owned Grey Moss in the 1920s and 1930s and added a bedroom wing. Charles F. Crisp, father of the present owner, bought the plantation in 1942. It now covers 2,000 acres of farmland and timber.

Pinebloom, 1848

Hartwell Hill Tarver is said to have owned thousands of acres west of the Flint River in southwest Georgia, acquired after the territory was vacated by the Creek Indians in about 1826.

Some sources refer to Hartwell Harrison Tarver. This may be a brother, or the same person. The Baker County courthouse burned years ago with all records, so information on some southwest Georgia plantations is sketchy. Tarver's acreage was within a Baker County that was much larger before the Civil War.

Three of Tarver's children and a brother settled in southwest Georgia, and for each of his children, as a wedding gift, Tarver built a manor house to preside over a gift of land sufficiently large, according to local tradition, to be worked by 250 slaves.

A daughter, Dorothy, married Alfred H. Colquitt, a Princeton graduate who later became a Confederate general and, after the Civil War and Reconstruction, governor of Georgia and United States senator. The Colquitts were given Pinebloom, later called the Governor's Mansion. By 1860, Colquitt owned over 100 slaves.

The manorial estate was later owned by Hal Price Headley, who lodged his race horses in Georgia during the winter and moved them to Lexington, Kentucky, during the summer season.

Pinebloom is now owned by John M. Harbert III of Birmingham, Alabama.

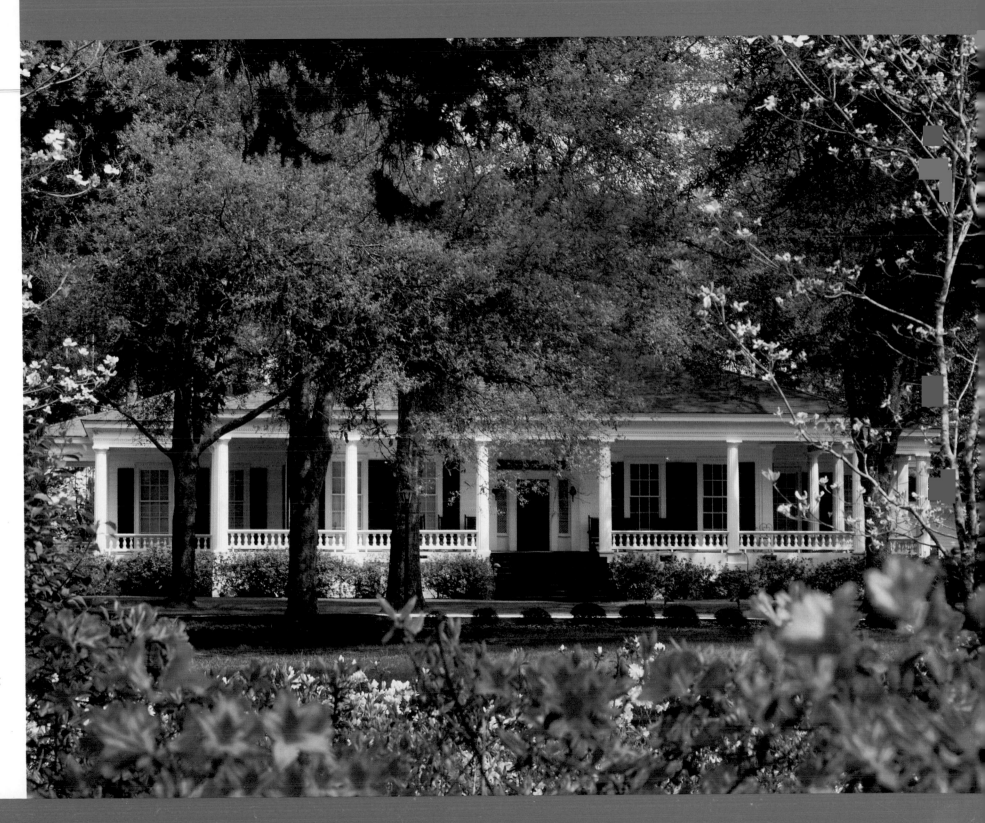

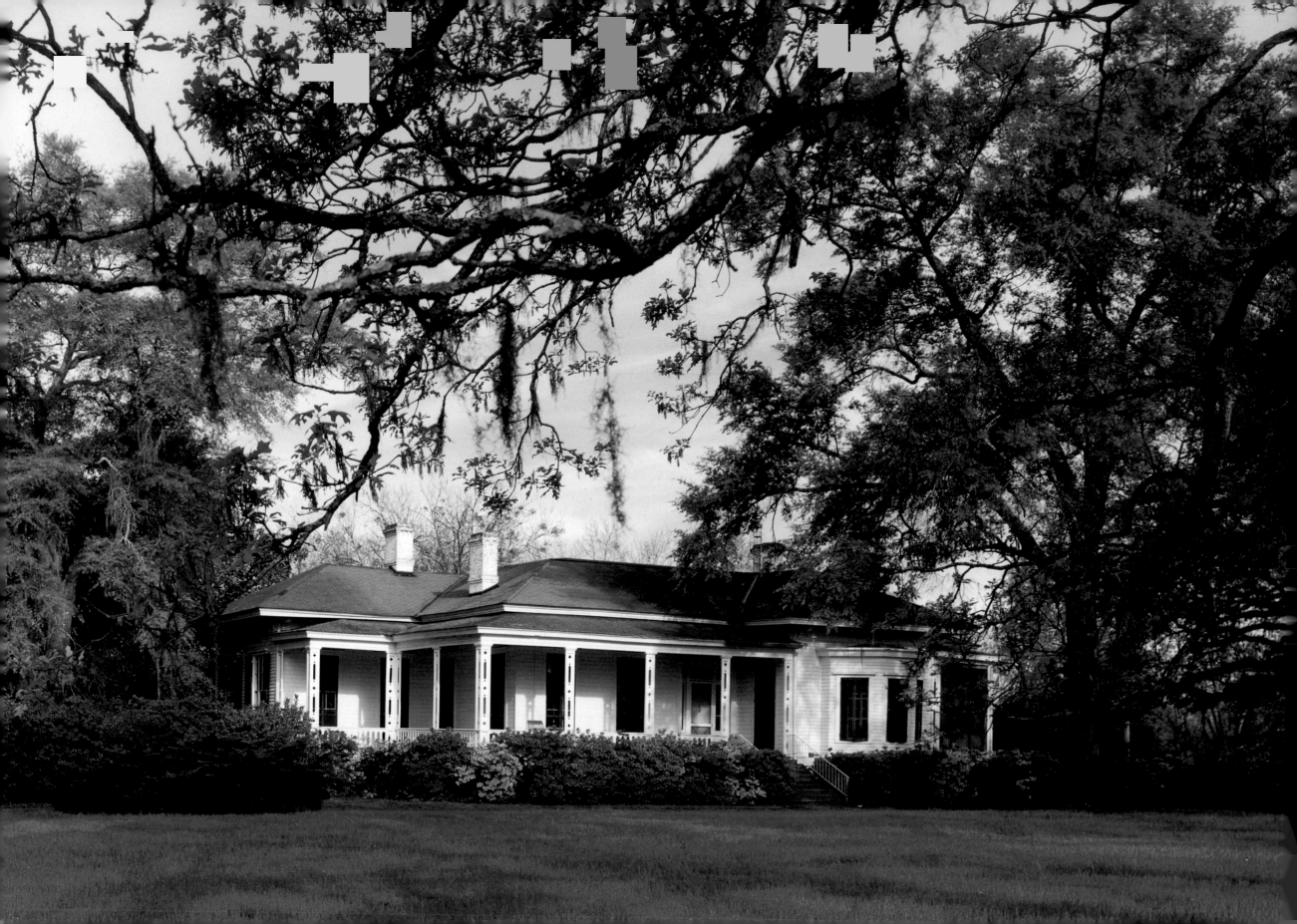

Cypress Pond, 1851

Confederate President Jefferson Davis was sheltered near Albany at Cypress Pond, according to local tradition, during the dying days of the Confederacy when he was attempting to evade pursuing Union troops.

The Tarver relationship with Cypress Pond is pretty well substantiated, but accounts are unclear as to whether Cypress Pond was built for a Tarver son or daughter. The house may have been built by Philadelphia craftsmen as a wedding present for his daughter from Hartwell Harrison Tarver, or it may have been built by Tarver's oldest son, Paul, who died just a few years after the house was built.

Cypress Pond appears larger on the inside than on the outside. The interior rooms of the one-story cottage have fifteen-foot ceilings with elaborate plaster cornices and medallions. The spacious rooms, two on each side of a center hall with a vaulted ceiling, have floor-length windows that open into the ceilings, providing excellent ventilation and making the veranda an extension of the interior rooms.

At about the turn of the present century, the Gault family from Scotland bought Cypress Pond and planted pecan trees on the plantation. They sold it some forty years later to the Smith family.

Chip and Betsy Hall of Albany, Georgia, bought the house in 1986 and have made it their family home. The plantation covers about twelve hundred acres, of which four hundred acres are planted in pecans.

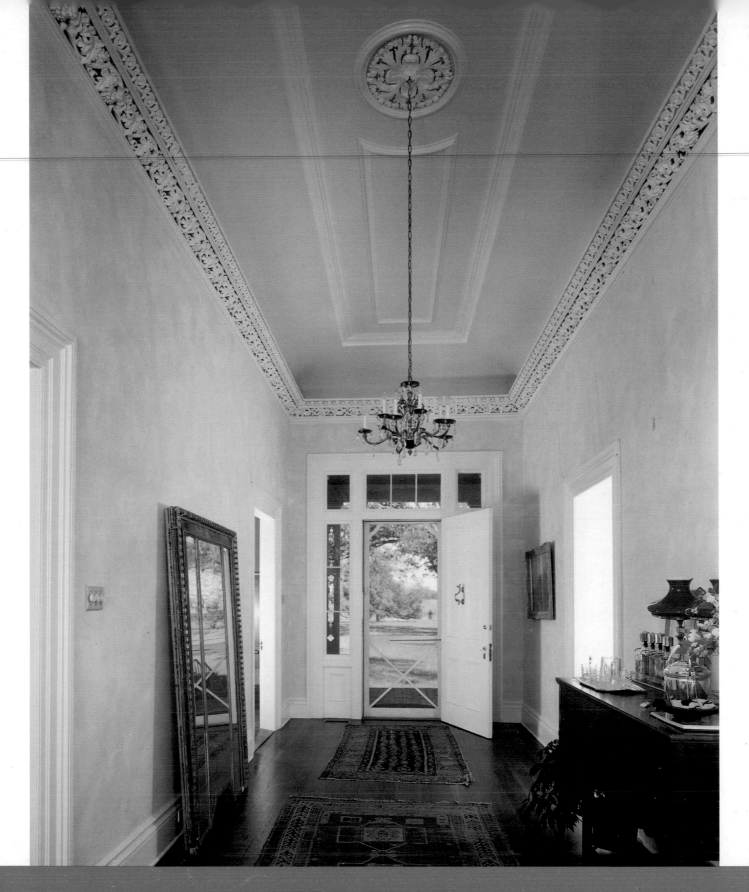

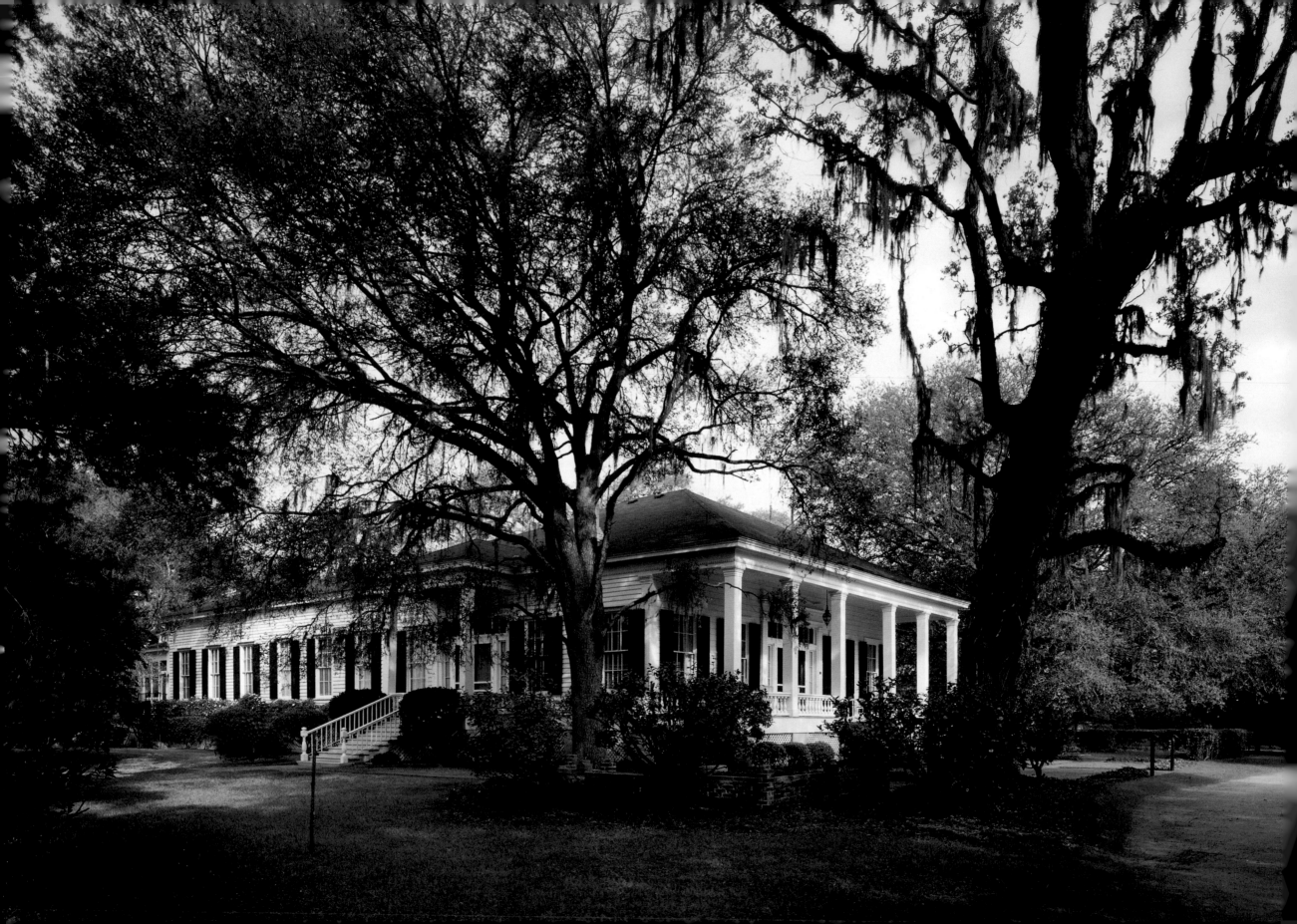

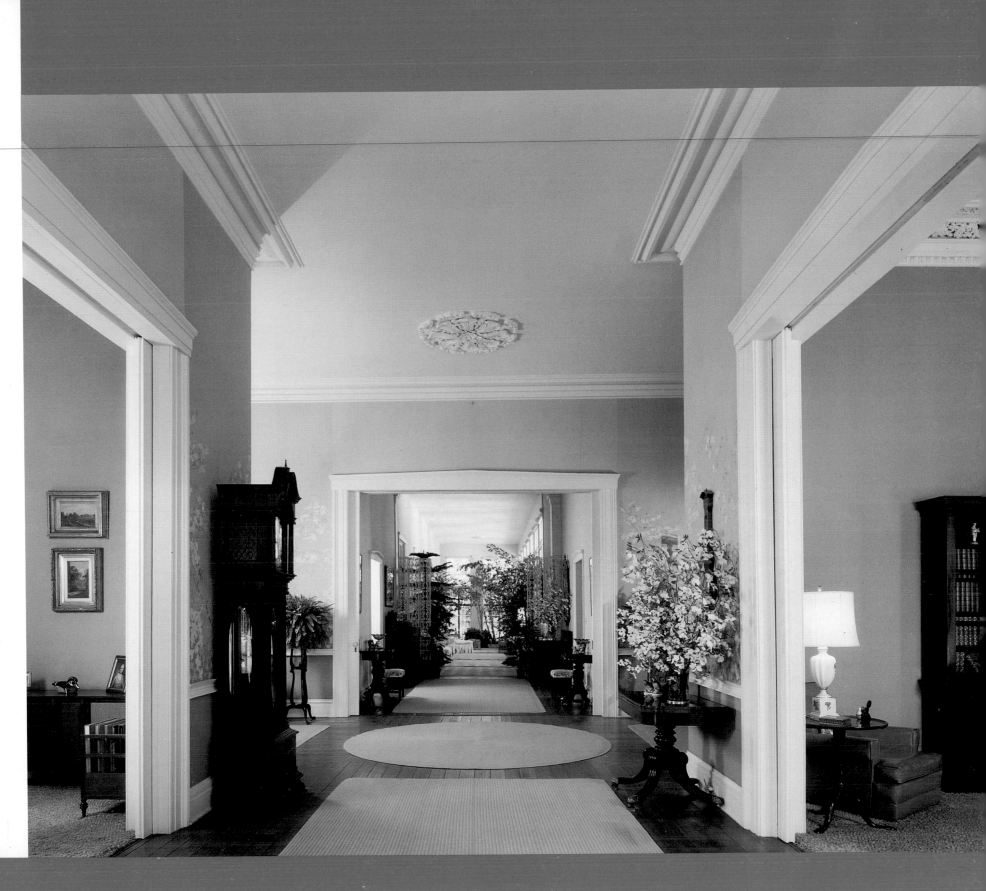

Tarva, *ca.* 1850

Henry Andrew Tarver and Elizabeth Griffin Solomon, both from Twiggs County southeast of Macon, married on March 6, 1850, and received the cottage now known as Tarva as a wedding gift. The couple had ten children, eight of whom lived to maturity.

The architect-builder is said to have been a Mr. Sessions from Twiggs County, who designed the one-story Greek Revival cottage with two 16-foot-wide center halls on a cross plan and a twenty-four-foot-square room in each corner. The house faces east, and the east-west hall extends to form a louvered veranda of a rear bedroom wing. That veranda has been glassed in by later owners (the original louvers remain outside) to create an impressive center hall that is at least one hundred feet long.

Tarver heirs owned the plantation of nearly seven thousand acres in 1860 until 1940, when it was acquired by Russell A. Alger, Jr., of Chicago. He restored the house (restoration architect was Edward Vason Jones of Albany) and used it as a winter hunting preserve. Alger sold it in 1947 to Don and Mary Hunter, and Tarva remains in that family.

Hunter Plantation, *ca.* 1846

Abraham Hunter, from North Carolina, was among the first settlers of southwest Georgia, and according to family tradition, he located his property on an original British land grant.

Hunter Plantation, in Brooks County, is said to have been in the same family for over 150 years. It is said that the plantation's acreage amounted to 5,000 acres before the Civil War, tended by about 275 slaves.

By 1986, the house was unoccupied but still owned by Hunter heirs.

Eudora, 1859 (right)

Built just before the Civil War as a wedding present for Sarah Spain and Mitchell Jones, Eudora Plantation acquired its present name in the 1960s when the Old Jones Place was once again owned by a descendant of Francis Jones I, a Welshman who became a Virginia planter and whose grandchildren moved to Thomas and Brooks counties in southwest Georgia. The architect is believed to have been John Wind, designer of Greenwood and Susina, among others, in Thomas County.

Mitchell and Sarah (he twenty-four years of age, and she nineteen) were given the house and almost two thousand acres in January, 1860. Only a year later, Mitchell went to war. After Appomattox, the Joneses moved into a new home in Valdosta, Georgia, but the plantation remained in the family until 1900.

The great house, with an unusual ogee arched entranceway, has four twenty-by-twenty-foot rooms on each floor, with twelve-by-forty-foot center halls.

The Old Jones Place went through a succession of owners until 1962, when it was purchased, restored, and given a new name, Eudora, by Mr. and Mrs. Jinnin P. Worn, Georgians who had lived in California for twenty-five years but had always wanted to return to their native state. Eudora burned to the ground in February, 1987.

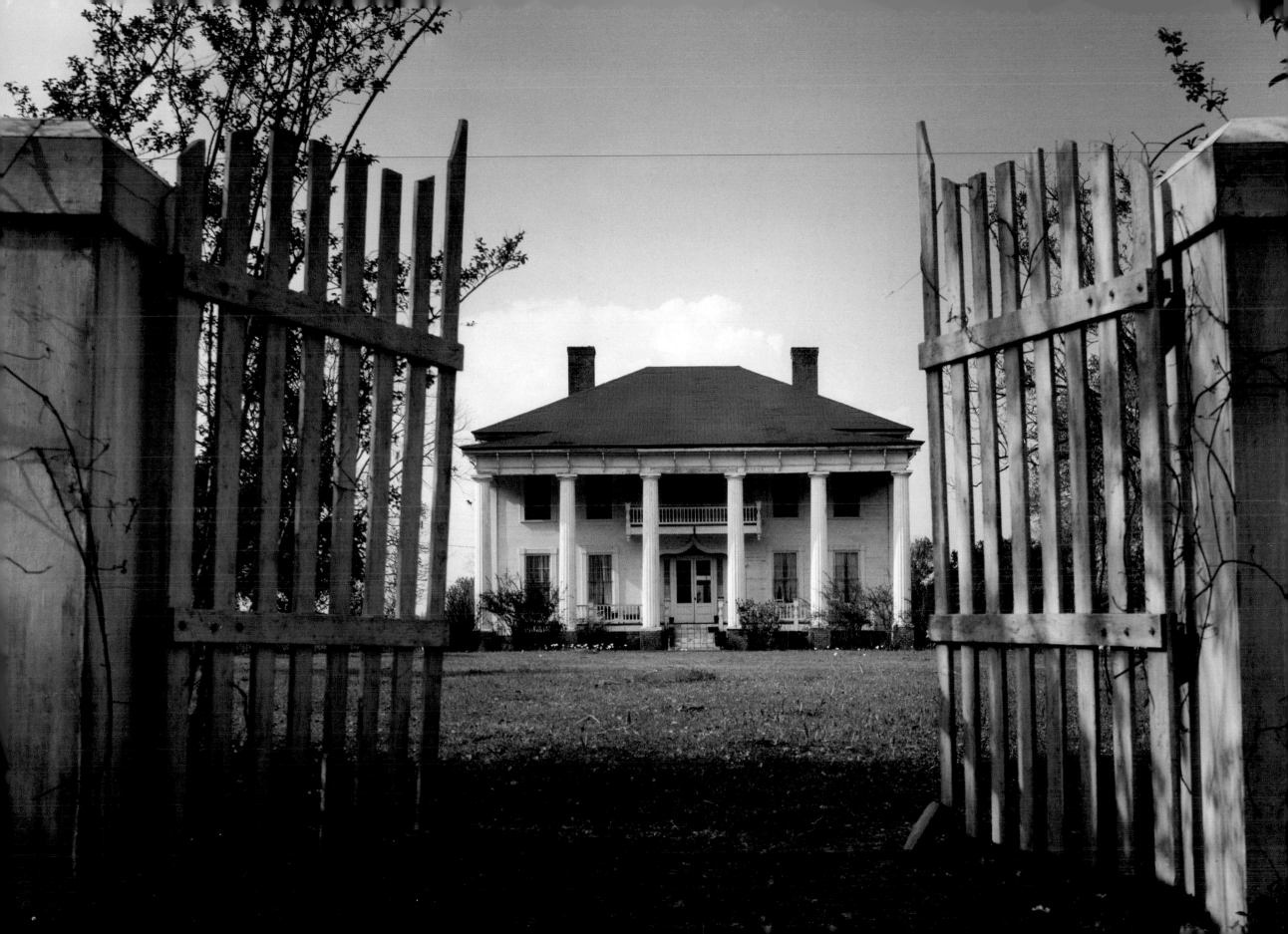

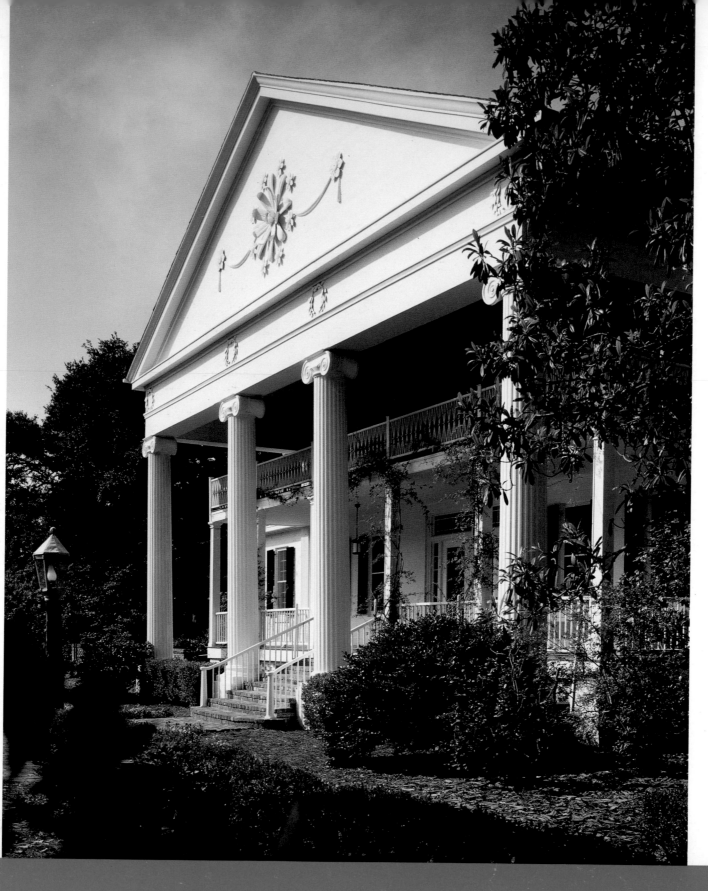

Greenwood, 1830s

Thomas P. Jones and his wife Lavinia came to Thomas County in 1827 and made their first home in a log cabin. Construction on Greenwood was begun in the 1830s, supervised by English architect-craftsman John Wind, who is said to have carved the wooden rosette in the pediment over the fluted Ionic columns with a pocketknife.

After the death of her husband, Lavinia continued to make Greenwood her home until 1889, when she sold it, along with thirteen hundred acres, to S. R. VanDuzer of New York City, who made it his winter home and hunting lodge. The plantation acreage has since expanded many times over.

Stanford White, a prominent turn-of-the-century architect, visited Greenwood and suggested only minimal changes. John Wind's classic design needed little improvement.

In 1899, Greenwood was purchased by Colonel Oliver H. Payne. His nephew, Payne Whitney, inherited the plantation in 1917. Whitney was an associate of David O. Selznick, and when the motion picture rights for *Gone With the Wind* were in negotiation, he insisted Selznick buy them at the historic price of $50,000 for a first novel.

Greenwood is now owned by Payne Whitney's son, John Hay (Jock) Whitney.

Pebble Hill Plantation, 1820s, 1936

The plantation Pebble Hill was in existence before
Thomas County and Thomasville were created by the
founder of the plantation, Thomas Jefferson Johnson,
who had become a state legislator.

John H. Mitchell, Sr., married Johnson's daughter,
Julia Ann, and they built a one-story H-shaped house
designed by architect John Wind.

In 1896, industrialist Howard Melville Hanna of
Cleveland, Ohio, acquired the plantation and made it
the winter home for his family. The original house
burned in 1934. The present Pebble Hill manor house,
completed in 1936, echoes the design of the earlier
one, albeit on a much grander scale.

Pebble Hill remained in the Hanna family until the
death of the last of the Hanna heirs, Elisabeth Ireland
Poe, known as Miss Pansy, in 1978. A sportswoman
and patron of the arts, she established a foundation to
maintain the plantation in perpetuity after her death
and to open the house and grounds to the public.

The main house is the centerpiece of a complex of
buildings that constitute the winter estate of a very
wealthy family. Outbuildings include elaborate stables,
a guest house, firehouse, dog hospital, kennel nurse's
offices, and "The Waldorf," the staff kitchen.

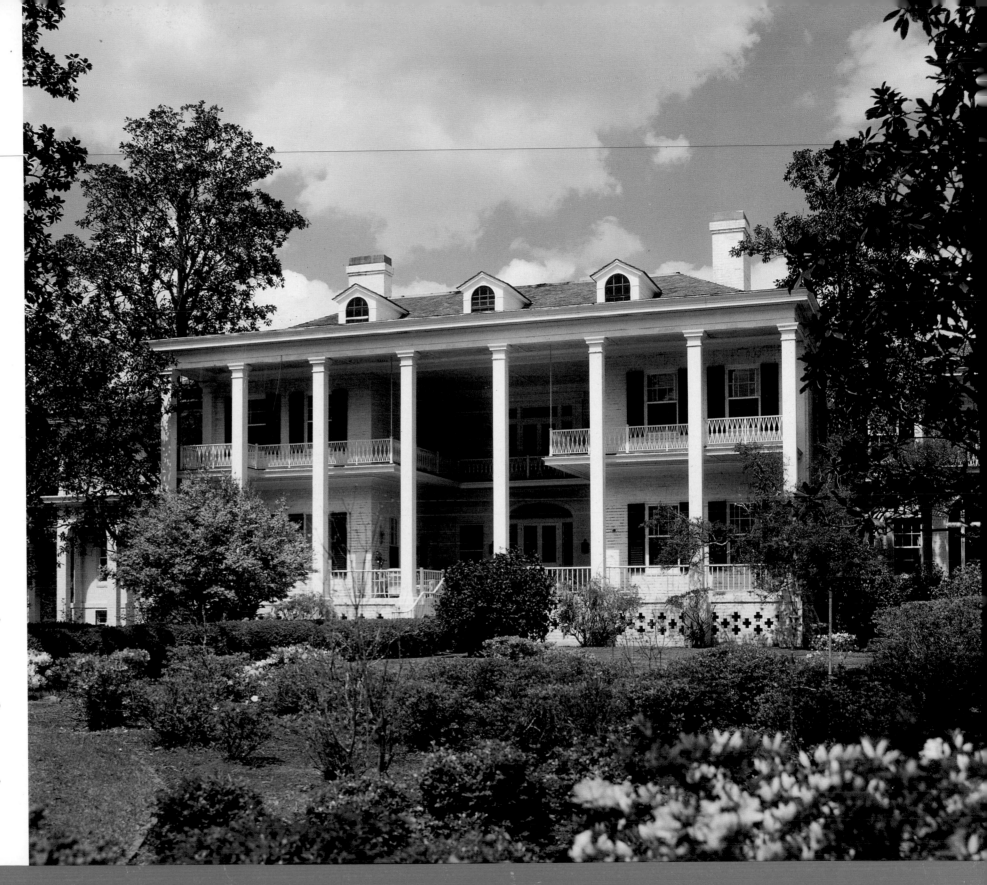

(left) Aerial view of Pebble Hill Plantation

(right) The stables at Pebble Hill

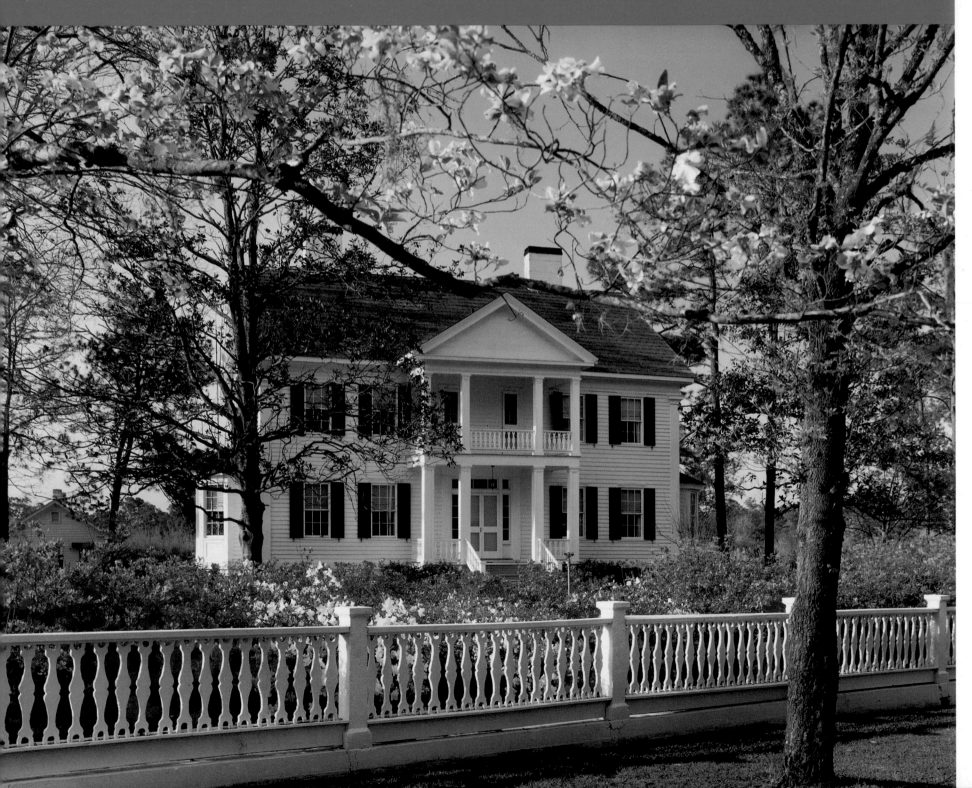

Seminole, *ca.* 1850

Originally called Ashland, and later Madreland, Seminole stands at the junction of the Twelve Mile Post Road and the Boston-Monticello Road about a dozen miles southeast of Thomasville.

Major Josiah Jefferson Everitt came to Thomas County from the area northeast of Savannah in about 1840 and built Seminole in the early 1850s, probably using the services of architect John Wind. The Everitts had family ties to Pebble Hill's Thomas Jefferson Johnson. Everitt and his wife and children are buried in the family cemetery on the grounds of Seminole Plantation.

His uncle, Aaron Everitt, surveyed and laid out the town of Thomasville when it was named the county seat in 1826.

Seminole is now the property of the owner of the Atlanta Falcons football team, Rankin Smith.

Susina, *ca.* 1841 (right)

Southwest of Thomasville in Grady County, not far from the Florida border, James Joseph Blackshear retained the services of John Wind to build a mansion for himself and his wife, Harriet Jones. One of the outstanding planters in Thomas County, Blackshear was killed in an accident in 1843, but with Wind's assistance his wife finished the house, then named Cedar Grove, and managed the plantation herself. The rosette in the pediment is said to have been carved with only a pocketknife by John Wind.

Dr. John T. Metcalfe bought the plantation from Harriet Blackshear's son, Thomas, in 1887, changed its name to Susina, and sold it to A. Heywood Mason, a Philadelphian, in 1891. Mason added side porches and a wing to the rear of the house.

Now called Susina Plantation Inn, its current owners, Anne-Marie and Robert Walker, operate the house as a tastefully restored bed, breakfast, and dinner inn.

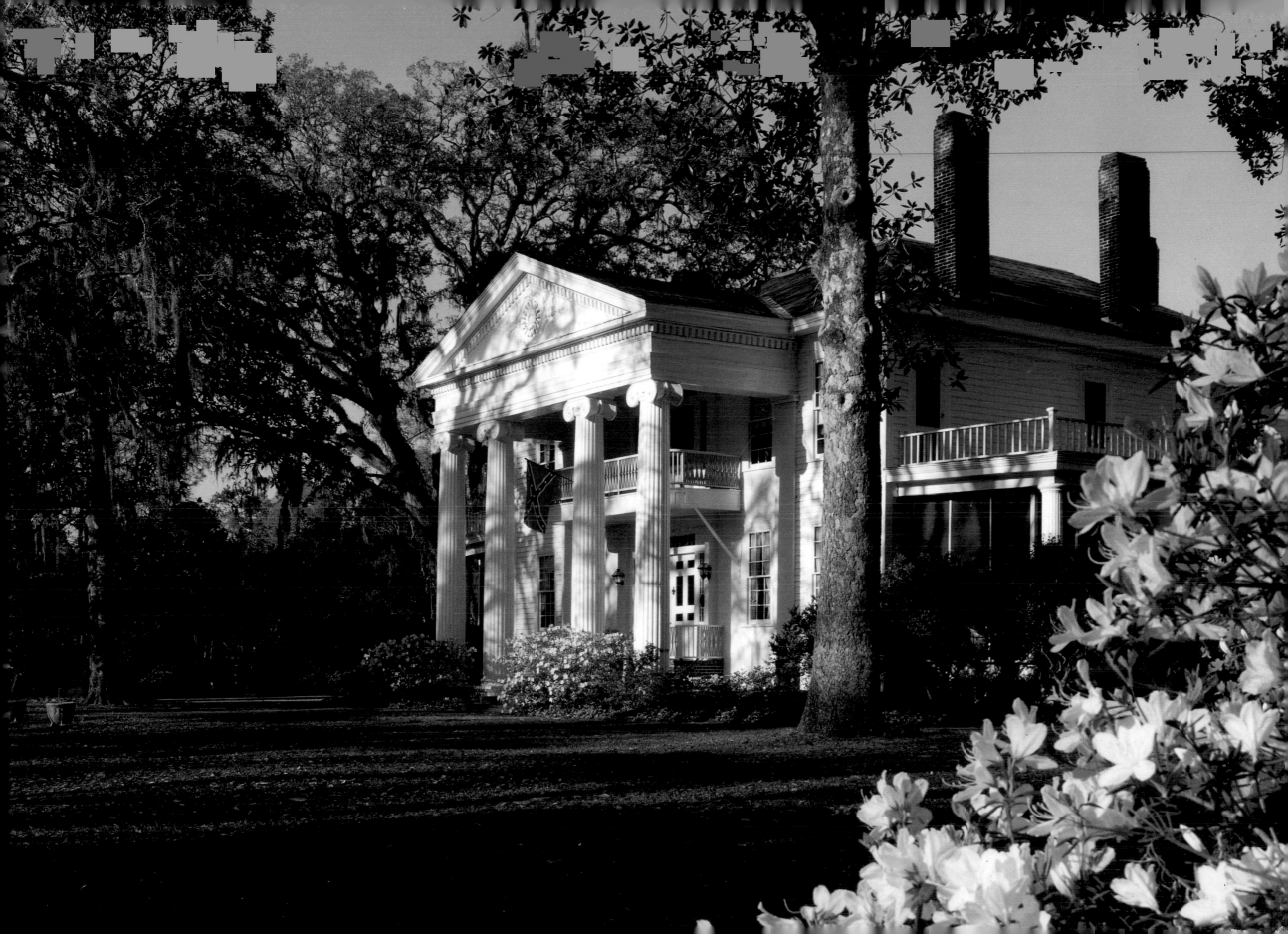

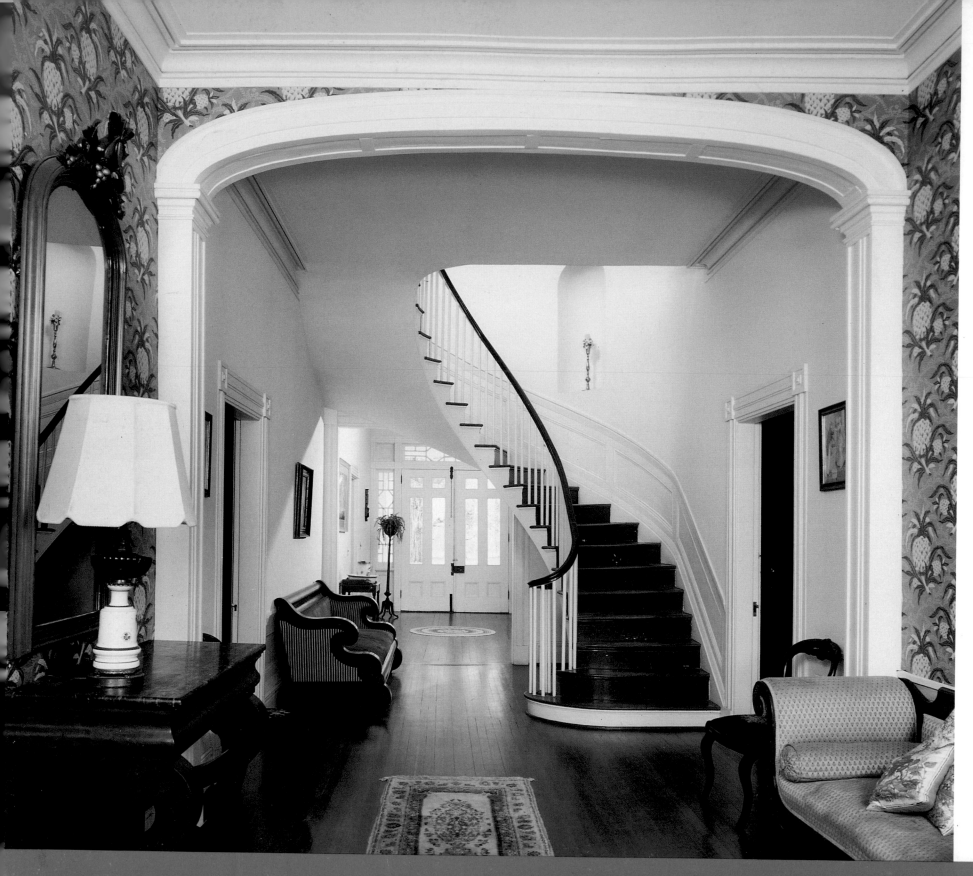

(left) Looking toward the rear of the center hall of Susina

(right) Rosette carved by hand by John Wind

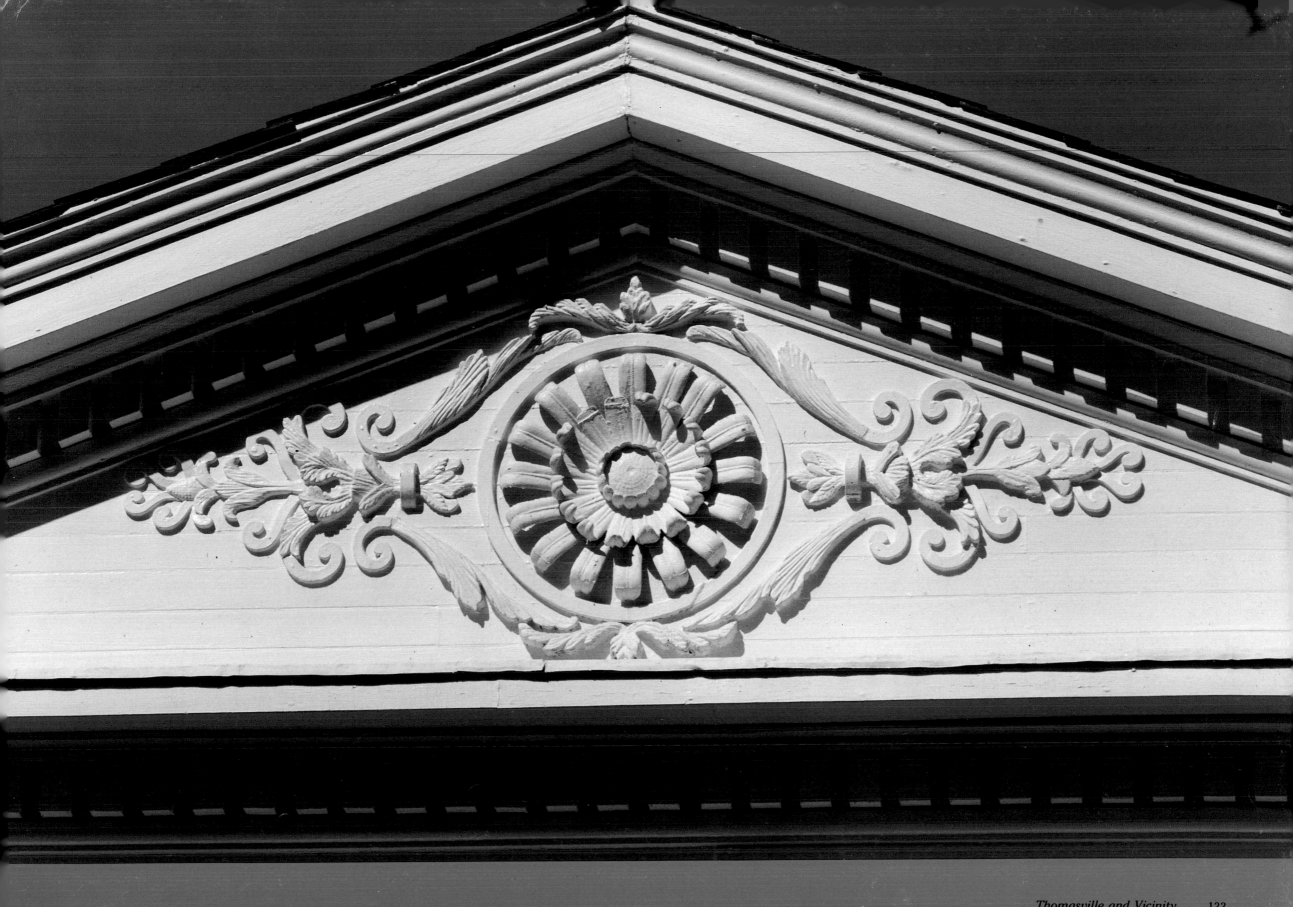

Notes on Photography

Georgia is a large state, the largest east of the Mississippi River. Covering the Empire State of the South required logging many thousands of miles on the family van and shooting several hundred rolls of film.

Since we were many miles away from our home base in Louisiana, on the road for a couple of weeks at a time, our equipment had to be compact. We traveled light, my bride Josie and I, with roll-film cameras, primarily the 6 × 7 Pentax system, with lenses from 45mm to 300mm. The 75mm Shift lens, with some of the controls of a view camera, has become a favorite.

Sometimes, however, the coverage of the 75mm lens just isn't wide enough (it's similar to a 35mm focal length on 35mm cameras). I have used the 45mm to good effect, when I don't need to tilt the camera up, but it bothers me to see a structure's vertical lines converging. The wider the angle of the lens, the greater the convergence. One day, perhaps, Pentax will unveil a 45mm or 55mm Shift lens for the 6 × 7, and I'll be the first in line to buy it.

Fortunately, Plaubel recently announced their Pro-Shift camera, using 120 roll film with a 48mm lens on 2¼ × 3¼ (this is wide, about like a 20mm lens on a 35mm camera) and with a rising front! The horizontal coverage is just a little wider than the 45mm on the 6 × 7, and with its rising front, I can control my verticals.

I used Eastman Kodak's color negative films, primarily 120 Vericolor III Professional. This film leaves the factory at an optimum color balance, and the best way to prevent a color shift is to keep it cool. This can be a problem traveling in a van in Georgia in the summer, but we brought a Playmate cooler, keeping ice in one wide-mouthed Mason jar and

exposed film in another to protect it from the inevitable condensation in the bottom of the cooler. If there were minor color shifts, Gisela O'Brien, our resident master printer, controlled them in the process of enlarging.

Two questions regularly arise: Why color negative instead of color transparency? And why Vericolor III Professional?

If I lived on the road, I'd probably just shoot Kodachrome transparency film and send it to Kodak for processing. But we've had our own color lab for years and enjoy the flexibility and control that the enlarging process offers. With color negative, we can, in a typical antebellum home, make the deep-set porch somewhat lighter, darken the foreground, and add a little blue to the sky.

In addition, each house will have its own color balance, depending on how much greenery is around it, how much red clay, the time of day (the light becomes warmer in color as the sun nears the horizon), and the direction the house faces in relation to the sun. The color of the shadows is influenced by the blueness of the sky, thunderheads reflecting white light, and adjacent vegetation.

Rather than asking the pressman or the color separator to bring these varying color balances into line, or carrying a three-color meter and a box of color-correcting filters in the van, we do it in the darkroom, producing a set of matched, reproduction-grade color prints.

Why Vericolor III? It handles the extreme contrasts of the plantation home scene well and is totally predictable, extremely sharp, and quite forgiving.

For aerials, however, we prefer the brilliance of Kodacolor. From one thousand feet up, there really isn't much contrast, and we need all the help we can

get. The newest emulsion of Kodacolor, VRG, is tremendously sharp with great color saturation. We also use it on the ground for lower contrast situations and use Kodacolor 400 in low light levels.

Because we were working out of a van for days at a time, we had limited space for lighting equipment. We carried four of Balcar's compact but versatile MonoBloc II electronic flash units, which put out just about as much light (roughly one thousand watt-seconds) as our studio units, but which weigh eight pounds each instead of twenty-two and recycle quickly, gaining full power in just a half-second!

We illuminated our Georgia interiors with four MonoBlocs, which, complete with reflectors, barn doors, cords, and umbrellas, fit nicely in two medium-sized Igloo ice chests, looking more like a shipment of fresh shrimp than expensive photographic equipment. We balanced our lighting (white umbrellas, mostly) with longer shutter speeds (from ⅟₃₀ to about ¼ second) to balance the exterior light coming in through the windows. Our average exposure ran between f/8 and f/11 at around ¼ second, using a Pentax spot meter to read the brightness of the windows and a Calculite strobe meter to measure the output of the MonoBlocs.

As a final test when shooting interiors, we used an NEC Polaroid back permanently mated to a 6 × 7 Pentax body. This gave us a quick Polaroid color print to see exactly what our lights were doing and also provided a permanent record of each house, inside and outside. This simplified the job of identifying the several hundred negatives exposed on each trip.

Index